A **PANTONE**® Color Resource

COLOR: messagesandmeanings

LEATRICE EISEMAN

Published by Hand Books Press
Gloucester, Massachusetts

Distributed by North Light Books
Cincinnati, Ohio

COLOR: MESSAGES AND MEANINGS, A PANTONE® COLOR RESOURCE
by Leatrice Eiseman

Copyright © 2006 by Hand Books Press

Published by Hand Books Press
86 Eastern Point Boulevard, Gloucester, MA 01930 USA
TEL 978-283-1135, FAX 978-776-2299
info@handbookspress.com

Distributed by North Light Books, an imprint of F+W Publications, Inc.
4700 East Galbraith Road, Cincinnati, OH 45236 USA
TEL 513-531-2690, 800-289-0963, FAX 513-891-7185

ISBN-13: 978-0-9714010-6-8
ISBN-10: 0-9714010-6-3

14 13 12 11 10 09 9 8 7 6 5 4 3

Author: Leatrice Eiseman, www.colorexpert.com, www.morealivewithcolor.com
Publisher/Creative Director: Stephen Bridges
Art Director/Designer: Laura H. Couallier, Laura Herrmann Design
Picture Researchers: Joan B. Herrmann, Laura H. Couallier
Front Cover Photographs by Don Paulson
Staff Photographer: Don Paulson, www.donpaulson.com, TEL 360-830-2212
Indexer: Jack Beckwith, Beckwith Bookworks
Pantone Advisor: Carmine Matarazzo, Technical Director/Print Division, Pantone, Inc.
Printing: SQL Direct, Inc., www.sqldirect.net

© Don Paulson

contents

preface

© Hank Drew

Leatrice Eiseman, called the "color guru" to a variety of industries, is executive director of the Pantone Color Institute® and founder of the Eiseman Center for Color Information and Training.

In my multi-faceted career as a color consultant, speaker and author, I continue to study color and observe that the psychological messages and meanings of color apply to so many areas of design. What does differ is the application and context of color.

For example, vibrant red is no less exciting on the printed page or website than it is on a product or the packaging that holds the product. Whether or not the bright red is appropriate for the intended usage and targeted consumer is the decision to make. The purpose of **Color: Messages and Meanings, a PANTONE® Color Resource** is to help you make those decisions. It's all about the emotional response to color, the latest, up-to-date guidelines and inspiration on effective color combinations including the integration of color trends.

Is there anyone in the business world today who doubts the impact of color? If you are involved in marketing, display, design, advertising, point of purchase or retailing there is always a need to be as informed

as possible about the usage of color as a means of instant communication.

This book is a follow-up to the **PANTONE® Guide to Communicating with Color** and although it is not absolutely necessary to have read that book prior to reading this current book, it will provide you with some additional information and guidelines.

In that book there were various shades and values that were featured: red, pink, orange, yellow, green, blue, purple, white, black, brown and the neutral tones of gray, beige and taupe. This book will similarly highlight variations of those color families and, in addition, will bring some

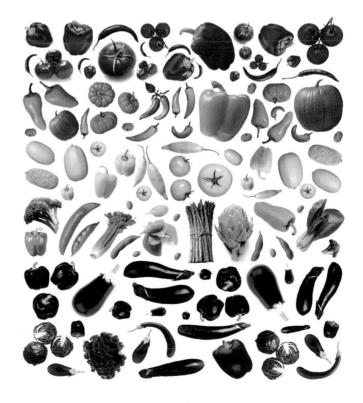

broader insights to the meanings and consumer responses to those colors.

Each section will include the words that are most frequently used to describe the specific shade. They are divided into the two headings of positive vs. negative reactions. Some words will have no negative reactions listed, as they were statistically insignificant in consumer word association studies.

16 ANS DE FIERTÉ

Please bear in mind that "negative" is a relative term. For example, among other attributes, red is suggestive of fire and danger which may be viewed as negative. Fire burns; fire is red hot. Used in the proper context, such as the packaging for a new super-spicy salsa, red is clearly an evocative choice. It can be dangerous (to the palate) and that is the primary selling point as any lover of spicy foods is well aware.

So, when perusing the positive-negative connotations, always think of context. In real estate, it's about location, location, location. In graphic design (as it is in all design disciplines), it's about context, context, context.

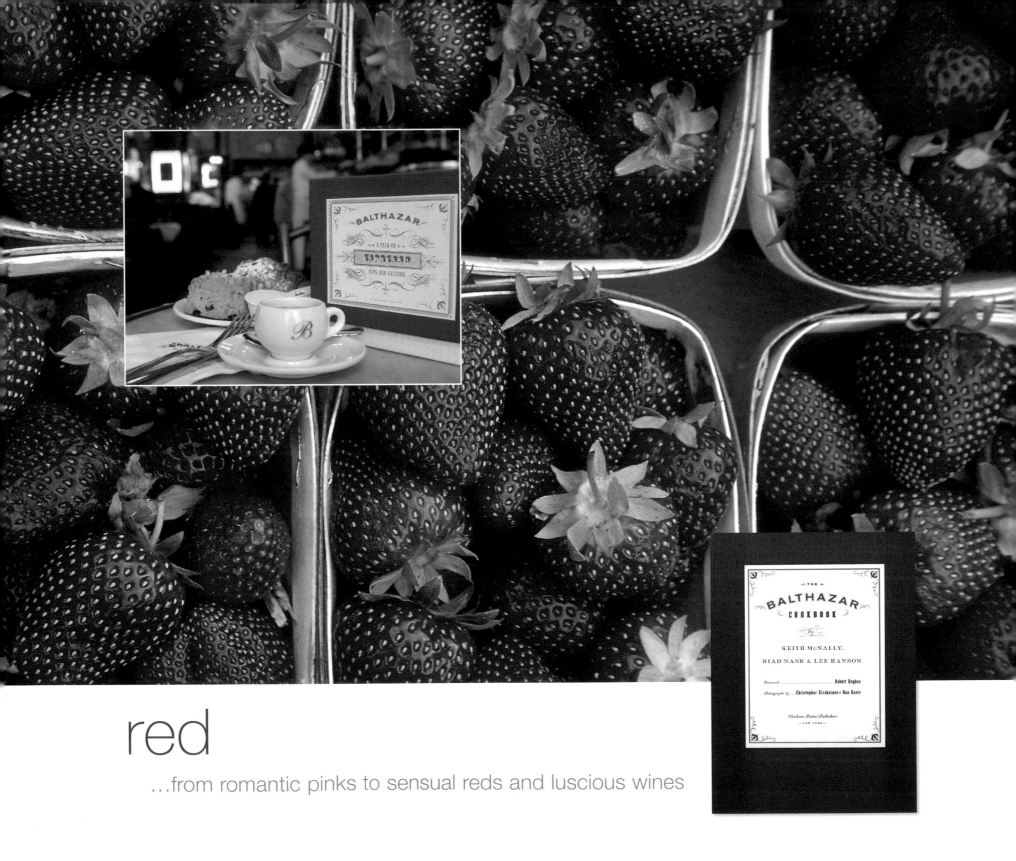

red

...from romantic pinks to sensual reds and luscious wines

From the beginning of time red has been deeply ingrained in the human mind as a signal to act or re-act, to fight or to flee. It is the color of life-sustaining blood or life-threatening bloodshed as well as the color of enticing, appetite arousing ripened fruits and delicious foods that sustain humans' very existence.

Red is an unrelenting hue. As an attention-getter, red can muscle out surrounding colors—whether on a website, in the window of a designer boutique or on a super market shelf. Red's more aggressive traits have to be handled judiciously so that the viewer is not overwhelmed or antagonized by its demanding presence. But if demanding is what you want, then red is your color.

The most physical color in the spectrum, red suggests the very ebb and flow of life. It is the most viscerally alive hue, the symbolic color of the heart, strong-willed and expressing strong emotions. It may command us to stop but at the same time encourages movement. Physiologically, red is a call to the adrenaline glands to get the body and senses activated.

This tempting suggestiveness can be used in the color of the product itself, for example, on a sleekly sexy and vibrantly red cell phone. While a cell phone may not be thought of as sexy, it is, in fact, one of the most intimate objects we own. Red does evoke passion for all sorts of products—an important issue at point of purchase, no matter where that point happens to be located.

Word association studies invariably show red is perceived as the most sensual of all colors and, as the saying goes, "sex sells". So the use of eye-riveting reds in the context of cosmetics, lingerie and let's not forget sports cars, does titillate the senses. It is a provocative and sultry use of a blatantly "come-on" color that can easily be translated to an ad, packaging, signage or retail display.

Not unexpectedly, the brightest reds make the boldest statements. Whether expressing danger, celebration, love or passion—lipstick reds, scarlet and crimson will not be ignored. These are the reds that "get the blood up" and arouse the strongest emotions.

Similarly, bright pinks capture some of the same essence of the red that spawns them. Some of the pinks are called bright and shocking because that is exactly what they are meant to be. Intensely theatrical, they radiate with high energy exerting a youthful and sensual force. When red seems a bit cliché or is in need of a more playful or youthful attitude, hot pinks, magentas and fuchsias serve as excellent stand-ins.

© Don Paulson

Deeper reds, such as burgundy, are the most sumptuous of the red family but they are much more subtle in their suggestiveness. Inevitably connected to rich, red wine and the "good life", they are thought of as elegant, cultivated, rich and refined. There is the expectation that deeper wine colors will be more expensive than their brighter red sister shades, but that can be used to advantage in a marketplace where luxury looks are being promoted.

Lighter pinks and roses carry the connotation of flowers or confections—sweetly scented and sweet tasting. The palest pinks are tender and girl-baby-ish, (a concept that some modern parents would like to change because of the inevitable stereotyping). Dusty roses are a bit more nostalgic and associated with gentility and all rose tones are forever tied to romance.

Brick reds are always connected to the earth, bringing the inevitable thoughts of country and warmth, yet not without a bit of the exotic interplay when combined with other unexpected earth tone shades, such as aubergine or vegetal yellow greens.

COONAWARRA
australia's other red centre

"When I gain these ruby slippers, my power will be the greatest in Oz!"

— *The Wicked Witch of the West*

PANTONE® 1895 PC	PANTONE® 693 PC	PANTONE® 205 PC	PANTONE® 186 PC	PANTONE® 188 PC	PANTONE® 1945 PC

LIGHT PINK

Positive:
romantic, affectionate, compassionate, soft, sweet tasting, sweet smelling, tender, delicate, innocent, fragile, youthful

Negative:
too sweet

DUSTY PINK

Positive:
soft, subtle, cozy, dusky, gentle, composed, nostalgic

BRIGHT PINK

Positive:
exciting, theatrical, playful, hot, attention-getting, high-energy, sensual, wild, tropical, festive, vibrant, stimulating, flirtatious

Negative:
gaudy

BRIGHT RED

Positive:
exciting, energizing, sexy, passionate, hot, dynamic, stimulating, provocative, dramatic, powerful, courageous, magnetic, assertive, impulsive, adventurous, demanding, stirring, spontaneous, motivating

Negative:
overly aggressive, violent, warlike, temperamental, antagonistic, danger

BRICK RED

Positive:
earthy, warm, strong, sturdy, established, country

DEEP REDS

Positive:
rich, elegant, refined, tasty, expensive, mature, sumptuous, cultivated, luxurious, robust

Last Mango in Paris

le dernier

Cantaloupe Frosty

orange

...from nurturing peach to vibrant orange and earthy terra cotta

COALESCE
marketing & design, inc.

The first mention of the fruit that gave a name to the color orange dates back to 500 BC. Oranges had their origins near the South China Sea. From there they were transported and cultivated throughout Malaysia, India, East Africa and into the Mediterranean regions and the rest of Europe. There was literally no word for orange in Europe until the fruit arrived. Oranges became known as the fruit of the gods, of emperors and kings and the hierarchy of the church—exclusively for aristocrats and the wealthy, ultimately gaining symbolic importance in Renaissance paintings.

So the origins of the fruit, as well as the appreciation for the color, started in rather exotic lands. Eventually orange was impressively integrated into fine art available only to a rather privileged society and finally available to the masses when oranges were imported into the "new land".

The mid 20th century saw the popularity of orange plummet among the elite as the color was adapted not for fine dining but in fast food restaurants. But the 90s saw a "rebirth" of orange in the high fashion world and, because of the proliferation of the web, a wider exposure to the use of the color in other cultures. There was also the explosion of more vibrant color, including orange, in industrial design and consumer products.

PANTONE®
1645 PC

PANTONE®
715 PC

As a matter of fact, if a prize were awarded for the best "makeover color" in recent history, it would have to go to outgoing, optimistic orange. While still juicy, joyful and ripe for fun in its brighter skins, it's no longer down graded to eat and run logos, cheap plastics or cheesy polyester shirts. Orange has now gone uptown, especially when clothed for both fashion and home in light to mid peach tones or deeper terra cottas.

No matter where and how it's used, just a slice of various tones of orange adds zest to the highly visual flavor. It is, in fact, most often suggestive of tangy or spicy food. Many of the names attached to various shades of orange are also the names of foods: tangerine, nectarine, melon, mandarin, carrot, pumpkin, persimmon and the glowingly edible nasturtium flower. Its appetite-stimulating proclivities make it a natural around food.

It is seen as a vitamin-enriched, vital color and although the actual complement to orange is blue, skewing the blue to a bit more blue green brings an intriguing contrast that will highlight the orange message; it is also a more tropical 'take' on that particular combination. Because of the association with the Mother hue of red from which it comes, vibrant orange is a very physical, high-visibility color, seeming to be in constant outward motion, calling for attention. But because of its connection to convivial, sunny yellow, orange is seen as friendlier and more approachable, less aggressive than red—a gregarious, fun-loving hue. It is a great favorite for children, as they become more fascinated by the secondary colors, especially in the three to six year old age group.

The closer orange moves to red, the more sultry and sexual it becomes, especially in exotic tigerlily-like shades. These tones can be thought of as wild, provocative and uninhibited. Corals also have a sensual connotation and coral roses are symbolic of desire. In Buddhist teachings, coral is one of the five sacred stones and symbolizes the energy of life force, teaching flexibility and flow. It is an auspicious color in Tibetan culture, harboring a belief that one who wears coral will have success in life, while in China it is a symbol of longevity.

© Doris Mitsch

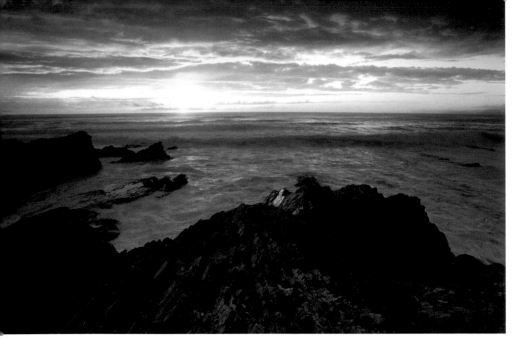

© Don Paulson

the
perfect
peach

get grilling!

celebrate with style
summertime parties

There is no better example of the glorious usage of orange and the mesmerizing fascination it holds in attracting the human eye than in the amazing striations of a tropical sunset or the crackling embers of a fire on a blustery winter night. Orange may not be everyone's favorite color, but the need to observe and experience the warmth is inescapable.

While bright orange is perceived to be the hottest of all colors and some people might feel uncomfortable with all that intensity (precisely why they make great prison garb), the lighter and less intense apricot and peach tones seem to wrap you in a warm, welcoming embrace. Just as the delicious, fuzzy fruits that inspired their names, they are the perfect shadings for imbuing any product, packaging or environment with a sense of smelling a sweet scent, feeling a soft touch, and having a pleasurable visual experience. Pale peach also implies modesty.

Mid to deep orange tones such as terra cotta or brick literally are "of the earth" and "down to earth"—as are any russet-toned, baked clay colors. They are wholesome, unassuming, warm shades that are known and used by many cultures—from the southwest regions of the U.S. to weathered Italianate villas in Tuscany.

So orange has gone from crass to classy in a relatively short period of time and, to tell the truth—orange you glad?

PANTONE® 162 PC	PANTONE® 170 PC	PANTONE® 715 PC	PANTONE® 1585 PC	PANTONE® 180 PC	PANTONE® 7522 PC

PEACH

Positive:
nurturing, soft, fuzzy, tactile, delicious, fruity, sweet tasting, sweet smelling, inviting, warm, physical comfort, intimate, modest, embracing

CORAL

Positive:
life force, energizing, flexibility, desire

TANGERINE

Positive:
vital, juicy, fruitful, energizing, tangy

VIBRANT ORANGE

Positive:
fun, whimsical, childlike, happy, glowing, sunset, hot, energizing, active, gregarious, friendly, good-natured, expansive, spontaneous, optimistic, communicative, jovial, sociable, self-assured, persuasive, animated

Negative:
loud, raucous or frivolous

GINGER

Positive:
spicy, flavorful, tangy, pungent, exotic

TERRA COTTA

Positive:
earthy, warm, country, wholesome, welcoming, abundance

yellow

... from comforting custard to sunny yellow and the richest gold

Inexorably connected to the sun, yellow sparkles with heat, vitality, energy and light. This is the color that best expresses the essence of light and also suggests an intellectual energy, curiosity and the need for enlightenment—the ability to see all things more clearly—literally and philosophically.

Yellow sends out its glimmering rays to capture anyone within its presence, confident that its friendly message of warmth and sunlight will stimulate the imagination to new heights. It is an extroverted hue, one that can never be described as dark or dim.

© Don Paulson

As one of the most important colors in human development, yellow will always attract the infant's eye. And when they are old enough to draw, yellow is inevitably the color that toddlers will choose to embellish the upper right or upper left side (experts say it depends on their right or left hand proclivities) with a big yellow sun. Even at those earliest ages, children recognize the strong presence of the sun and the need to express it in yellow.

It is the color of highest visibility, with pure, bright and vibrant yellows the easiest for the human eye to see. It is the color that heightens awareness and creates clarity, lighting the way to the intelligence, originality and the resourcefulness of an open mind—the color of hope, joy and optimism.

© Steven Rydberg

Because of high reflectivity and the ability to draw the eye so quickly, the use of yellow in signage, point of purchase displays and packaging is a significant attention-grabber. The combination of yellow and all-powerful black is even more commanding (so much like the markings of wasps, tigers, diurnal mammals, poisonous fish and New York taxis) and the indelible message is deeply implanted in the human mind to WATCH OUT!

Believers in the powers of gemstones say that carrying a yellow gemstone promotes self-expression and that yellow stones stimulate movement and mental awareness, necessary for enhancing decision-making skills. As a matter of fact, yellow light waves are said to stimulate the brain, bringing clear-headed, decisive action.

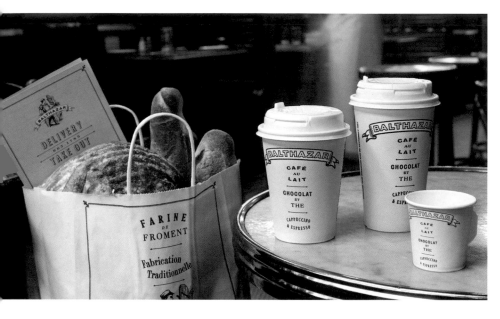

**PANTONE®
7402 PC**

The softer and more golden shades of yellow bring thoughts of pleasant relaxation and warming comfort, as in comfort foods. In times of stress, there is an increase in the sale of yellow foods as people revert to childhood comfort foods such as macaroni and cheese, buttered popcorn, custard, puddings, crackers, cookies, warm soups and ubiquitous, golden-toned French fries. Your definition of comfort foods could also include, of course, a foam-topped mug of amber ale or a glass of Chardonnay!

Intuitively and eternally acknowledged as the gilded representation of life sustaining sunlight, glittering gold has always been perceived of as being on a "higher plane". Throughout the ages gold has possessed numerous religious connotations—figures in the divinity, the halo around a sainted head, the priesthood and Egyptian pharaohs as god-kings. On a more worldly (although still lofty) level, gold is seen as the measure of earthly wealth and luxury. The perception of value is always intensified with the use of gold.

"Follow the yellow brick road…."

—Dorothy in the "Wizard of Oz"

| PANTONE®
127 PC | PANTONE®
116 PC | PANTONE®
130 PC | PANTONE®
1385 PC | It is not possible to simulate metallic inks with CMYK process color. |

LIGHT YELLOW

Positive:
cheering, happy, soft, sunny, warming, sweet, easy, pleasing, babies

BRIGHT YELLOW

Positive:
illuminating, joyful, hot, lively, friendly, luminous, enlightening, energetic, sunshine, stimulating, innovative, radiating, awareness, surprise, caution

Negative:
cowardice, betrayal, hazard

GOLDEN YELLOW

Positive:
nourishing, buttery, tasty, sun-baked, wheat, hospitable, comfort and comfort food

AMBER

Positive:
jewelry, multi-cultural, mellow, abundant, original, autumn

GOLD (metallic)

Positive:
rich, glowing, divine, intuitive, luxurious, opulent, expensive, radiant, valuable, prestigious

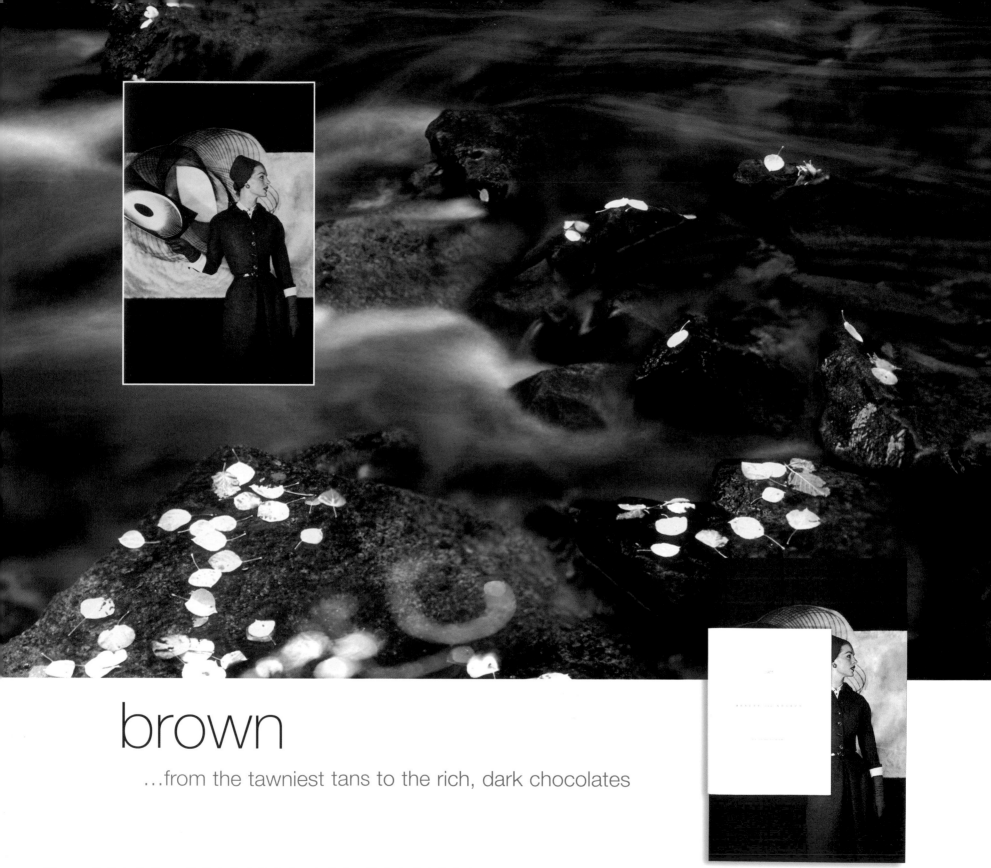

brown

...from the tawniest tans to the rich, dark chocolates

Many dictionaries will describe brown as "a pigment or dye that is formed from a combination of red, yellow and black and has or is near the color of wood or soil". Or perhaps "a dark color inclining to red or yellow, resulting from the mixture of red and black, or of red, black, and yellow; a tawny, dusky hue". Other resources refer to brown as "technically a mixture of orange and black", or "a darkened orange" associated with "plowed earth and hard work". End of story.

But this is not the end of brown's history or current story. Today brown includes a rich mosaic of meanings based largely on the undertones of the color; changes in lifestyles, newly acquired concepts of the usage of brown and the context in which it is used.

It is true that brown is the color most identified with earth and with the diligence it took to work the earth. It was the shade often worn by workingmen and women as the dyestuffs were always easily available and inexpensive—and they didn't "show the dirt".

Drabber, grayed browns were seen as reliable, lacking social pretensions, disdaining the brighter more "lustful colors". For these same reasons, they were preferred by religious and Puritan moralists groups and became synonymous with piety, poverty, economy, industriousness and modest ambitions. Brown is also seen as benign and non-threatening.

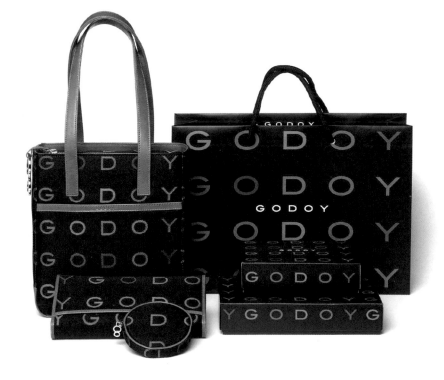

Those associations have been tempered over the years as brown became the color highly favored by sports activities, specifically hunting, fishing, hiking and camping. Brown became more of a "fashion" statement as those outdoor pursuits became stylish and were also worn by the wannabee outdoor types. Eddy Bauer, L.L. Bean, Coldwater Creek, Norm Thompson and Sundance catalogs proliferated and so did the reliable family of browns.

NOWHERE ELSE IS SIX FEET OF REAL ESTATE
WORTH SO MUCH.

THESE GUYS ARE GOOD.

© Don Paulson

AUX BELLES DE CANCALE

THE BOLD LOOK OF **KOHLER**

Brown truly does inhabit the earth with all manner of shades in mammals and the animal kingdom. It is also the color of many woods and woodland creatures. So for many people it speaks more of a rustic nature, primitive art and artifacts than it does of technology and modernism. It also reminds us of hearth and home, the color of brick and fundamental building materials. There is a wholesomeness and certain organic quality attached to the brown family (especially the tans) that the natural food movement has used to great advantage.

© Don Paulson

LIGHTS OUT
TO WHOM IT MAY CONCERN
CAPITOL RECORDS
Stylist JODY LEESLEY
▶ See Video

LISA MARIE **PRESLEY**

**PANTONE®
7526 PC**

But brown also has an amazing appeal to an expanded appetite, both in food and drink. Think of brown's own recipe—often having an undertone of red, yellow and/or orange—those warm tones that do appeal to the appetite. Think cappuccino, espresso, French roast, café au lait; chocolate mousse, mocha, caramel, chocolate covered biscotti and the ultimate topping, hot fudge. In the context of coffee or chocolate, brown is often irresistible.

THE BROWN OF THE
BLACK MAGIC? CHOC
CUP THAT GLOWED
RED WHEN YOU
HELD IT TO THE
LIGHT

There is a fashionable cachet now attached to these delicious chocolate/coffee shades that has spread into all other design areas, including graphics. Certainly chocolate and coffee have been around for years, but now there is a certain luxurious edge to both. What was a cup of java in the 50s is now more likely to be called

an elegant espresso or a double latte while chocolate candy, always a great consumer favorite, especially for special occasions, is now packaged in a glamorous brown box, with each piece of chocolate looking more like a small exquisite work of art than a mundane piece of candy. Interestingly, consumers are willing to pay for the added luxury.

"There is, after all, safety in umbers."

—Leatrice Eiseman (from "Colors for Your Every Mood")

© Don Paulson

**PANTONE®
729 PC**

**PANTONE®
477 PC**

**PANTONE®
438 PC**

TANS

Positive:
rugged, outdoor, rustic, woodsy

**CHOCOLATE/
COFFEE BROWN**

Positive:
delicious, rich, robust, appetizing

EARTH BROWN

Positive:
earthy, grounded, steady, solid, rooted, wholesome, sheltering, warm, durable, secure, reliable, natural, traditional, supportive

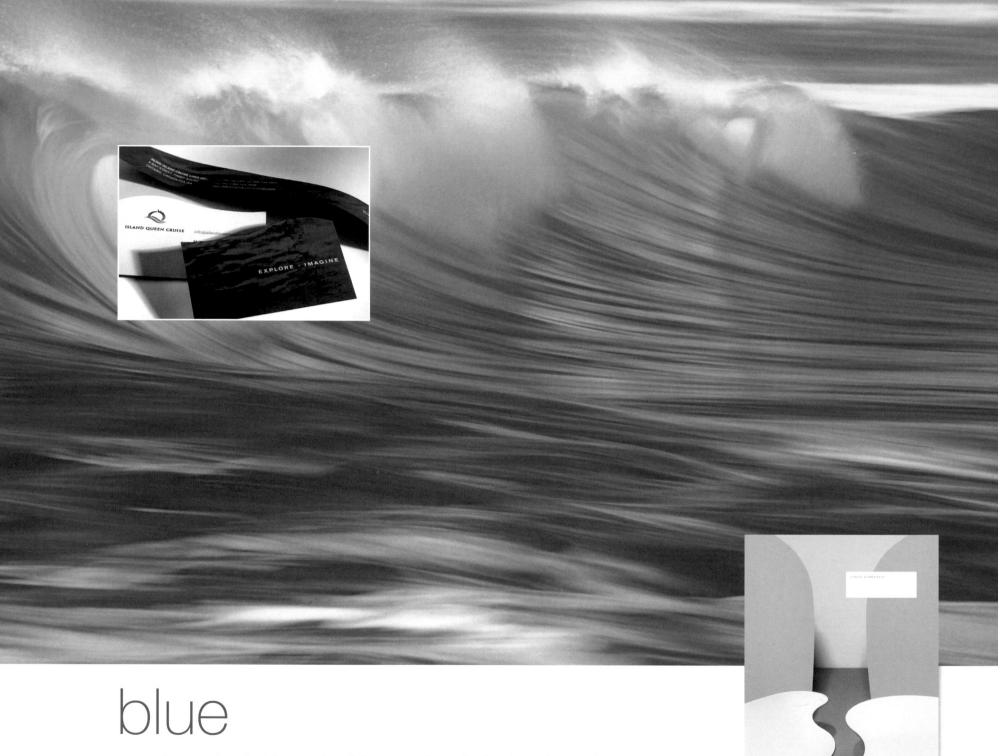

blue

...from the loftiest sky blue to the dark dazzling electric blues

Long associated with the serenity of a clear, cloudless blue sky reflected over a calm sea, the light, mid and deep blues bring a feeling of respite and introspection—a quiet, cool permanence. The human mind embraces the concept of blue as tranquil and constant and translates it into a symbolic image of dependability and loyalty. Obviously, this works well in a suggestion of "always being there for you" that inspires a remarkable dedication from the consumer.

Blue is the color associated with many religions, devotions and dedications, for example, the blue cloak of the Virgin Mary, often depicted in fine art.

It is the color symbolic of mercy and, as it is believed that the Ten Commandments were carved on sapphire tablets, blue also represents the highest orders of justice and moral behavior. Blue became the color of the most venerated and respected honors, the blue ribbon of quality and skill.

© Don Paulson

Many industries have made good use of the intrinsic belief that blue represents constancy, quality and achievement. It is the #1 choice for use in corporate branding and identification. The constant challenge of such pervasive use of the color is to keep it looking fresh and not hackneyed. If the essential message begs for a true blue image, look to a combination of dominant blue used in innovative combinations.

The Puritans took the concept of law and order more punitively as they printed their rules and regulations for observing the Sabbath on blue paper. Interestingly, a "blue movie" or a "blue joke" is considered indecent—perhaps because they defied the blue laws. In the 16th century it was not uncommon to depict or describe devils in blue, giving them a certain "other-worldly" or demonizing effect.

PANTONE®
662 PC

PANTONE®
645 PC

Even in modern times, complexions rendered in blue do seem weird. If a person appears in an "unnatural", depressed or melancholy state, he or she is said to "have the blues". As with any color family, a color used in an unexpected manner and/or out of the usual context (such as blue green lips) can be risky or confusing, but it is very likely that it will command attention wherever it is used.

Blue is also seen as a protective color in many cultures. In Greece, a small blue ribbon is pinned to a baby's undergarments as a talisman. In Jerusalem, blue hands are painted on front doors while, in many areas of the southwest and southeast United States, front doors and/or porch ceilings are often painted blue to keep the evil spirits away.

Light to mid blues are open and expansive, like the sky, while others in the deeper range extend beyond the sky and exist on a higher heavenly plane. Dark blues are far more serious and thought provoking as they retreat, drawing inward. Although blue sky and sea are perceived as eternal, enduring and calming, there is always the possibility of a lurking turbulence. These moody blues lean to grayer, more unsettling undertones. But with typical hopefulness, there is always the optimistic promise of a clear blue sky.

From the Greek word "electros" meaning "gleaming, shiny and brilliant" come the electric blues. These are the glowing hues that defy the typically cool message of the blue family, depicting the spark that can emanate from glittering resplendent fireworks or the flashy iridescence of exotic underwater creatures. Ironically, the hottest stars burn a radiantly intense blue, as do the hottest gas flames.

Purply periwinkle blue, with its undertone of red, is the happiest and warmest of all the blue hues. It is also a symbol of everlasting friendship. And while periwinkle carries the connotation of Mother color blue's faithfulness, it's done with a perky, fun-loving and insouciant attitude.

Blue very profoundly develops the element of calm.

—Vasily Kandinsky, artist

**PANTONE®
283 PC**

**PANTONE®
7458 PC**

**PANTONE®
285 PC**

**PANTONE®
7452 PC**

**PANTONE®
2747 PC**

LIGHT BLUE

Positive:
calm, quiet, patient, peaceful, cool, water, clean

SKY BLUE

Positive:
calming, cool, heavenly, constant, faithful, true, dependable, restful, contentment, tranquil, reassuring, trusting, serene, expansive, open, infinity, transcendent, distance

BRIGHT BLUE

Positive:
electric, energy, brisk, vibrant, flags, stirring, impressive, aquatic, high spirits, exhilarating

PERIWINKLE

Positive:
genial, lively, sprightly, convivial, cordial

DEEP BLUE

Positive:
credible, authoritative, basic, conservative, classic, strong, reliable, traditional, uniforms, service, nautical, loyal, confident, professional, thought-provoking, introspective, aids concentration, clarify thoughts

Negative:
aloof, distant, melancholy

green

...from tender shoots and pine tree greens to elegant emeralds, turquoise and teals

Take a walk in the park, even on a dull wintry day, and you will count more variations of green than you would have thought possible. Every tree, leaf, bit of foliage and blade of grass can render still another shade of green. Some are vibrant yellow green, some are true deep green, some are subtle gray green and wait—there's the bluish spruce, not to mention the deep blue green of the neighboring lake, or the mossy greens gathered on the sides of the rocks. Even if your climate isn't as verdant as most and what you are viewing runs more to succulents, sagebrush and cacti, you will still surprise yourself with the number of greens you will see.

With a multitude of greens so plentiful in the surrounding world, the human eye literally sees more green than any other color. As a result, there are many moods that green can convey. A majority of people see green as symbolic of nature and "new beginnings" as green refreshes, restores and reaffirms that the seasons repeat in exactly

the same sequence every year, always heralded by the emergence of the tender young green shoots in spring. An abundance of green indicates that there is available water—so necessary for human survival. As a result, humans respond on a very visceral level to the reassuring presence of green.

Leafy greens connect with newness, youth, and growth. Various greens identify vegetables or fruits—fresh, healthy and, so important in today's world, organic. Green (as in green tea) is simply good for you, enhancing your life, making you more vital and alleviating stress. Physiologically, green affects the nervous system, causing us to breathe slowly and deeply, helping the heart to relax by slowing the production of stress hormones.

Enjoy Free Shipping on All Rugs
in This Catalog

From folklore come the green leprechauns, urchins, imps and dragons that inhabit forests or otherworldly places. But there is a benevolent aspect to these yellow green creatures especially with more lovable green characters in children's stories (think Shrek) and with recent space exploration that has dispelled much of the mystery and folklore. Thoughts of little green people from Mars overtaking our planet now seem more than a little silly. However, if you (or your client) were ever frightened by a slimy green snake, I would have a hard time convincing you that yellow green can be an appropriate and useful color.

As a result of ongoing concerns for the preservation of the environment and the larger issue of sustainability, many industries are striving to become more "green". We are distanced from Kermit the Frog's lament, "It's not easy being green". The 21st century has been deemed the "green century"—as green symbolically represents the pressing need to make the planet a healthier place.

Indian mystics wisely referred to green as the "great harmonizer". It is the color of prophets, the color of trinity, an empathetic color and the most soothing color to the eye. Green portrays the coming together of the blue of sky and sea and the yellow of sun, the most balanced color in the spectrum.

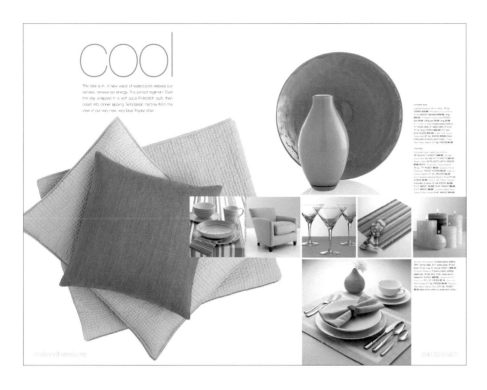

Historically, the gemstone turquoise is often described as a sky blue with a hint of green. In modern usage, there are varying shades of the gemstone, as well as the name of the color it inspired, that can range from blue to green and several nuances in between.

In many cultures, turquoise occupies a very special position in the world of color. The actual name for the gem is derived from the French phrase meaning "Turkish stone" as the first stones were mined in Turkey. Turquoise was used (and continues so in many cultures) as a protective talisman against evil by cultures as varied as the Persians, Egyptians, Greeks, Indians, Spanish, Israelis and Mexicans, as well as the early Aztecs and Native Americans.

The earliest Americans did not distinguish between blue and green and both colors denoted coolness, water and fertility. The combination of both blue and green that results in blue green reinforces that association. The Navahos believed that turquoise was a "fallen piece of sky". Similarly, Tibetan Buddhists believed in turquoise as symbolic of the infinity of sea and sky. For the Egyptians it was the color of faith and truth, also inspired by water and sky.

There is also a widespread belief that turquoise is the color of deep compassion and healing, encouraging both an external healing and an inner healing. It is a hue that communicates compassion effectively as it expresses the protective and steadfast qualities of blue along with the soothing effects of green.

There is another view of turquoise that also involves water and that is the association of a more tropical setting—a languorous, luminous and more exciting connection to the hue that speaks of exotic destinations and the great escape to paradise. While still expressing the concept of water, the brighter turquoise shades also bring a hint of tropical warmth.

There are many shades of teal—essentially there is a teal blue, with an undertone of green, a teal green with the undertone of blue, and the classic teal that virtually combines both blue and green in equal amounts. The color name, "teal" was inspired by gracefully gliding iridescent ducks that quietly grace rippling freshwater surfaces. The name suggests the interplay and connectedness of both blue and green, bringing the best qualities of both color families into play.

It is a thoughtful color that exudes confidence, more elegant than an ordinary blue or green, embracing the symbolic qualities of both. It is a tasteful color, often preferred by those who appreciate sophisticated styling, a rather "upscale" shade that could not be described as "ordinary".

Literally from the Spanish word meaning water, aqua defines the cool liquid surface that is so essential for all plant and animal life. The cleansing properties of water are the most important aspect of this color, as the expectation is that any object or surface colored in aqua will clean and refresh, just as water inexorably does. Lightness is also attributed to aqua—not only light in weight and in tone, but a certain cool, baby-soft expectation of touch.

PANTONE®
358 PC

LIGHT GREEN

Positive:
calm, quiet, soothing, neutral, lightweight

PANTONE®
347 PC

BRIGHT GREEN

Positive:
fresh, grass, Irish, lively, spring, renewal, lush

PANTONE®
334 PC

EMERALD

Positive:
luxurious, jewel-like, up-scale

PANTONE®
349 PC
::

FOLIAGE GREENS

Positive:
natural, fertile, healthy, balance, life, growth, soothing, harmony, restful, restoration, reassurance, environmental awareness, new beginnings

PANTONE®
3435 PC
::

DARK GREEN

Positive:
nature, trustworthy, refreshing, cool, restful, stately, forest, hushed, woodsy, traditional, reliable, money, prosperity

PANTONE®
584 PC
::

CHARTREUSE

Positive:
artsy, bold, trendy, startling, sharp, pungent

Negative:
gaudy, tacky, slimy, sickening, mold

PANTONE®
377 PC

LIME

Positive:
fresh, citrusy, youthful, acidic, tart, refreshing

PANTONE®
5767 PC
::

OLIVE GREEN

Positive:
military, camouflage, safari, classic

Negative:
drab

PANTONE®
565 PC

AQUA

Positive:
water, refreshing, cleansing, young, babies, cool, dreamy, soft, lightweight

PANTONE®
3258 PC

TURQUOISE

Positive:
infinity, compassionate, protective, faithful, water, coolness, sky, gemstone (bright turquoise), tropical, oceans

PANTONE®
315 PC

TEAL

Positive:
serene, cool, tasteful, sophisticated, confident

Bling Bling!

ONEIDA

Octave, from our LTD® collection of luxury flatware. www.oneida.com

See 300 different bands refuse to play "Freebird."

purple

...from fragrant lilacs to majestic royals and ultra violets

www.midwestmusicsummit.com

Purple is a magical and intriguing color—a fascinating dichotomy of both meditative blue and explosive red—it is simply different from the more easily understood symbology of either of those primaries. Some people don't "get" pure purple—half blue and the other half red—because it has too complex a personality for their taste. If you have ever had clients who resisted purple, they are probably so totally left brained and analytical that the creative aspect of this multifaceted hue eludes them.

In order to "sell" purple to the unconvinced, it's necessary to skew the shade either to the warm red or to the cool blue side so that the message becomes more obvious. The more intense heat of a decidedly red undertone renders a purple that is more closely akin to the dynamism and sensuality of red, therefore easier to connect to red's symbology. The same holds true for the bluer purples. Their cooler temperatures bring more of a pensive, cerebral connection to the calmer blue family.

purple

But purple does have its very own distinctive personality. It's an excellent substitute for blue or red when either seems to be the obvious choice. For example, a corporate logo for a business that wants to be thought of as dependable and forthright, yet at the same time capable of creative innovation, might well consider a blue purple in a business arena where so many logos are blue. Tweaking the purple to the blue side (yet still maintaining the undertone of red that is inherent in purple) would give the company image the added boost it is seeking.

Purple flowers and foods that are more distinctive in appearance or taste than most support the uniqueness of the hue. Think aubergine, the elegant French word for eggplant. It's definitely an acquired taste. Think berries, grapes and purple plums—as sweet as they might be, there is often a burst of tang that accompanies the first bite. And there are purple potatoes that are certainly not considered ordinary "spuds"!

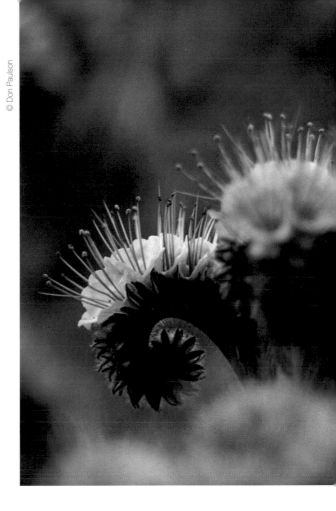

Florals are often more distinctive or strikingly different in purple. It's impossible to disregard purple in the garden, especially when centered or contrasted with its complementary yellows. Many purples are named for flowers: orchids, irises, hydrangeas, heliotropes, lavenders, lilacs, violas, violets, anemones and autumn's blazingly beautiful, un-ignorable asters.

The exclusivity concept attached to purple came about because of affordability and availability. In ancient times, only the wealthy could buy purple garments as the dyes were extracted from tiny mollusks—approximately 336,000 snails yielded one ounce of dye! So purple became the provenance of kings, queens, nobles and wealthy, powerful patrons.

Purples, particularly the blue purples, have been used in other lofty levels as well, particularly when expressing certain mystical, heavenly, transcendental or spiritual properties. Purple, as relates to the cosmos, takes awareness to a higher level of thought. Metaphysically, "purple power" means possessing psychic ability. Purple stands for the quality of leadership in the Kabala, the religious mystical system of Judaism that claims insight into divine nature that was also adapted by some Christian mystics in the Middle Ages. There has also been ecclesiastical usage of the hue throughout many other religions.

Amethyst, generally a blue purple, takes on some of the protective qualities of the blue family. In Egypt, amethyst was thought to be a healing amulet, offering divine protection from evil. It was believed that amethyst brought peace of mind and protection from insomnia. The Greeks had a slightly different take on it as, in that

language, amethyst meant "not drunk". It was proposed that the priests wear amethyst to keep from imbibing too much of the sacramental grape wine.

At one time considered an old-fashioned, rather sentimental color, mauve has become less age-related and more acceptable for male slanted product or wearing apparel, especially in the smokier tones. Lavenders, long associated with aging and femininity, have now become more trans-gender and used by all ages. It is still considered a gentle and nostalgic color and, just like its closely related rose cousins, it is seen as light in weight, sweetly scented and sweet tasting.

"I think it pisses God off if you walk by the color purple in a field somewhere and don't notice it." —*Alice Walker, author*

**PANTONE®
264 PC**

LAVENDER

Positive:
romantic, nostalgic, fanciful, lightweight, lightly scented

**PANTONE®
5145 PC**

MAUVE

Positive:
wistful, sentimental, thoughtful

**PANTONE®
2573 PC**

AMETHYST

Positive:
curative, protective, peace of mind

**PANTONE®
267 PC**

BLUE PURPLES

Positive:
contemplative, meditative, spiritual, soul-searching, intuitive, mysterious, enchanting

**PANTONE®
2602 PC**

RED PURPLES

Positive:
sensual, thrilling, intensely exciting, dramatic, creative, witty, expressive

**PANTONE®
2627 PC**

DEEP PURPLES

Positive:
visionary, rich, royal, prestigious, subduing, distant, introspective

Negative:
aloof

neutrals

... from shadowy mist to classic charcoal or shining silver
and from forest mushroom to dappled fawn

Gray is the middle ground between black and white, truly the perfect neutral. For that all-important reason, color matching is best done against a gray background. Grays can be tricky, as a true gray is rarely found in nature. A walk along the beach reveals a grey stone in the distance, but on closer inspection, there may be a mix of undertones that reveal themselves. A bit of blue, a touch of pink, a mauve-ish tinge, a greenish cast—perhaps all of those tones combined in a single striated rock, stone or pebble.

Most furry animals and gray-haired people do not have one definitive shade of gray in their hair but a, sometimes, complex mix of several shades. Occasionally the perfect gray appears, whether in a paint sample, a new paper product or a color specifier—somewhere between warm and cool, so colorless that it is difficult to discern the color temperature. And that's the beauty of neutral gray.

Gray is shade or shadow, mist and fog, so there can be a bit of mystery, depending on the imagery. It is this kind of ambiguity that lends an air of sophistication to the deeper grays, especially as they begin to approach black. Just as there are venerated statues, monuments and historical sites that are tinged with gray (even more so as they age) many variations of gray are seen as classic and tasteful. There is also an implied quality attached to anything that is so long lasting.

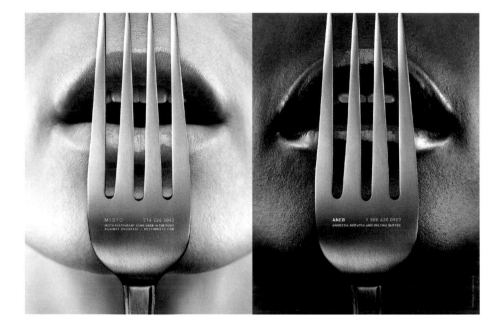

Because of this perceived neutrality, gray does have some interesting psychological connotations attached to it. The man (or woman) in the gray flannel suit is the perfect arbiter. He or she is deemed responsible, staunch, steadfast, accountable, solid, and resolute. They use their wisdom and "gray matter" (the brain) judiciously. This translates well into the corporate world where any of those traits, although seemingly dull, are most desirable. If those images are desired, know that neutrals are some of the very best backgrounds for more vivid shades. So, in a logo or brand identity image, a vibrant red or purple, for example, can create the excitement against the quiet assurance of gray.

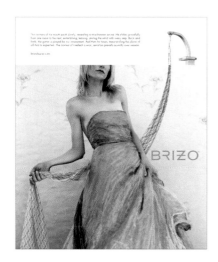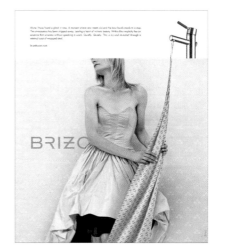

Silver is the more exciting metallic sister to gray. Just as gold is invariably connected to the sun, silver is inevitably paired with the light emanating from the moon. Silver was actually referred to as "Luna" to ancients and alchemists alike. The color of coins, jewelry and those pricier items with a silvery shimmer establish a perceived value to the finish wherever it is used. There is a certain fluidity of motion attached to silver.

There is also an implied old world elegance to silver, especially in more rococo design, while at the same time, a silver finish can also speak of sleek modernism. Currently, more consumers attach a clean, classy, streamlined stylishness to silver; it's cool in every sense of the word.

Similar to gray and sharing some of the same attributes, taupe is difficult to define. The definitive neutral taupe would have an equal balance of warm and cool undertones, so it is literally a mix of light to deeper beige and gray. Taupe (or greige as it is often called) literally straddles the brown-beige and gray families.

It is particularly adaptable as a neutral color, conciliatory and flexible in usage as well as attitude. One thesaurus lists no less than 99 synonyms for taupe. However, some are questionable. For example, one option is termed Quaker-colored (do all Quakers have the same coloring, or perhaps it's the color of Quaker Oats?). Another suggested synonym is chocolate, which it definitely is not.

AUSSIE WOOL BEDDING

Another group of natural-looking neutrals are the off-whites, ivories, bones, creams, ecrus and beiges. Just as every woman knows, a strand of pearls is a basic part of every jewelry wardrobe as are the classic pearl-like tints that are essentials in every design vernacular. There is a subtle, stylishly elegant and classic connotation attached to these natural nuances.

In more recent history (the early 90s), these tones gained a great deal of social significance as part of the growing environmental concern. As part of the movement to eliminate damaging bleaching processes and chemical treatments that harm the atmosphere and the waterways, these so-called non-colors became very popular. They are still symbolic in the movement to sustainable resources, such as natural fibers and recycled paper products.

Most descriptive names for taupe come from various natural sources like fawn, otter, mushroom and sepia. Authentic is an apt description for this versatile shade, as it is often thought of as an organic, modest, unobtrusive shade. In this striving to be environmentally correct era, taupe is definitely a color to consider. There is also a timelessness and basic lack of "trendiness" that fosters a confidence in the longevity (or shelf-life) of the shade.

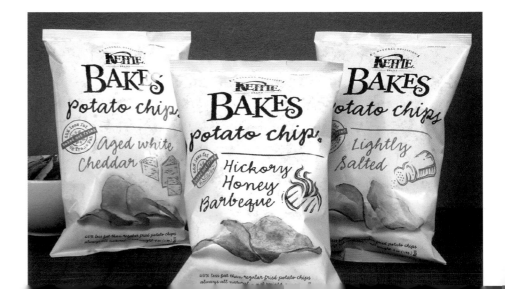

Beige, in particular, suffers a rather non-descript positioning in the world of color. We sometimes hear, "He leads a rather beige existence"—implying a rather uninspiring, colorless life. However, even though beige is considered achromatic—literally without color—it still carries an undertone of warmth and pleasantness.

Can we deny the look and feel of an inviting sandy beige beach on a summer's day or the tempting deliciousness of a batch of cookies right out of the oven? This "colorless color" may lack the excitement of red or orange, yet its inherent warmth and subtlety does have a comforting, nurturing presence.

"The inner equilibrium of Cezanne's paintings, which are never insistent or obtrusive, produces this calm almost velvety air." (referring to the color gray) —*Rainer Maria Rilke, poet*

PANTONE®
423 PC

PANTONE®
425 PC

PANTONE®
7536 PC

PANTONE®
7401 PC

It is not possible to simulate metallic inks with CMYK process color.

NEUTRAL GRAY

Positive:
classic, sober, corporate, practical, timeless, quality, quiet, neutrality, logical, unobtrusive, deliberate, reserved, fundamental, basic, modest, efficient, dutiful, methodical

CHARCOAL GRAY

Positive:
steadfast, responsible, staunch, accountable, conscientious, resolute, restrained, conservative, professional, classic, sophisticated, solid, enduring, mature, business-like

Negative:
dull, conformist, detached

TAUPE

Positive:
classic, neutral, practical, timeless, quality, basic, authentic, organic, versatile, inconspicuous, understated, discreet, compromising, modest

Negative:
bland

OFF-WHITE IVORY, BONE CREAM, ECRU BEIGE

Positive:
classic, neutral, soft, warm, comforting, good taste, smooth, subtle, natural

Negative:
boring

SILVER (metallic)

Positive:
sleek, classy, stylish, modern, cool

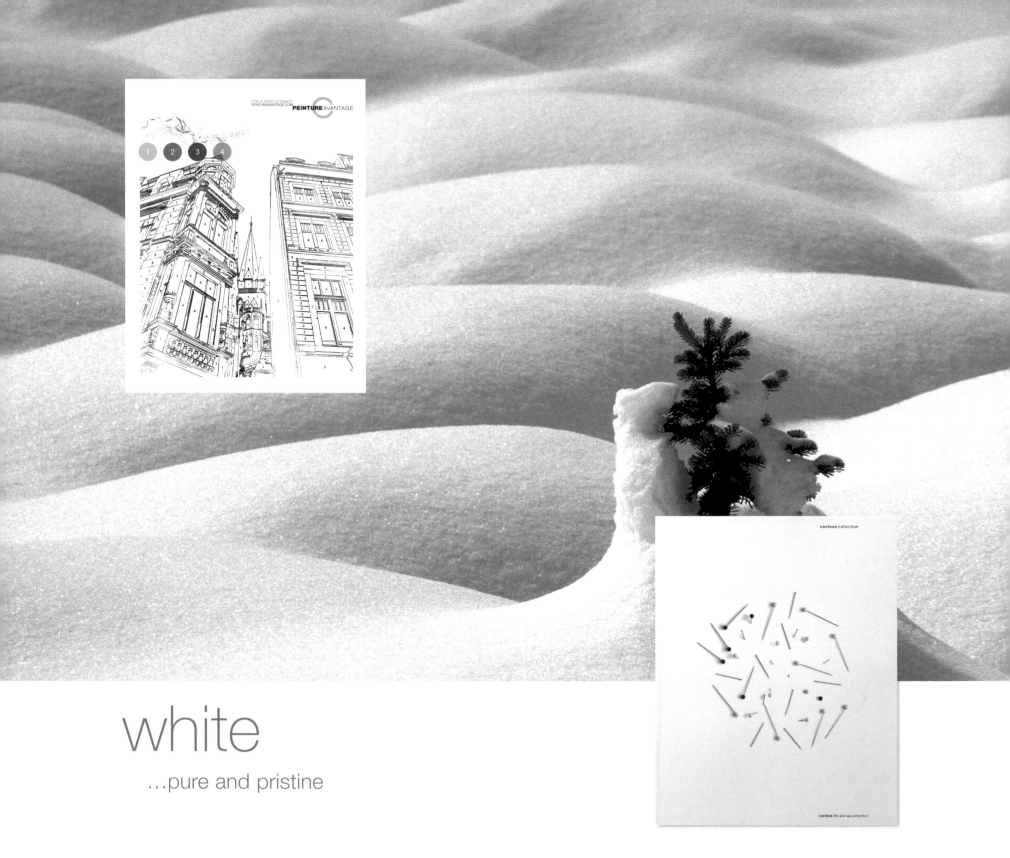

white

...pure and pristine

Where black is thought of as the absence of light, white is the complete presence of light. In ancient legends white was symbolic of big fluffy clouds and snow-capped mountains where the Gods dwelt. In the Christian church, white is the color of a heavenly, pure presence and God himself is thought of as wearing a white robe and having a long white beard. Similarly, an ethereal, ghostly illusion is white, perhaps a bit scary but generally not as threatening as a darker, more sinister presence.

In secular life, white most often stands for purity, clarity and simplicity. There is an unsullied innocence and delicacy around white—the unblemished quality of a baby's christening dress or the illusion of chastity (more historical than actual) in a bridal gown.

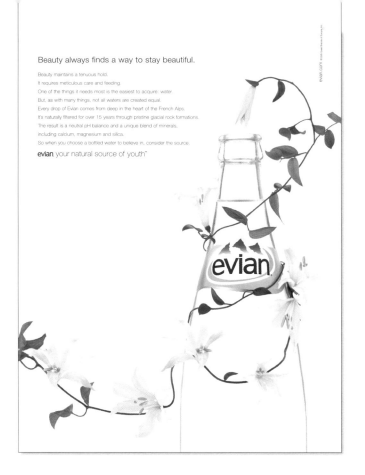

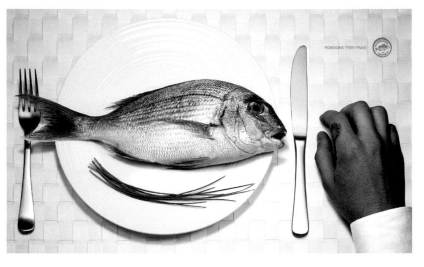

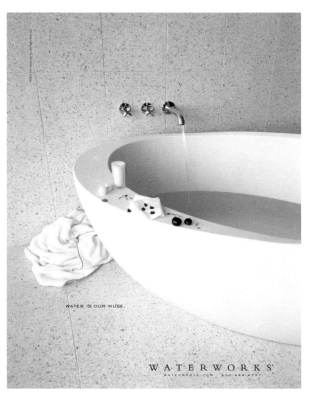

As in the utter quiet of falling snow, white expresses silence and the almost total lack of sound. A quiet "shushing" frequency is called white noise. A little white lie is considered no big thing as it might spare someone's feelings and the white flag signals the need for a truce, the suspension of hostility. The dove of peace is white. It is a conciliatory color.

"White is gently romantic or starkly modern, depending on how you use it"

—Hilary Mandleberg, author

Pure white is crisp, succinct and viewed by the human eye as having the same vibrancy as a brilliant color. So it truly should not be thought of as a neutral color that works when all else fails. It does have an ample presence, especially on the printed page, at point of purchase or in packaging. The eye is very sensitive to even minute differences in whiteness when two or more substrates, like paper, plastics, paints or textiles are placed next to each other. So it's important to get the whites right so that they don't appear to be a poor match.

original design for home and fashion

Garnet Hill

Thank you for your order!

we are 100% cotton

Cleanliness is always best represented by white as there is no other color that gets the concept of hygiene over as clearly. Because of the connection to cleansing water, light blue or green may run a close second, but white is immediately understood as pristine, untainted and unflawed. This spotless reputation can also make white seem immaculate, perhaps even sterile, clinical and cold. For packaging purposes, especially for products expressing cleanliness or the concept of extreme cold, utilizing a stark white can be a definite advantage. But in expressing warmth, unless there are puffy white clouds in a tropical setting, humans simply don't see pure white as warm.

White becomes far more friendly and approachable when combined with another color, especially warm colors, or when the whiteness is not quite so pure-as-the-driven-snow, as in cream, ivory, ecru, bone or off-white. (See Neutrals)

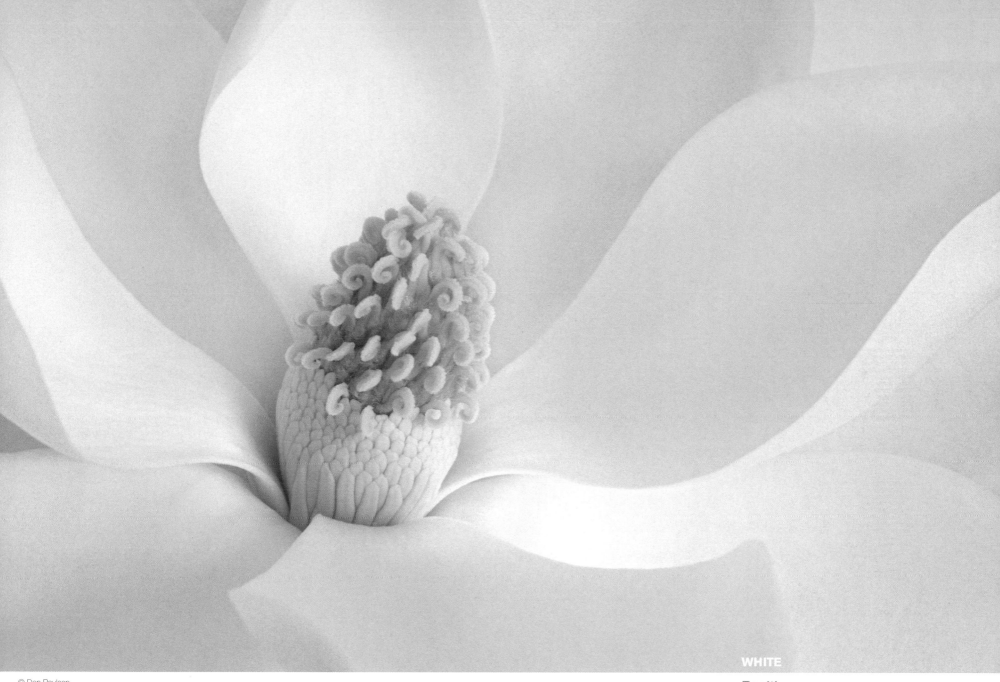

© Don Paulson

"White is not a mere absence of color,

it is a shining and affirmative thing…."

—G.K. Chesterton, author

WHITE

Positive:
pure, clean, pristine,
spotless, innocent, silent,
lightweight, airy, bright,
ethereal, clarity, simplicity

Negative:
sterile, cold, clinical
(depending on context)

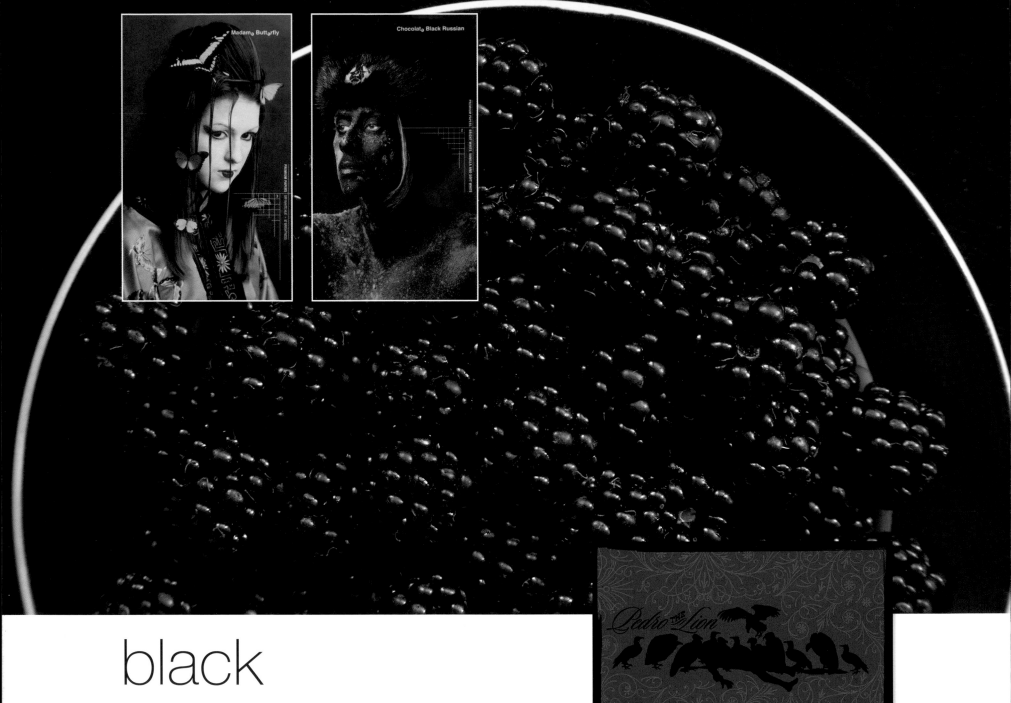

Madam Butterfly

Chocolat Black Russian

black

...the deepest depths

Pedro the Lion

EARLIMART AT THE SOCIAL · 8PM · $13 · THURSDAY JANUARY 27TH

Every few years, some fashion "authority" decrees that black is back! My response is, "I didn't know it had gone away!" Was it skulking in the shadows for several seasons, waiting to pounce on any unsuspecting victims? Often when I am asked, "What is the new black?" I respond with, "Black is the new black" as black truly never goes away.

Another color can come forward and claims in the fashion press will be made that it is usurping black's place but the reality is that black will always have a presence, not only in the world of fashion, but in all design disciplines. Adding black to any color renders that color more powerful, creating an illusion of depth, weight, solidity, substance and most often, more subtlety. Black is a fundamental factor in process printing; the final letter of CMYK is the last letter of the word black.

black

Black was thought of as gloomy and heavy. Portentous would be another word to describe black in those days, in that it was connected to the fear of the unknown and ultimately death. It was the total negation of color, yet in real life, black wields a strong psychological presence. Although cinematically black can be rather Darth Vader-ish, in other contexts the shade has become far less ominous. It became the symbolic color of social statements such as the "black is beautiful" movement in the 60s. For several decades before that it was also the color that extolled nonconforming lifestyles such as "bohemians". Ultimately, beatniks, rockers, bikers and punks adapted black as the symbol of the negation of a society whose values and/or appearances they rejected.

In Webster's 1913 dictionary, black is defined as that which is destitute of light or whiteness; the darkest color, or rather a destitution of all color. Interestingly, the word destitute implies sadness—to be destitute is to be impoverished; poor black, suffering from the lack of color. In the early 20th century widows, villains, pious merchants and members of the clergy wore black; this was a very serious and somber hue.

INTEGRAL

GATX 4087

EXPERIENCED

REAL

KAILIS
ORGANIC
OLIVEGROVES

No longer the color cloaked in fearful darkness, black has become the color most often worn after dark. It is more worldly-wise and sophisticated, the shade most worn to cocktail parties and black tie events, the lustrous hue of a Steinway grand piano, the glossy black stretch limo or the sleek stealth of a low-slung Ferrari. In the 80s it became the color of hi-tech; even lo-tech appliances like toasters and microwave ovens gained greater glamour by being sheathed in black.

Black is perceived as all-powerful and empowering. It is the color in packaging that consumers see as "worth more". It is stylish, contained, modern, and yet classic.

Performance enhancers.

The visibility factor of black against white in print, or vice versa, is indisputable. The final authority that verifies the ultimate truth is often expressed by "I want to see it in black and white".

The combination of black and white always expresses extreme opposites. Symbolically, the ultimate connection is something that all humans can relate to as in the cover of night vs. the light of day. They are the alpha and omega, the yin and yang, the salt and pepper that season the flavors of color.

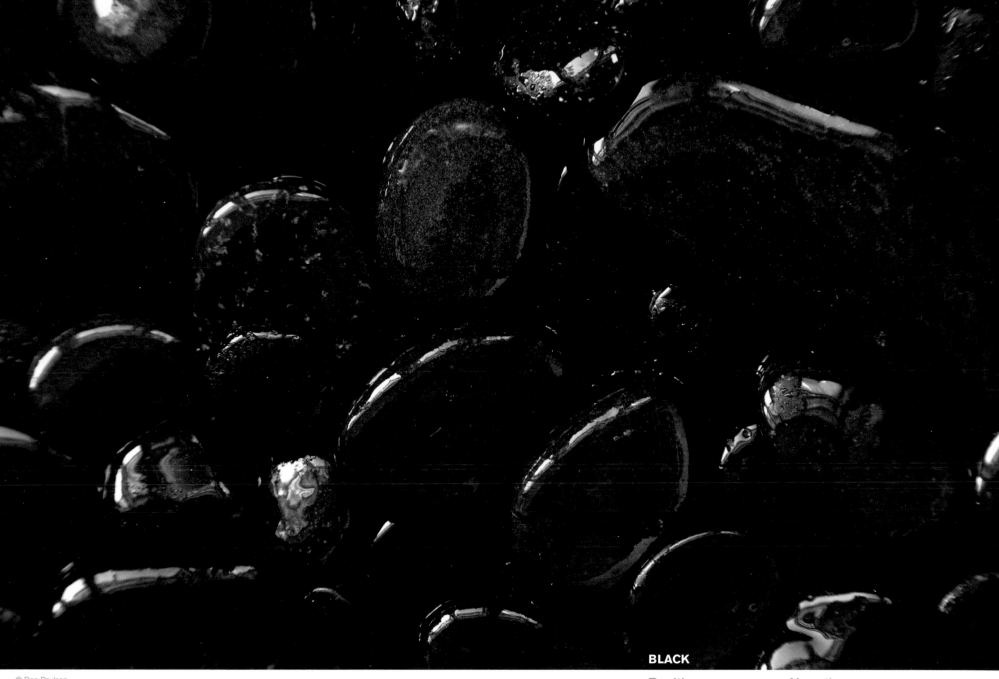

© Don Paulson

"Black is beautiful."

—*Huey Newton, social activist*

BLACK

Positive:
powerful, empowering, elegant, sophisticated, mysterious, heavy, bold, basic, classic, strong, expensive, invulnerable, magical, nighttime, sober, prestigious, stylish, modern

Negative:
depression, death, mourning, underworld, evil, oppression, suppression, menacing

color in the marketplace

About Advertising

There is no question that color is a powerful communication tool that can be used most eloquently in advertising. Color informs, bringing instant comprehension, calling attention, delivering information, creating an identity and explaining the characteristics of a product (or service). Above all, colors evoke emotions and these emotions must somehow connect with the essence of the product in the advertisement.

Color can be, and often is, more effective than words. If you view that last sentence somewhat skeptically, think of an advertisement on the web for a product that emanates from another country (not uncommon in this globally-connected world). You might not be able to understand the verbiage, yet the colors can tell a compelling story about what the product promises to deliver.

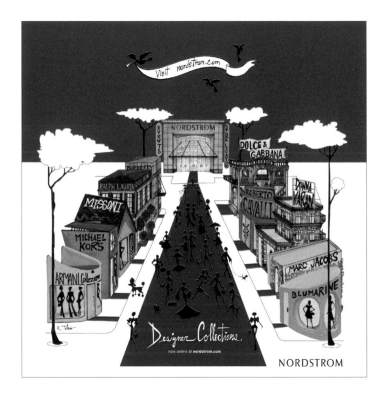

Viewers of an advertisement might doubt the veracity of the verbiage, but they have no reason to doubt the suggestions that the colors are making as they work on a more subtle, often subconscious level. So the powers of colorful persuasion are often subliminal and the would-be buyer, viewer or customer is not always aware they are being persuaded to buy.

Color can not only move people on an emotional level, but it is also a "moving element" that can stimulate an action or reaction, causing people to move in a desired direction.

Color can also emphasize the most important features in an ad, leading the eye along a pathway that connects all of the visual elements (including the words) that define the

message. As demonstrated in Chapter 1, there is a need to be very thoughtful in the choice of colors because each family contains its own unique messages. The choice of an inappropriate color (or colors) can invite disaster in the marketplace.

Whether on a web page, in a sleek and elegant magazine, on a giant billboard or as the simplest bullet point highlights on a flyer, color should serve a better purpose than simply embellishing the ad. It should become a part of a well-integrated design process and, as the world is seen in color and not in black and white, color in an ad somehow seems more realistic, inviting the viewer to participate.

Studies have shown that color in newspaper ads can generate up to 50% more inquiries than ads in black and white. It is fairly obvious that color, when surrounded by black and white print, would be more outstanding. This does not prove that black and white should never be

used—it is a matter of context and contrast. In a magazine, catalog, mailer or website filled with many colors, black and white can offer a bold option.

There is no question that color is the ultimate manipulative tool, so essential in advertising appeal. Although this manipulation can be thought of as negative, there are other, more positive meanings, literally, "to control or influence somebody in an ingenious way". Ingenious is further defined as "possessing cleverness and imagination" or "clever, original and effective". In the end, the advertising objective is always the same—to sell the product or service. And that is precisely what color—used cleverly, imaginatively and effectively—will accomplish.

For Brand Image and Identity

While it is a given that a successful brand logo is a happy marriage of shapes, symbols and colors, it is truly the colors that evoke the emotional message. Many leading brands are so linked to specific hues that they are primarily recognized by their color or colors. Think Coke red, American Express blue, Kodak yellow and red, British Petroleum (BP) yellow and green, DeWalt black and yellow.

When a color and design "signature" is established, it becomes the brand identifier that reinforces the image in the marketplace across many levels of communication.

This should include print and collateral materials, websites, packaging, point of purchase displays, signage, as well as the product itself, creating what is termed a "total brand experience".

Consumers need to have that brand experience wherever they shop or seek information about the brand, as it also helps to establish that they will receive the same quality and service across many platforms. So it's not just about image.

There are five essential steps in making a color choice for brand image/identity. They are:

- **"Shop" the competition.** You don't want to spend precious time and effort creating the perfect image only to find that somebody got there before you did. If your color ID is too similar, your product can be confused with a competitor's offering and this would defeat the brand image intention. In a crowded marketplace, differentiating your brand is vital to the success of the product/message.

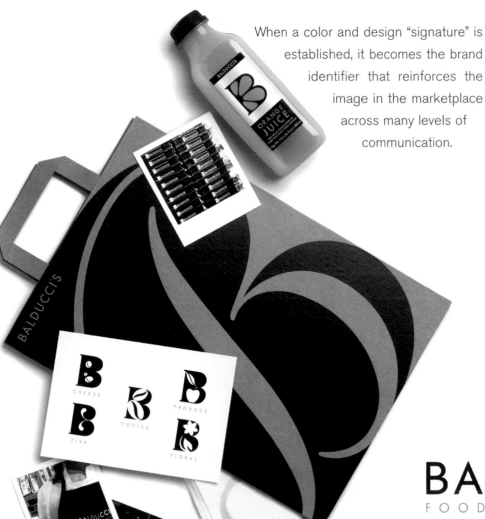

BALDUCCI'S
FOOD LOVER'S MARKET

- **Do your homework.** Study the brand's background. What are the product or service goals? What are the company's intrinsic values? This helps to create a pathway to the colors that will best identify and communicate their goals. For example, because of the inevitable connection to blue as being steadfast, constant and dependable (see Chapter 1), the blue family is a popular choice for the financial world. The real challenge is to utilize a blue that has not been overused. Another solution would be to arrange the hues in unique new combinations that will help to reinforce the dominant blue presence.

- **Know the target audience.** Explore market research regarding consumers' perception of the product and color preferences. Many companies are now using mall intercepts and/or lifestyle research where consumers are literally accompanied in the course of a normal day so that their lifestyle and buying habits can be observed. On the other hand, some companies do not believe in market research and will rely solely on the designers' or colorists' choices. No matter what research exists (or does not), in the end, it is your intuitive and educated input that should always be included and presented.

- **Always keep the psychology of color a major priority when choosing appropriate brand image hues.** A key element in color choice is its emotional meaning. Be certain that the information is current, credible and reliable, as this will form the basis of your rationale for your selections. When refreshing any component of a brand image, color trends are important but it is best to combine the "new" or skewed colors with more familiar brand image colors.

- **It's important to note that as much as 95% of consumers' decision-making is dictated by the subconscious.** As far as color is concerned, most decision-making is intuitive and emotional, so the appropriateness and first impression of color is critical. Approximately 5% of decision-making is rational. As a result, most consumers do not make purchasing decisions based solely on logic, but on perception. Colors play a major role in creating those perceptions.

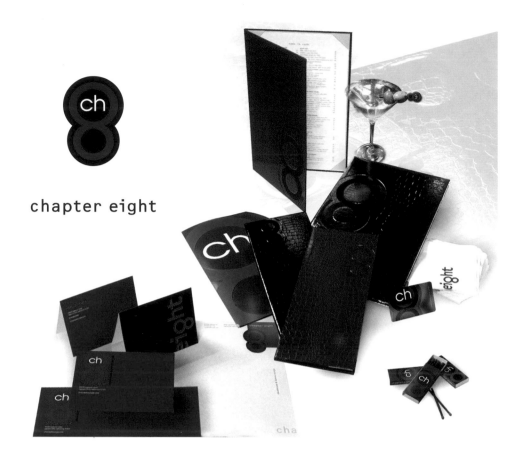

8

chapter eight

Brand Equity vs. Brand New

Change for the sake of change is not necessarily a good idea. When a company has used a specific design and colors that are instantly recognizable, trustworthy and familiar, it runs the risk of breaking that linkage of "consumer connection" to the brand. This is especially important when they peruse the shelf or display looking for that dependable logo. As megastores proliferate, there is more "shopping from a distance", where an easily identified brand ID should be used as the primary color on packaging, but product differentiation demands additional colors to identify a specific category. For example, Kodak's wall of yellow is coded by product type in a variety of shades, enabling customers to find their specific needs more readily.

A refresh can certainly give the impression that there is, in fact, something fresh or new. This might be a simple "tweaking". For example, changing one color in a three-color combination that is inevitably viewed as "traditional". While hunter green, navy blue and burgundy convey a traditional image, skewing the burgundy to a more vibrant claret red could be just the update that would add some excitement to the brand. As a general rule, evolutionary alterations are less risky than revolutionary changes. However, with changing times and expectations in the marketplace, some risk-taking can be a real attention getter. But it should be a calculated, thoughtful and intelligent change that can be backed up with a meaningful rationale.

There are examples of risk-taking that have brought exceptional focus to a product. In packaging, there is the classic example of Minute Maid orange juice. They were the first in their product category to depart from the ordinary. In a sea of white and orange on the supermarket shelf, a black package highlighted with the necessary orange provided a stark contrast to the surrounding competitors. How could anyone ignore that container? It also added a degree of sophistication to the product, as black always does. Guinness is another company that has used black to great advantage for a product that is not ordinarily thought of as elegant.

Color is not the only means of attracting attention. There are other considerations as well, such as:

- the shape of the package
- the "fit" in the hand
- the texture (rough or smooth)
- the finish (shiny or matte)
- the perceived weight of the object
- the graphics

But all of the above can be further enhanced and made even more suggestive by the proper, intelligent use of color.

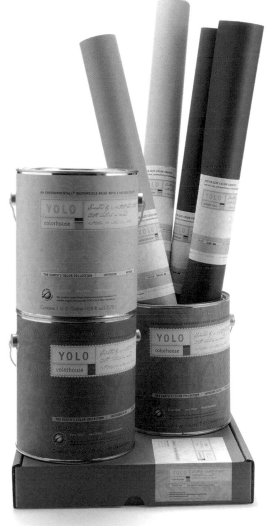

In Packaging

From a consumer's perspective, scanning the vast array of available products in the marketplace is a visual challenge. There are so many products competing for attention that, even though a customer may enter the store with a very clear notion of what specific product they plan to buy, the constant challenge is, "where will I find it?" If they are headed for a well-known brand that occupies a certain piece of real estate in the store such as Schick razors or Campbell soups, the challenge is less daunting.

However, as surveys are telling us that between 70% and 85% of would-be buyers don't make a decision until they are actually at the point of purchase, there is every reason to believe that the fickle fingers of the consumers may find their way to another product, albeit in the same category, that may hold some additional appeal. And that additional appeal or functionality may very well express itself in the colors of the packaging.

A very important aspect of these visual tempters is called the "sensorial cues". These cues link colors to all of the senses and conjure up thoughts and perceptions of how the product will taste, smell, feel and in some cases, sound. For example, a cool, placid blue background photo of an undulating body of water (further enhanced by a metallic finish) may also evoke the peaceful quiet that would be characteristic of such a scene. Light pastels are felt to be light in weight while dark colors are perceived as heavy. Pink and lavender are seen as sweet-scented and sweet in taste, while yellow greens are tart and lemony. More of these kinds of color concepts are included in the sections on each color family in Chapter 1.

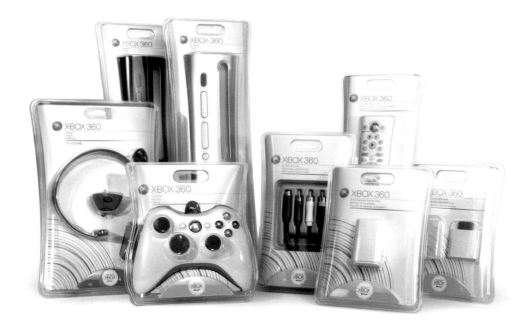

Verbiage alone on the package will not convey the entire meaning. We are living in an age of "sound bites" where consumers don't always read the messages on the package. This is also an "iconic age", where people are more accustomed to icons, as on the computer or in international signage, when expressing concepts or directions. It's a visual, often non-verbal world and color is a vital part of that communication link.

At Point of Purchase and Display

Used wisely, color is the vitally important and instant attention-grabber, succinctly getting the message across at point of purchase, enticing the would-be customer and "ka-ching" (as the old cash registers used to say) the sale is made.

In this time-crunched society, it comes as no surprise that a majority of purchase decisions are made at the point of purchase, so it is vital that color appears current and appealing no matter what the product level may be. It could

be argued that a website or catalog could be referred to as a point of purchase as well, but that is not the usual usage of the term. The term "point of purchase" or "point of sale" has traditionally denoted the virtual space where the purchase is made and more often describes the actual signage or container for the merchandise.

Gender and Age

When women are looking for new products, they will frequently check out catalogs or websites where they are accustomed to seeing well-coordinated merchandise, often by finish or color family. However, they may opt not to purchase from a catalog or a website, but prefer seeing the merchandise "in person". If the display is well presented and color coordinated to their satisfaction, it can clinch the sale immediately. Signage, packaging and POP displays, as they are called, all play an integral part in influencing the final decision.

In general, women shop more emotionally and deliberately than men and respond to merchandise that really entices them. Colors play a large part in that enticement. In a retail setting, if a woman is attracted to the product or product presentation she will go back and visit it several times before buying it. So it must be visually appealing in order to bring her back.

In general, men are impulsive shoppers, leaning to more "spur of the moment" decisions. But even they have become more color aware. Studies done in England reveal that men are decisive and efficient in their shopping habits. It seems that evolution is still playing a part in shopping

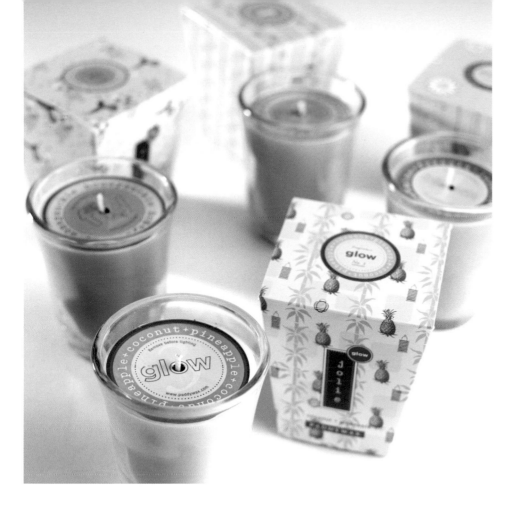

It's the older seniors you have to treat with caution, as they are most likely to plow into a display or signage that is not well marked. It is the cool color range in print that is especially problematic to older eyes, so it is important to intensify and brighten the cool colors, separating those shades by interjecting some neutral tones or incorporating some contrast of warm colors.

At the other end of the age spectrum and, as any parent who has ever navigated down a market aisle knows, it's the littlest "shoppers" who start to grab items off the shelf the moment they are old enough to reach them. Character-istically, the colors used for the toddler age groups are usually in the primary range of red, blue and yellow, but at approximately age three to six, their fascination starts to veer to the secondary shades of orange, green and purple.

Stereotypically, during infant and toddler years, pink is for girls and blue for boys. But as they grow older, especially with the usage of more vibrant pinks and blues in sports equipment and video games, there is far more opportunity for gender-specific colors to co-mingle.

habits—the guys are the hunters heading for the "kill" (their heart rate actually goes up when they make the purchase), while the women are the gatherers—collecting and managing resources. I think there might be many women who would say that their heart beats faster, too, especially when they find a great sale!

Regardless of gender, it's the "50 plusses" who have the most expendable income. They have more experience in buying, they are the most demanding and make no mistake about it, they are style and trend aware. However it is also this age group that starts to have trouble reading the fine print on packaging or in signage, especially if the lighting is not good. If they can't read it, they'll leave it.

It's the tween market, ages 7 to 12, that is smarter than ever and super-aware of trends. So it may be less about personal color preferences and more about choosing colors similar to what their friends are choosing. They are all rehearsing to be teens and are heavily influenced by what teenagers consider cool. Teen magazines, both for boys and girls are an excellent source of color trend info for both tweens and teens. (See Chapter 6, Guidelines for Spotting Trends.)

Shopping Patterns

Studies show that shoppers have a tendency to walk to the right as they enter a store. Interestingly, in Great Britain shoppers walk to the left. Researchers believe this may be linked to the driving patterns in the two countries. Placing objects that have a reflective surface, that flicker or capture light (such as pearlescent or metallic surfaces) on the left side of the store (in the U.S.) is recommended as the human eye is always captivated by such surfaces.

Studies also show that using coordinated color in low traffic zones, such as the back of the store, in a predominant color family, for example, variations of red, can lead shoppers to that area. Orange, hot pinks and reddish purples are all red-based advancing colors that will essentially have the same pull.

EXTRA STRENGTH HAYMAN
QUALITY BUILT SAFES

FOR 37 YEARS, HAYMAN'S PRACTICALLY INDESTRUCTIBLE, TOUGH-AS-NAILS SAFES HAVE BEEN BUILT WITH ONE VERY SIMPLE GOAL IN MIND: TO MAKE YOU EXTRA SAFE.

As yellow is the color of highest visibility and luminance, it too is a good choice for drawing the consumer eye. Greenish yellows, or yellowish greens are equally effective, while yellow combined with black is the most visible of all possible combinations.

I am not suggesting that bold, bright or hot hues are always appropriate or necessary. The use of the classic color wheel (as explained in Chapter 3) can yield some great and imaginative combinations. Visual drama can also be achieved any

place in the retail environment with the use of just one major color statement and it doesn't have to be red. Even white, used repeatedly in the same setting, can have great impact, especially as the eye "sees" white, with its high reflectance, as a brilliant color.

Although conventional wisdom has it that neutral backgrounds are best for display, conventional wisdom is not always wise. Don't underestimate the impact of a darker or more vibrant color as background to make the merchandise "pop". And the space doesn't have to be large to have a visual impact. Even the smallest vignette will benefit from the educated use of color.

Obviously, there are many considerations in making color selections for the areas mentioned above. The psychological messages and meanings of each color family (as explained in Chapter 1) play the most critical part in the ultimate color selection.

On Visual Presentations

All visual images, including text, can be made more meaningful and memorable through the use of color and contrast. When presenting your concepts and ideas to an audience, whether to a client or in a classroom, to co-workers or at a trade show, the clever use of color can increase the audience reaction considerably.

Studies have shown that color accelerates learning, retention and recall by 55% to 78%; improves and increases comprehension by up to 73%; increases recognition by up

to 87%; and increases motivation and participation, moving people to action, by up to 80%, reduces error count from 55% to 35% and sells products and ideas more effectively by 50% to 85%.

When using text and/or graphs:

- Limit text to phrases—simply stated and to the point
- Maximize white space between points to avoid cluttered look
- Choose a basic text color that best reflects the message. For example, red for excitement, orange to express heat
- Changing the color of a word or phrase within the body of the text will make the word or phrase more memorable
- Legibility is best served by contrast—light text on darker background or dark on light
- White against a color can provide high contrast. The human eye perceives of white as a brilliant color

Graphic Images

Viewers today expect to be "wowed" by color. More than ever they are exposed to colorful and creative websites, TV ads, films, computer software and games. Imaginative, highly animated and often sophisticated, graphics have achieved a new level of artistry.

This exposure leads to a greater expectation level as the consumer assumes that they will be educated and entertained at the same time.

This presents a very real creative challenge to the designer, but that is what graphic design has always been about. Culled from the usual resources, such as books, fine and pop art, nature, travel and so on, ultimately inspiration must emerge from keen observation and the designer's own fertile and productive mind.

As far as photographic images are concerned, there are many stock photos and web resources available that offer a multitude of colorful images. Every subject can be researched through those always-available resources. In addition, a digital camera can be a designer's best friend. There is a multi-hued world of color that, if we keep our eyes constantly open to the possibilities, is waiting to be digitally captured and forever frozen in that moment in time.

As every presentation should have some humor in it, a digital camera can catch images that really defy description unless we experience it with our own eyes. On a personal note, I missed a great opportunity one day in New York for lack of a camera to record the moment. A woman with brightly colored streaked hair was walking about a half block ahead of me. From a distance, what appeared to be a striped hat perched on top of her weird hair coloring was actually a striped lizard that mimicked exactly the same hues of her hair. Now that would have made a great visual introduction to a presentation on color!

spinning the color wheel

When divided into 12 "pie slices", the classic color wheel can provide inspiration for many color combinations. Utilizing the wheel as a guide, there are several categories of color schemes. The dominant color(s), such as the warmer reds, yellows and oranges or cooler blues, blue greens, greens and violets (purple) will suggest the temperature of the intended theme or mood.

Even within a color family, a difference in undertone can change the perception of warm vs. cool. For example, in the red family, blue reds are cooler than yellow reds.

Purple and green are the most adaptable to changes in perceived temperatures as they are seen as the bridge between warm and cool colors. As purple moves closer to red, it not only appears hotter, but more psychologically connected to red. As the hue moves closer to blue, the reverse is true in that purple is then seen as cooler and calmer. The same is seen for variations of green.

Obviously, general concepts about color temperature do prevail, but color must always be thought of in terms of positioning in combinations.

1

MONOCHROMATIC schemes are varying shades of the same color, such as powder blue, slate blue and navy blue. (Figure 2)

ANALOGOUS or neighboring combinations emanate from immediately adjacent portions of the wheel, for example, yellow green chartreuse, deeper foliage green and a blue green turquoise. Both monochromatic and analogous combinations carry a very specific psychological message, as one color family and all of its implied meanings become the predominant theme. They are also harmonious because of their close proximity on the wheel and very effective in suggesting a specific color temperature. (Figure 3)

COMPLEMENTARY or contrasting color schemes utilize opposites on the color wheel, providing maximum contrast. For example, a dramatic and exuberant dandelion yellow and vivid violet, with metallic gold and lilacs added to the mix for some interesting variation. (Figure 4)

DOUBLE COMPLEMENTARY combines two variations of a color family that are opposites on the wheel, for example, the yellow and violet mentioned above coupled with yellow orange and blue violet. This arrangement of related color placed with their related complements would further emphasize the drama and complexity of the message. (Figure 5)

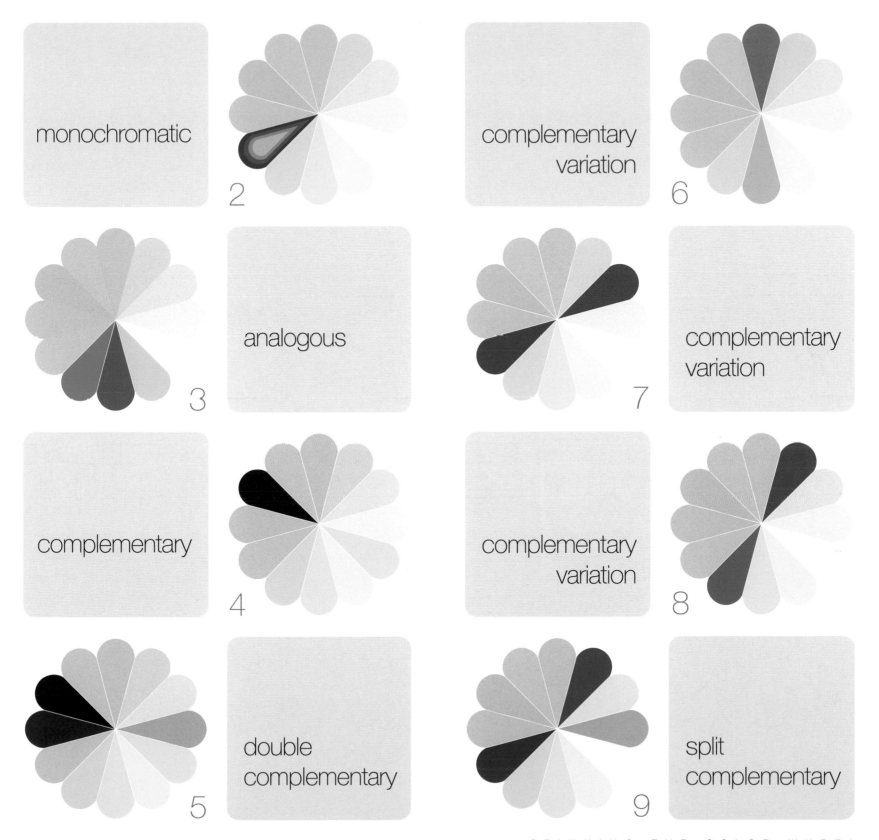

monochromatic

2

analogous

3

complementary

4

double
complementary

5

complementary
variation

6

complementary
variation

7

complementary
variation

8

split
complementary

9

COMPLEMENTARY VARIATIONS Complementaries need not be blatantly bright. Primary or secondary opposites may be lightened or darkened, yet still intensify each other. For example, a primrose pink and mint green or mocha brown (a variation of orange) and its complement of sea blue. The real meaning of the term "complementary" is that each member of the pair visually "completes" the other. Yellow will appear ever more yellow when it is juxtaposed against purple; greens will appear even greener when coupled with reds and pinks and the same holds true for contrasting tones of blue and orange. (Figures 6, 7 & 8)

SPLIT COMPLEMENTARY produces a threesome by using one hue with the colors flanking its opposite. For example, combining a blue with red orange and a yellow orange. This makes for a somewhat more complex and intriguing combination. (Figure 9)

TRIAD Employing three equidistant colors on the wheel forms a triad, which is primary, secondary or tertiary. The primary triad is more "simplistic", while the secondary and tertiary are more complex and sophisticated. (Figure 10)

TETRADS include four colors equidistant on the wheel that are actually two diverse complementary pairs, for example persimmon and navy used with lime green and a red violet. This produces a rather unique and complicated scheme that would need a strong hierarchy of color—one dominant color with the others becoming more gradually subordinate. However, if the goal is to create "cacophony", more equal amounts will represent more discord. (Figure 11)

ADVENTUROUS ANALOGOUS Combinations need not be strict interpretations of any of the above. For example, the blue, violet and red violet skips a space which would have made it "perfectly" analogous, but it still represents a harmonious combination, yet a bit more "adventurous". (Figure 12)

TWEAKED TRIAD Red, blue green and yellow is not quite a primary triad, but by tweaking a true green to a blue green, an interesting new dimension is added. (Figure 13)

FLICKERING EFFECTS Contrasting, vivid blue and radiant, orange yellows viewed side by side create instant attention. However, these strong contrasts can also cause a flickering visual effect. If this illusion is not desired, separating the colors with a neutral gray will ease the visual contrast between the two brights. (Figure 14)

LIVELY, MONOCHROMATIC AND ANALOGOUS SCHEMES While brighter complementary combinations offer maximum contrast, harmonious monochromatic and analogous schemes can offer a similar verve. For example, yellow, yellow green and true green are a lively group of citrusy shades with plenty of bite. (Figure 15)

VALUE AND SATURATION IN SCHEMES The value (degrees of light and dark) and saturation (the amount of color within a hue) of selected colors and the proportions in which they are used make for a broad variety of possibilities. For example, a dominant red orange used with a deep blue violet and a lighter yellow green provides a study in contrasts in both light and dark, as well as in the mix of hues. (Figure 16)

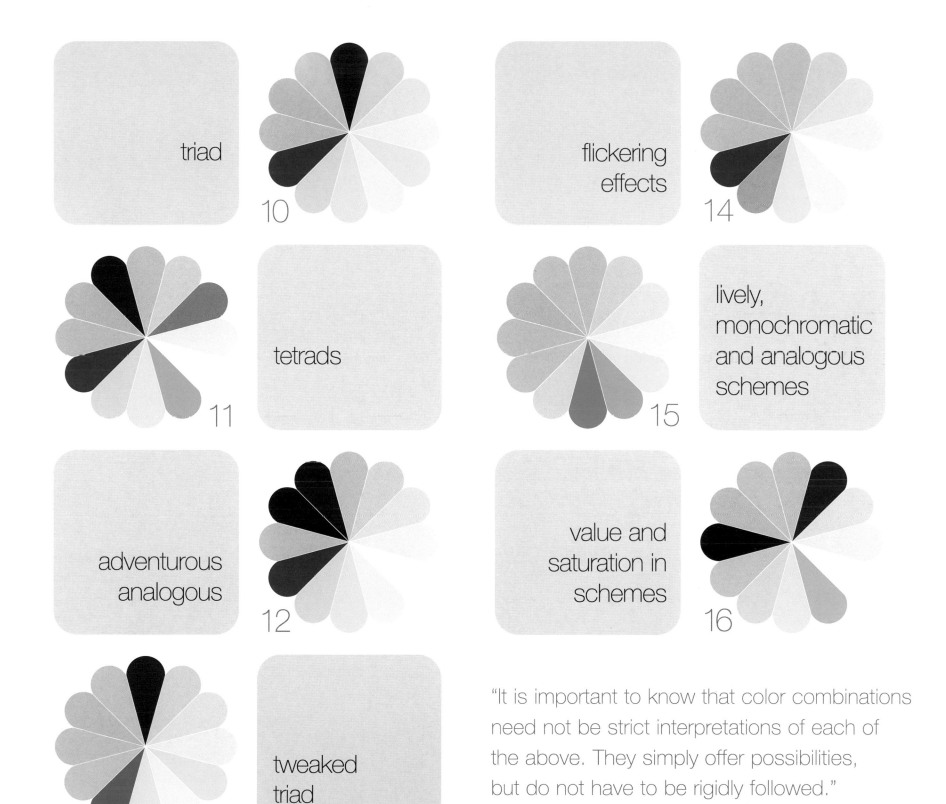

triad

10

flickering
effects

14

11

tetrads

lively,
monochromatic
and analogous
schemes

15

adventurous
analogous

12

value and
saturation in
schemes

16

13

tweaked
triad

"It is important to know that color combinations
need not be strict interpretations of each of
the above. They simply offer possibilities,
but do not have to be rigidly followed."

the rank order of color

Dominant, Subordinate and Accent

Defining the Message

- Is it invigorating, exotic or intimate?
- Should it suggest a certain mysterioso, sentiment or taste?
- Select the dominant color that most conveys the message
- Choose subordinate and accent colors to support the message
- Fine tune the choices for appropriateness to the targeted audience
- Check competition colors for similarities and "tweak" if necessary
- Utilize the combinations from the classic color wheel or the illustrations starting on page 83 as a "jump start"

Cues for Color Combinations

To establish an immediate message, color combinations should contain visual color cues that trigger specific responses. As a general rule, there should be a rank order of dominant, subordinate and accent colors. Chapter 1 explained the messages and meanings of each color family and contained a specific list of word associations attached to various shades in each family. Please note that for most color families the positive aspects far outweigh the negative connotations. These responses as well as the classic color wheel and/or the color combination pages that follow will help you to develop the most effective combinations and moods.

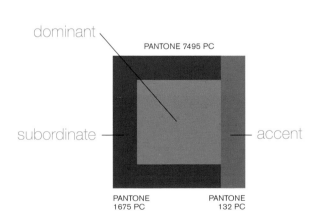

dominant
PANTONE 7495 PC
subordinate
accent
PANTONE 1675 PC
PANTONE 132 PC

SANTINA
DESIGN

santina
design

creating moods with color combinations

The color moods or themes on the following pages are illustrated in combinations of three colors. If more than three colors are appropriate, additional choices can be made from another color grouping within the same theme. For example, in the Provocative theme, shown below, the dominant shade is a vibrant coral (PANTONE 1787), the subordinate hue is a hot pink (PANTONE 245) and the accent color is a deep violet (PANTONE 7435). The next combination is a terra cotta (PANTONE 7418), a rich brown (PANTONE 222) and lavender pink (PANTONE 244). Terra cotta would add a fourth color and a bit more complexity to the original mix.

PANTONE 1787 PC · PANTONE 7418 PC

PANTONE® 1795 PC

| PANTONE 245 PC | PANTONE 7435 PC | PANTONE 222 PC | PANTONE 244 PC |

If a fifth color would be added, any other color in the Provocative theme, for example, an orange red (PANTONE 1795), would be a possibility for expanding the original choice as they blend well and share the same mood.

PANTONE 559 PC · PANTONE 141 PC · PANTONE 153 PC

PANTONE 277 PC · PANTONE 251 PC · PANTONE 124 PC

Some combinations, depending on the usage and the desired effect, may utilize only two colors. For example, a soft green (PANTONE 559) and a sky blue (PANTONE 277) certainly suggests a Restful mood, while Eye Candy says just that with a banana yellow (PANTONE 141) and sugary pink (PANTONE 251). But a cinnamon brown (PANTONE 153) and tasty orange (PANTONE 1585) will be made even more pungent with a curried yellow (PANTONE 124). Design elements come into play, as well as space, however many messages are further enhanced by the use of more, rather than less, color.

There are no hard and fast rules about how many colors are appropriate in a combination. The final choice rests on the creators' eye, but the mood of the piece will be determined by the chosen colors. The following pages will help to define those moods and provide some suggested combinations.

eye candy

Beginning in early childhood, there is an expectation that certain colors will be sweet. The eye literally entices the taste buds with luscious peaches, apricots, berries, cherries, grapes, creams, custard yellows, candy pinks, mochas and the ultimate enticement of chocolate brown.

tasty

EDIBLE ART
The Art Institute of Boston at Lesley University
Thursday, April 28, 2005

EDIBLE ART
The Art Institute of Boston at Lesley University
Thursday, April 28, 2005

delicious

Yes.

It's that easy.

ch-chocolates

one dozen hand-crafted truffles

HAZELNUT MILK CHOCOLATE

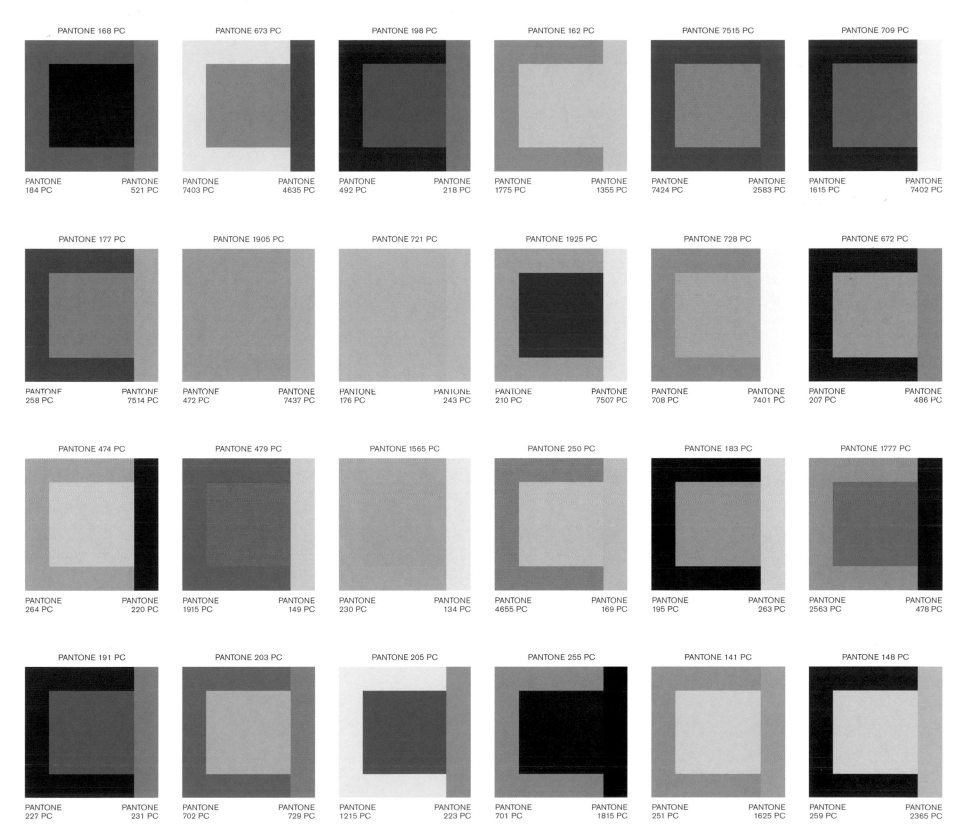

PANTONE 168 PC

PANTONE
184 PC

PANTONE
521 PC

PANTONE 673 PC

PANTONE
7403 PC

PANTONE
4635 PC

PANTONE 198 PC

PANTONE
492 PC

PANTONE
218 PC

PANTONE 162 PC

PANTONE
1775 PC

PANTONE
1355 PC

PANTONE 7515 PC

PANTONE
7424 PC

PANTONE
2583 PC

PANTONE 709 PC

PANTONE
1615 PC

PANTONE
7402 PC

PANTONE 177 PC

PANTONE
258 PC

PANTONE
7514 PC

PANTONE 1905 PC

PANTONE
472 PC

PANTONE
7437 PC

PANTONE 721 PC

PANTONE
176 PC

PANTONE
243 PC

PANTONE 1925 PC

PANTONE
210 PC

PANTONE
7507 PC

PANTONE 728 PC

PANTONE
708 PC

PANTONE
7401 PC

PANTONE 672 PC

PANTONE
207 PC

PANTONE
486 PC

PANTONE 474 PC

PANTONE
264 PC

PANTONE
220 PC

PANTONE 479 PC

PANTONE
1915 PC

PANTONE
149 PC

PANTONE 1565 PC

PANTONE
230 PC

PANTONE
134 PC

PANTONE 250 PC

PANTONE
4655 PC

PANTONE
169 PC

PANTONE 183 PC

PANTONE
195 PC

PANTONE
263 PC

PANTONE 1777 PC

PANTONE
2563 PC

PANTONE
478 PC

PANTONE 191 PC

PANTONE
227 PC

PANTONE
231 PC

PANTONE 203 PC

PANTONE
702 PC

PANTONE
729 PC

PANTONE 205 PC

PANTONE
1215 PC

PANTONE
223 PC

PANTONE 255 PC

PANTONE
701 PC

PANTONE
1815 PC

PANTONE 141 PC

PANTONE
251 PC

PANTONE
1625 PC

PANTONE 148 PC

PANTONE
259 PC

PANTONE
2365 PC

rich

Rich not only describes a taste, but is also suggestive of a taste level. Think olives in a martini glass, robust wines, elegant aubergine purples, succulent berries, espresso browns—often accented with glints of gold. These are complex, sophisticated mixes, appealing to an "up-scale" audience.

PANTONE 228 PC
PANTONE 466 PC
PANTONE 463 PC

PANTONE 1945 PC
PANTONE 4695 PC
PANTONE 2425 PC

PANTONE 464 PC
PANTONE 215 PC
PANTONE 119 PC

PANTONE 7433 PC
PANTONE 476 PC
PANTONE 1245 PC

PANTONE 7525 PC
PANTONE 477 PC
PANTONE 201 PC

PANTONE 7434 PC
PANTONE 4505 PC
PANTONE 209 PC

PANTONE 4645 PC
PANTONE 194 PC
PANTONE 242 PC

PANTONE 732 PC
PANTONE 682 PC
PANTONE 466 PC

PANTONE 451 PC
PANTONE 234 PC
PANTONE 469 PC

PANTONE 1245 PC
PANTONE 222 PC
PANTONE 7425 PC

PANTONE 2415 PC
PANTONE 465 PC
PANTONE 4625 PC

PANTONE 468 PC
PANTONE 490 PC
PANTONE 235 PC

PANTONE 241 PC
PANTONE 4715 PC
PANTONE 216 PC

PANTONE 730 PC
PANTONE 683 PC
PANTONE 215 PC

PANTONE 1255 PC
PANTONE 188 PC
PANTONE 385 PC

PANTONE 1955 PC
PANTONE 1245 PC
PANTONE 675 PC

PANTONE 682 PC
PANTONE 229 PC
PANTONE 729 PC

PANTONE 512 PC
PANTONE 4725 PC
PANTONE 1817 PC

PANTONE 676 PC
PANTONE 730 PC
PANTONE 731 PC

PANTONE 260 PC
PANTONE 4495 PC
PANTONE 4515 PC

PANTONE 221 PC
PANTONE 497 PC
PANTONE 7407 PC

PANTONE 467 PC
PANTONE 504 PC
PANTONE 2612 PC

PANTONE 208 PC
PANTONE 1245 PC
PANTONE 505 PC

PANTONE 249 PC
PANTONE 248 PC
PANTONE 464 PC

Let the flavor
carry you away...

RIDE THE GONDOLA TO
REDWOOD CREEK
SATISFY YOUR TASTE FOR *ADVENTURE!*

GENUINE
Fiesta
An American Icon

THE HOMER LAUGHLIN CHINA COMPANY
800-452-4462 • Newell, WV 26050-1299 • www.hlchina.com

woodland

Woodland hues extend far beyond inevitable greens and browns to inspiration
derived from the intricate colors of leaves and foliage co-mingled on the
autumnal forest floor. This is a dramatically intense mosaic of golden russet,
fir green, teal, magenta, citron, fiery red, deep wine and chestnut brown.

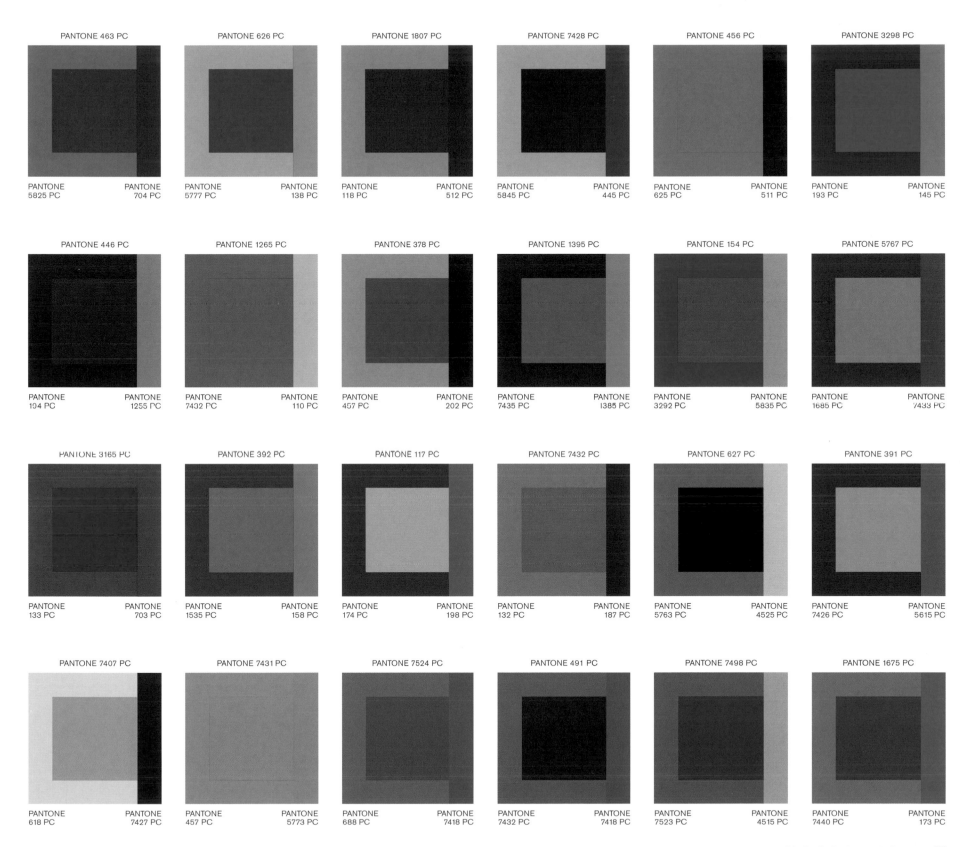

PANTONE 463 PC
PANTONE 5825 PC PANTONE 704 PC

PANTONE 626 PC
PANTONE 5777 PC PANTONE 138 PC

PANTONE 1807 PC
PANTONE 118 PC PANTONE 512 PC

PANTONE 7428 PC
PANTONE 5845 PC PANTONE 445 PC

PANTONE 456 PC
PANTONE 625 PC PANTONE 511 PC

PANTONE 3298 PC
PANTONE 193 PC PANTONE 145 PC

PANTONE 446 PC
PANTONE 194 PC PANTONE 1255 PC

PANTONE 1265 PC
PANTONE 7432 PC PANTONE 110 PC

PANTONE 378 PC
PANTONE 457 PC PANTONE 202 PC

PANTONE 1395 PC
PANTONE 7435 PC PANTONE 1385 PC

PANTONE 154 PC
PANTONE 3292 PC PANTONE 5835 PC

PANTONE 5767 PC
PANTONE 1685 PC PANTONE 7433 PC

PANTONE 3165 PC
PANTONE 133 PC PANTONE 703 PC

PANTONE 392 PC
PANTONE 1535 PC PANTONE 158 PC

PANTONE 117 PC
PANTONE 174 PC PANTONE 198 PC

PANTONE 7432 PC
PANTONE 132 PC PANTONE 187 PC

PANTONE 627 PC
PANTONE 5763 PC PANTONE 4525 PC

PANTONE 391 PC
PANTONE 7426 PC PANTONE 5615 PC

PANTONE 7407 PC
PANTONE 618 PC PANTONE 7427 PC

PANTONE 7431 PC
PANTONE 457 PC PANTONE 5773 PC

PANTONE 7524 PC
PANTONE 688 PC PANTONE 7418 PC

PANTONE 491 PC
PANTONE 7432 PC PANTONE 7418 PC

PANTONE 7498 PC
PANTONE 7523 PC PANTONE 4515 PC

PANTONE 1675 PC
PANTONE 7440 PC PANTONE 173 PC

We carry the complete
Cargo product line.

www.edwardcarriere.com

We carry the complete
Cargo product line.

www.edwardcarriere.com

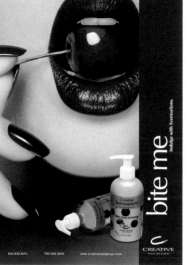

cosmetica

Cosmetica celebrates the colors that make up a panoply of international skin tones, in addition to many of the shades that most flatter a variety of complexions. This appealing palette is composed of various tones of mocha, brown and black as well as peach, rose, beige, red, ivory and plum.

TREND:

MORE OF THE WORLD'S PEOPLE ARE LIVING LONGER, HIGHER QUALITY LIVES.

AS A RESULT, CONCERN FOR MAINTAINING A HEALTHIER, MORE YOUTHFUL APPEARANCE CONTINUES TO GROW.

WE HAVE EXPANDED OUR TECHNOLOGICAL CAPABILITIES TO PROVIDE GREATER VALUE TO COSMETICS AND PERSONAL CARE MARKETS.

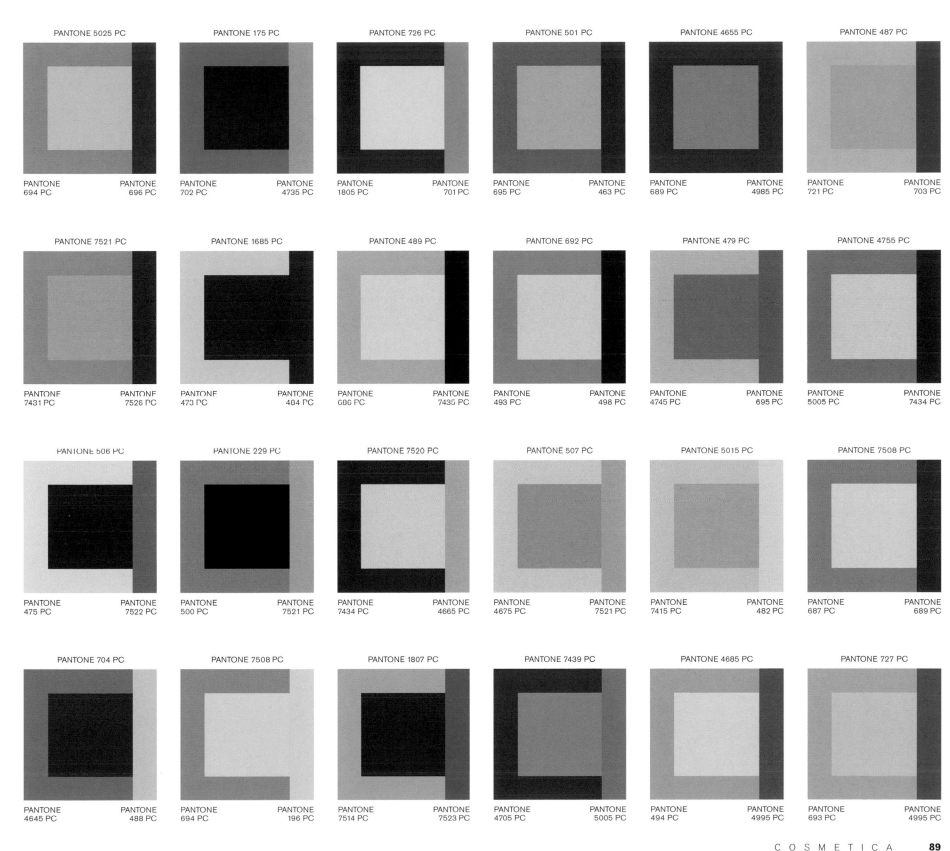

PANTONE 5025 PC
PANTONE 694 PC · PANTONE 696 PC

PANTONE 175 PC
PANTONE 702 PC · PANTONE 4735 PC

PANTONE 726 PC
PANTONE 1805 PC · PANTONE 701 PC

PANTONE 501 PC
PANTONE 695 PC · PANTONE 463 PC

PANTONE 4655 PC
PANTONE 689 PC · PANTONE 4985 PC

PANTONE 487 PC
PANTONE 721 PC · PANTONE 703 PC

PANTONE 7521 PC
PANTONE 7431 PC · PANTONE 7526 PC

PANTONE 1685 PC
PANTONE 473 PC · PANTONE 404 PC

PANTONE 489 PC
PANTONE 686 PC · PANTONE 7435 PC

PANTONE 692 PC
PANTONE 493 PC · PANTONE 498 PC

PANTONE 479 PC
PANTONE 4745 PC · PANTONE 695 PC

PANTONE 4755 PC
PANTONE 5005 PC · PANTONE 7434 PC

PANTONE 506 PC
PANTONE 475 PC · PANTONE 7522 PC

PANTONE 229 PC
PANTONE 500 PC · PANTONE 7521 PC

PANTONE 7520 PC
PANTONE 7434 PC · PANTONE 4665 PC

PANTONE 507 PC
PANTONE 4675 PC · PANTONE 7521 PC

PANTONE 5015 PC
PANTONE 7415 PC · PANTONE 482 PC

PANTONE 7508 PC
PANTONE 687 PC · PANTONE 689 PC

PANTONE 704 PC
PANTONE 4645 PC · PANTONE 488 PC

PANTONE 7508 PC
PANTONE 694 PC · PANTONE 196 PC

PANTONE 1807 PC
PANTONE 7514 PC · PANTONE 7523 PC

PANTONE 7439 PC
PANTONE 4705 PC · PANTONE 5005 PC

PANTONE 4685 PC
PANTONE 494 PC · PANTONE 4995 PC

PANTONE 727 PC
PANTONE 693 PC · PANTONE 4995 PC

Presenting our ice blue dinnerware

POSSIBLY THE MOST BEAUTIFUL TABLEWARE IN THE WORLD

Barbara Barry on options

MOHAWK

sentimental

© Don Paulson

Sentimental colors evoke thoughts of yesteryear—delicately pressed flowers, tinted postcards, faded photos in an old album, vintage ads and posters. These are the shades dusted over with time, nostalgic and reminiscent of another era—sepia browns, grays and taupes, the blues that are the color of dried hydrangeas, ash roses and wistful mauves.

PANTONE 415 PC
PANTONE 5145 PC
PANTONE 5285 PC

PANTONE 406 PC
PANTONE 7502 PC
PANTONE 5015 PC

PANTONE 7543 PC
PANTONE 5855 PC
PANTONE 5487 PC

PANTONE 7538 PC
PANTONE 5005 PC
PANTONE 537 PC

PANTONE 5497 PC
PANTONE 421 PC
PANTONE 5155 PC

PANTONE 5215 PC
PANTONE 7542 PC
PANTONE 7532 PC

PANTONE 400 PC
PANTONE Warm Gray 10 PC
PANTONE 5425 PC

PANTONE Warm Gray 5 PC
PANTONE 443 PC
PANTONE 5435 PC

PANTONE 7503 PC
PANTONE 442 PC
PANTONE 5205 PC

PANTONE 435 PC
PANTONE 666 PC
PANTONE 7531 PC

PANTONE 5225 PC
PANTONE 436 PC
PANTONE 5205 PC

PANTONE 5497 PC
PANTONE 7518 PC
PANTONE 5025 PC

PANTONE 7530 PC
PANTONE 5295 PC
PANTONE 7519 PC

PANTONE Warm Gray 9 PC
PANTONE 401 PC
PANTONE 5625 PC

PANTONE 5205 PC
PANTONE 7502 PC
PANTONE 7497 PC

PANTONE Warm Gray 6 PC
PANTONE 501 PC
PANTONE 7544 PC

PANTONE 7445 PC
PANTONE 414 PC
PANTONE 5215 PC

PANTONE Warm Gray 4 PC
PANTONE 7531 PC
PANTONE 7445 PC

PANTONE 443 PC
PANTONE 7539 PC
PANTONE 413 PC

PANTONE 422 PC
PANTONE 535 PC
PANTONE 467 PC

PANTONE 441 PC
PANTONE 403 PC
PANTONE 7504 PC

PANTONE 5635 PC
PANTONE 5865 PC
PANTONE 666 PC

PANTONE 5005 PC
PANTONE 7530 PC
PANTONE 7503 PC

PANTONE 5225 PC
PANTONE 7538 PC
PANTONE 7529 PC

Wild Berry Bright Eyes

opaque smoothies

Finch Opaque Swatchbook

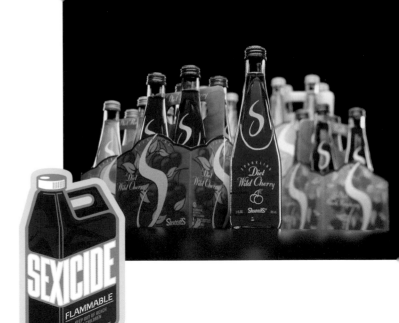

KISS MY FACE

Honey & Calendula Moisturizer

for Extra Dry, Chapped Skin

16 Fl Oz 473 mL

SEXICIDE

FLAMMABLE

KEEP OUT OF REACH OF CHILDREN

zesty

Suggestive of a youthful, vivacious, over the top energy, the Zesty palette is flavored with a vibrant piquancy suggestive of the lip puckering fruit that inspires the colors. It is a tasty blend of bright orange, pink grapefruit, pomegranate, grenadine and tart berry mixed with the added tang of kiwi or lime green.

original design for home and fashion

Garnet Hill

Enjoy Free Shipping on All Rugs in This Catalog

New Items

Maine Cottage
colorbook

SOLUTIONS
Products that make life easier

Unconditional Lifetime Guarantee!

Organize & Go!

Courtesy of Maine Cottage/Dennis Welsh

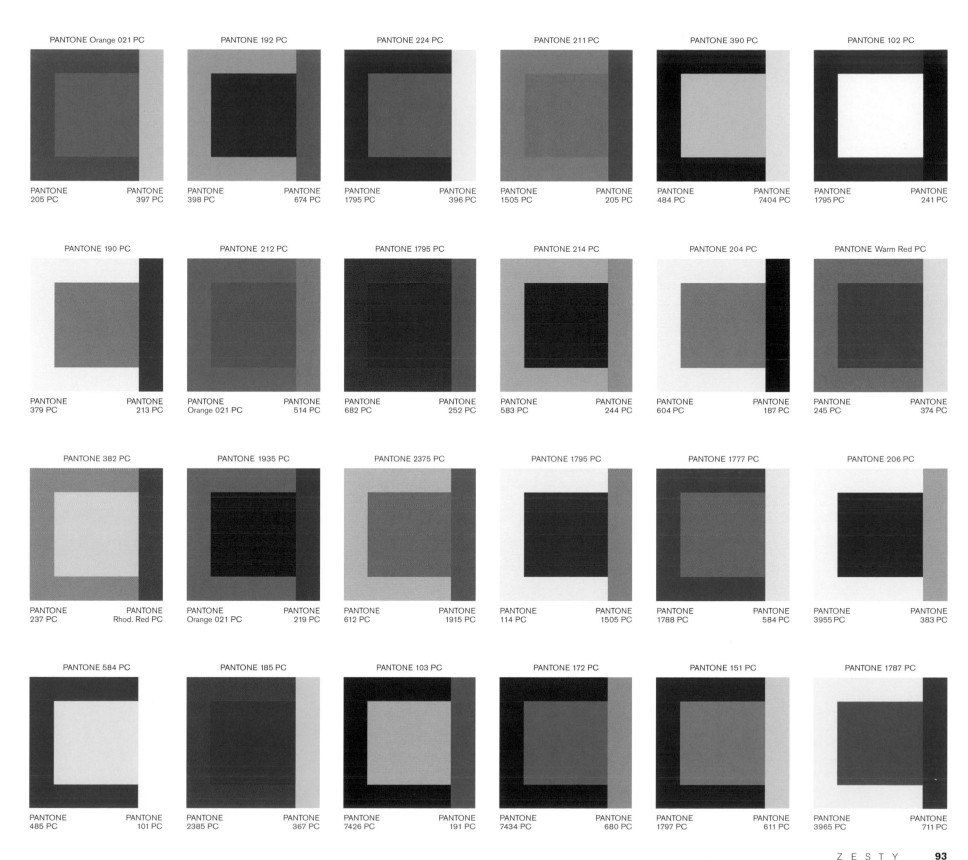

PANTONE Orange 021 PC	PANTONE 192 PC	PANTONE 224 PC	PANTONE 211 PC	PANTONE 390 PC	PANTONE 102 PC
PANTONE 205 PC / PANTONE 397 PC	PANTONE 398 PC / PANTONE 674 PC	PANTONE 1795 PC / PANTONE 396 PC	PANTONE 1505 PC / PANTONE 205 PC	PANTONE 484 PC / PANTONE 7404 PC	PANTONE 1795 PC / PANTONE 241 PC

PANTONE 190 PC	PANTONE 212 PC	PANTONE 1795 PC	PANTONE 214 PC	PANTONE 204 PC	PANTONE Warm Red PC
PANTONE 379 PC / PANTONE 213 PC	PANTONE Orange 021 PC / PANTONE 514 PC	PANTONE 682 PC / PANTONE 252 PC	PANTONE 583 PC / PANTONE 244 PC	PANTONE 604 PC / PANTONE 187 PC	PANTONE 245 PC / PANTONE 374 PC

PANTONE 382 PC	PANTONE 1935 PC	PANTONE 2375 PC	PANTONE 1795 PC	PANTONE 1777 PC	PANTONE 206 PC
PANTONE 237 PC / PANTONE Rhod. Red PC	PANTONE Orange 021 PC / PANTONE 219 PC	PANTONE 612 PC / PANTONE 1915 PC	PANTONE 114 PC / PANTONE 1505 PC	PANTONE 1788 PC / PANTONE 584 PC	PANTONE 3955 PC / PANTONE 383 PC

PANTONE 584 PC	PANTONE 185 PC	PANTONE 103 PC	PANTONE 172 PC	PANTONE 151 PC	PANTONE 1787 PC
PANTONE 485 PC / PANTONE 101 PC	PANTONE 2385 PC / PANTONE 367 PC	PANTONE 7426 PC / PANTONE 191 PC	PANTONE 7434 PC / PANTONE 680 PC	PANTONE 1797 PC / PANTONE 611 PC	PANTONE 3965 PC / PANTONE 711 PC

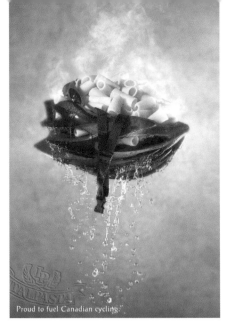

OAKVILLE AUDIO

skyscraper

Skyscraper connotes a modern landscape—an urban environment filled with concrete and asphalt, shiny steel and the glimmer of glass against the background of sky, sometimes blue, often gray or vaguely mauve, depending on the elements. The shades are, for the most part, cool and "techno-oriented". Silver surfaces are the perfect cool metallic to represent the feel of the palette.

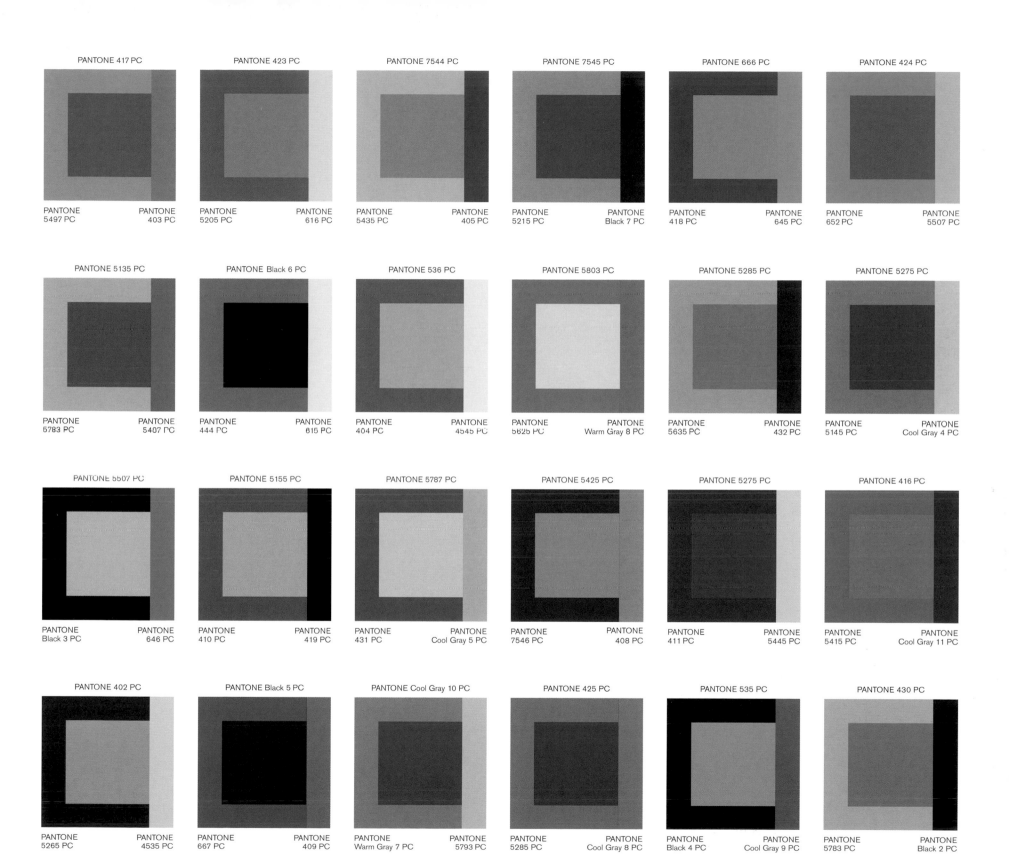

PANTONE 417 PC · PANTONE 5497 PC · PANTONE 403 PC

PANTONE 423 PC · PANTONE 5205 PC · PANTONE 616 PC

PANTONE 7544 PC · PANTONE 5435 PC · PANTONE 405 PC

PANTONE 7545 PC · PANTONE 5215 PC · PANTONE Black 7 PC

PANTONE 666 PC · PANTONE 418 PC · PANTONE 645 PC

PANTONE 424 PC · PANTONE 652 PC · PANTONE 5507 PC

PANTONE 5135 PC · PANTONE 5783 PC · PANTONE 5407 PC

PANTONE Black 6 PC · PANTONE 444 PC · PANTONE 615 PC

PANTONE 536 PC · PANTONE 404 PC · PANTONE 4545 PC

PANTONE 5803 PC · PANTONE 5625 PC · PANTONE Warm Gray 8 PC

PANTONE 5285 PC · PANTONE 5635 PC · PANTONE 432 PC

PANTONE 5275 PC · PANTONE 5145 PC · PANTONE Cool Gray 4 PC

PANTONE 5507 PC · PANTONE Black 3 PC · PANTONE 646 PC

PANTONE 5155 PC · PANTONE 410 PC · PANTONE 419 PC

PANTONE 5787 PC · PANTONE 431 PC · PANTONE Cool Gray 5 PC

PANTONE 5425 PC · PANTONE 7546 PC · PANTONE 408 PC

PANTONE 5275 PC · PANTONE 411 PC · PANTONE 5445 PC

PANTONE 416 PC · PANTONE 5415 PC · PANTONE Cool Gray 11 PC

PANTONE 402 PC · PANTONE 5265 PC · PANTONE 4535 PC

PANTONE Black 5 PC · PANTONE 667 PC · PANTONE 409 PC

PANTONE Cool Gray 10 PC · PANTONE Warm Gray 7 PC · PANTONE 5793 PC

PANTONE 425 PC · PANTONE 5285 PC · PANTONE Cool Gray 8 PC

PANTONE 535 PC · PANTONE Black 4 PC · PANTONE Cool Gray 9 PC

PANTONE 430 PC · PANTONE 5783 PC · PANTONE Black 2 PC

restful

This is a "Zen" palette, passive rather than active, comprised of those colors that sooth and relax both mind and body. There are sage or pine greens, placid and/or twilight blues, wispy grays, therapeutic lavenders and misted mauves. All may be combined with purifying white for maximum healing.

Courtesy of Maine Cottage/Dennis Welsh

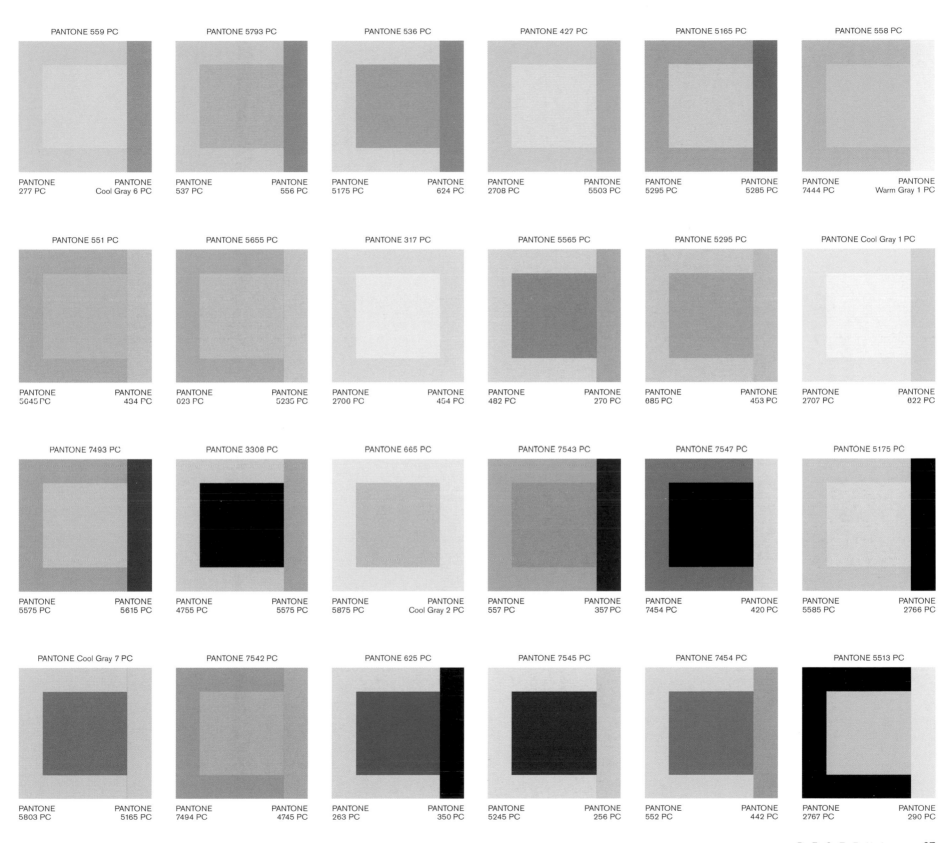

PANTONE 559 PC

PANTONE 277 PC | PANTONE Cool Gray 6 PC

PANTONE 5793 PC

PANTONE 537 PC | PANTONE 556 PC

PANTONE 536 PC

PANTONE 5175 PC | PANTONE 624 PC

PANTONE 427 PC

PANTONE 2708 PC | PANTONE 5503 PC

PANTONE 5165 PC

PANTONE 5295 PC | PANTONE 5285 PC

PANTONE 558 PC

PANTONE 7444 PC | PANTONE Warm Gray 1 PC

PANTONE 551 PC

PANTONE 5045 PC | PANTONE 434 PC

PANTONE 5655 PC

PANTONE 023 PC | PANTONE 5235 PC

PANTONE 317 PC

PANTONE 2700 PC | PANTONE 454 PC

PANTONE 5565 PC

PANTONE 482 PC | PANTONE 270 PC

PANTONE 5295 PC

PANTONE 085 PC | PANTONE 453 PC

PANTONE Cool Gray 1 PC

PANTONE 2707 PC | PANTONE 622 PC

PANTONE 7493 PC

PANTONE 5575 PC | PANTONE 5615 PC

PANTONE 3308 PC

PANTONE 4755 PC | PANTONE 5575 PC

PANTONE 665 PC

PANTONE 5875 PC | PANTONE Cool Gray 2 PC

PANTONE 7543 PC

PANTONE 557 PC | PANTONE 357 PC

PANTONE 7547 PC

PANTONE 7454 PC | PANTONE 420 PC

PANTONE 5175 PC

PANTONE 5585 PC | PANTONE 2766 PC

PANTONE Cool Gray 7 PC

PANTONE 5803 PC | PANTONE 5165 PC

PANTONE 7542 PC

PANTONE 7494 PC | PANTONE 4745 PC

PANTONE 625 PC

PANTONE 263 PC | PANTONE 350 PC

PANTONE 7545 PC

PANTONE 5245 PC | PANTONE 256 PC

PANTONE 7454 PC

PANTONE 552 PC | PANTONE 442 PC

PANTONE 5513 PC

PANTONE 2767 PC | PANTONE 290 PC

assertive

This is the palette that commands, "You will not ignore me!" The visibility and energy factor is high, as is the demand for attention reflected in the volatile red, orange and red purple families, as well as in the signal yellows and yellow greens. Interjecting black into the mix further empowers the combinations, while at the same time adding a dramatic contrast.

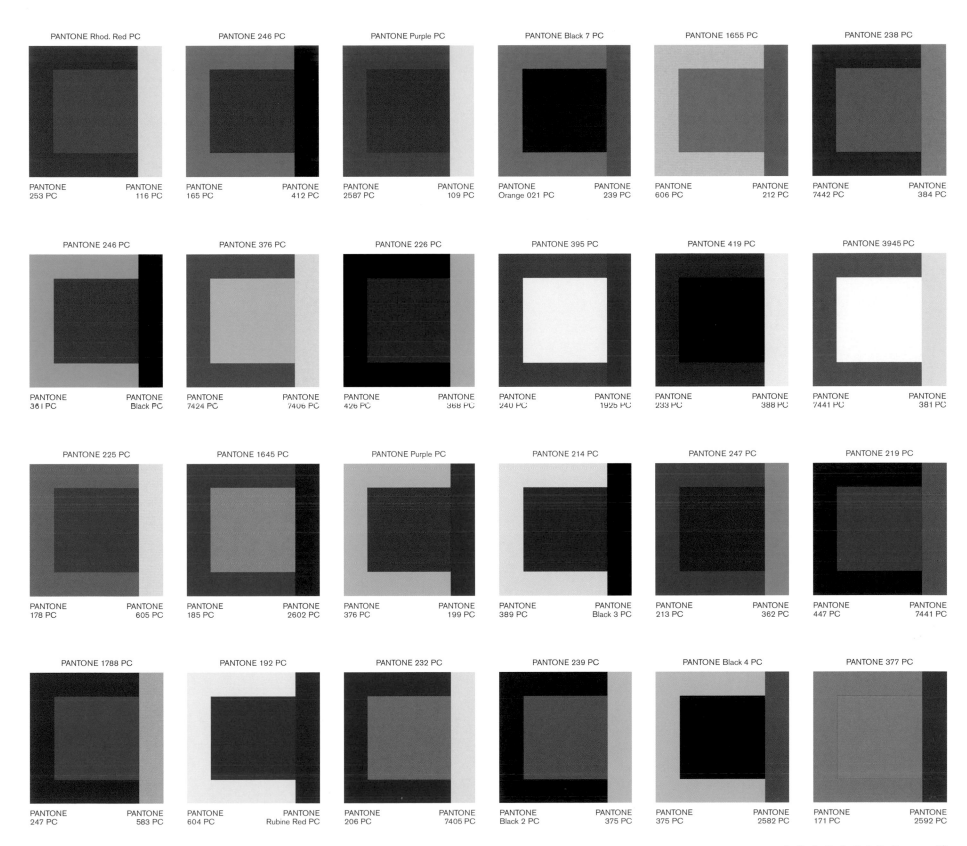

PANTONE Rhod. Red PC

PANTONE
253 PC

PANTONE
116 PC

PANTONE 246 PC

PANTONE
165 PC

PANTONE
412 PC

PANTONE Purple PC

PANTONE
2587 PC

PANTONE
109 PC

PANTONE Black 7 PC

PANTONE
Orange 021 PC

PANTONE
239 PC

PANTONE 1655 PC

PANTONE
606 PC

PANTONE
212 PC

PANTONE 238 PC

PANTONE
7442 PC

PANTONE
384 PC

PANTONE 246 PC

PANTONE
361 PC

PANTONE
Black PC

PANTONE 376 PC

PANTONE
7424 PC

PANTONE
7406 PC

PANTONE 226 PC

PANTONE
426 PC

PANTONE
368 PC

PANTONE 395 PC

PANTONE
240 PC

PANTONE
1925 PC

PANTONE 419 PC

PANTONE
233 PC

PANTONE
388 PC

PANTONE 3945 PC

PANTONE
7441 PC

PANTONE
381 PC

PANTONE 225 PC

PANTONE
178 PC

PANTONE
605 PC

PANTONE 1645 PC

PANTONE
185 PC

PANTONE
2602 PC

PANTONE Purple PC

PANTONE
376 PC

PANTONE
199 PC

PANTONE 214 PC

PANTONE
389 PC

PANTONE
Black 3 PC

PANTONE 247 PC

PANTONE
213 PC

PANTONE
362 PC

PANTONE 219 PC

PANTONE
447 PC

PANTONE
7441 PC

PANTONE 1788 PC

PANTONE
247 PC

PANTONE
583 PC

PANTONE 192 PC

PANTONE
604 PC

PANTONE
Rubine Red PC

PANTONE 232 PC

PANTONE
206 PC

PANTONE
7405 PC

PANTONE 239 PC

PANTONE
Black 2 PC

PANTONE
375 PC

PANTONE Black 4 PC

PANTONE
375 PC

PANTONE
2582 PC

PANTONE 377 PC

PANTONE
171 PC

PANTONE
2592 PC

mysterious

Mid to dark in value, the mysterious hues symbolize the unknown, the intrigue that never fails to fascinate the human eye. The mixtures are unusual and not at all formulaic, yet the message is beguiling in its collection of enchanting purples and wines, "other-worldly" greens, deep aubergines and hazy grays.

© Doris Mitsch

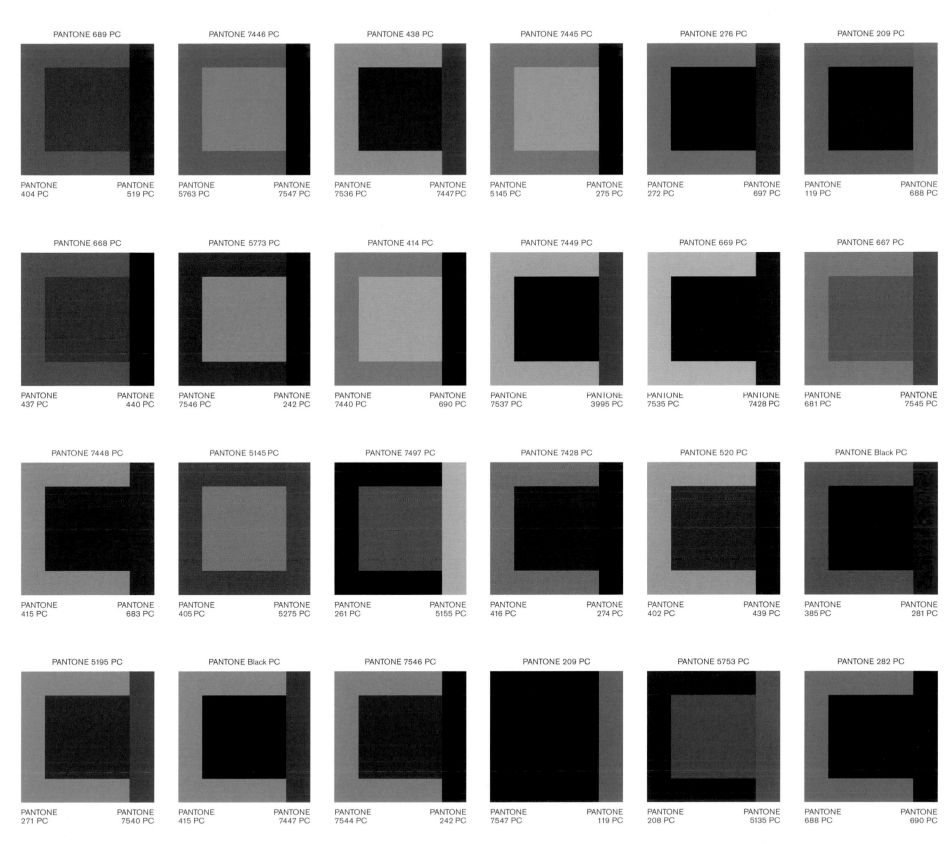

PANTONE 689 PC

PANTONE 404 PC　　PANTONE 519 PC

PANTONE 7446 PC

PANTONE 5763 PC　　PANTONE 7547 PC

PANTONE 438 PC

PANTONE 7536 PC　　PANTONE 7447 PC

PANTONE 7445 PC

PANTONE 5145 PC　　PANTONE 275 PC

PANTONE 276 PC

PANTONE 272 PC　　PANTONE 697 PC

PANTONE 209 PC

PANTONE 119 PC　　PANTONE 688 PC

PANTONE 668 PC

PANTONE 437 PC　　PANTONE 440 PC

PANTONE 5773 PC

PANTONE 7546 PC　　PANTONE 242 PC

PANTONE 414 PC

PANTONE 7440 PC　　PANTONE 690 PC

PANTONE 7449 PC

PANTONE 7537 PC　　PANTONE 3995 PC

PANTONE 669 PC

PANTONE 7535 PC　　PANTONE 7428 PC

PANTONE 667 PC

PANTONE 681 PC　　PANTONE 7545 PC

PANTONE 7448 PC

PANTONE 415 PC　　PANTONE 683 PC

PANTONE 5145 PC

PANTONE 405 PC　　PANTONE 5275 PC

PANTONE 7497 PC

PANTONE 261 PC　　PANTONE 5155 PC

PANTONE 7428 PC

PANTONE 416 PC　　PANTONE 274 PC

PANTONE 520 PC

PANTONE 402 PC　　PANTONE 439 PC

PANTONE Black PC

PANTONE 385 PC　　PANTONE 281 PC

PANTONE 5195 PC

PANTONE 271 PC　　PANTONE 7540 PC

PANTONE Black PC

PANTONE 415 PC　　PANTONE 7447 PC

PANTONE 7546 PC

PANTONE 7544 PC　　PANTONE 242 PC

PANTONE 209 PC

PANTONE 7547 PC　　PANTONE 119 PC

PANTONE 5753 PC

PANTONE 208 PC　　PANTONE 5135 PC

PANTONE 282 PC

PANTONE 688 PC　　PANTONE 690 PC

complexity

There are no primary, clear or clean colors to be found in this group—these are complex mixes done in complex colors—a sense of the unexpected as, for example, depicted in rosy pinks, grayed blues and turquoise combined with olive greens and greenish yellows. They are complicated mixes meant to attract a more sophisticated eye.

SHIBUYA

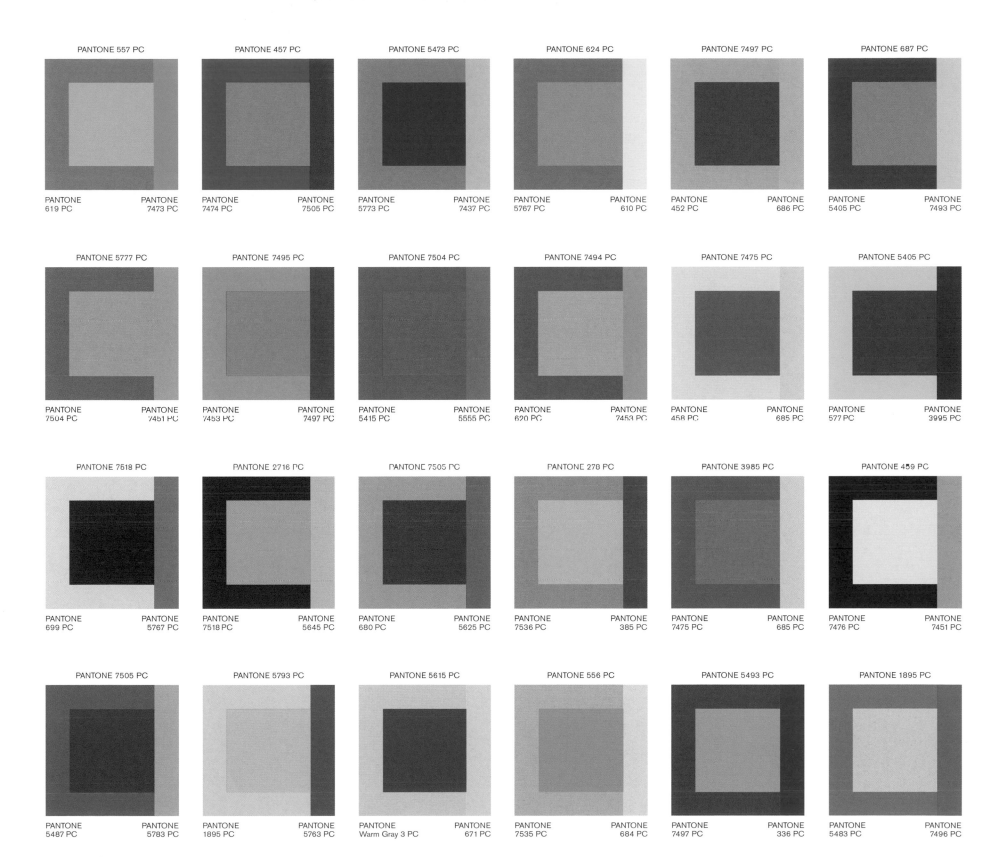

PANTONE 557 PC

PANTONE 619 PC — PANTONE 7473 PC

PANTONE 457 PC

PANTONE 7474 PC — PANTONE 7505 PC

PANTONE 5473 PC

PANTONE 5773 PC — PANTONE 7437 PC

PANTONE 624 PC

PANTONE 5767 PC — PANTONE 610 PC

PANTONE 7497 PC

PANTONE 452 PC — PANTONE 686 PC

PANTONE 687 PC

PANTONE 5405 PC — PANTONE 7493 PC

PANTONE 5777 PC

PANTONE 7504 PC — PANTONE 7451 PC

PANTONE 7495 PC

PANTONE 7453 PC — PANTONE 7497 PC

PANTONE 7504 PC

PANTONE 5415 PC — PANTONE 5555 PC

PANTONE 7494 PC

PANTONE 620 PC — PANTONE 7453 PC

PANTONE 7475 PC

PANTONE 458 PC — PANTONE 685 PC

PANTONE 5405 PC

PANTONE 577 PC — PANTONE 3995 PC

PANTONE 7518 PC

PANTONE 699 PC — PANTONE 5767 PC

PANTONE 2716 PC

PANTONE 7518 PC — PANTONE 5645 PC

PANTONE 7505 PC

PANTONE 680 PC — PANTONE 5625 PC

PANTONE 278 PC

PANTONE 7536 PC — PANTONE 385 PC

PANTONE 3985 PC

PANTONE 7475 PC — PANTONE 685 PC

PANTONE 459 PC

PANTONE 7476 PC — PANTONE 7451 PC

PANTONE 7505 PC

PANTONE 5487 PC — PANTONE 5783 PC

PANTONE 5793 PC

PANTONE 1895 PC — PANTONE 5763 PC

PANTONE 5615 PC

PANTONE Warm Gray 3 PC — PANTONE 671 PC

PANTONE 556 PC

PANTONE 7535 PC — PANTONE 684 PC

PANTONE 5493 PC

PANTONE 7497 PC — PANTONE 336 PC

PANTONE 1895 PC

PANTONE 5483 PC — PANTONE 7496 PC

intimate

Intimate colors are soft, nurturing, leaning decidedly to the warm side of the spectrum. Pink and rose are important colors, descending from the more sensuous Mother color of red but in a quieter, more romantic and less intrusive manner. Joining the pinks in equally subtle appeal are the light peach tones, blush, lavender, creamy yellow, rosy beige and bisque.

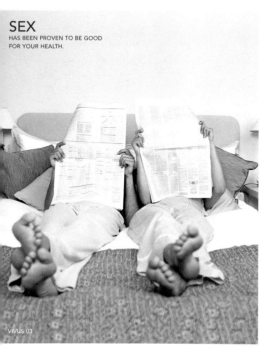

SEX
HAS BEEN PROVEN TO BE GOOD
FOR YOUR HEALTH.

VIVUS 03

PANTONE 727 PC

PANTONE 694 PC PANTONE 5225 PC

PANTONE 501 PC

PANTONE 468 PC PANTONE 482 PC

PANTONE 509 PC

PANTONE 687 PC PANTONE 7521 PC

PANTONE 680 PC

PANTONE 2635 PC PANTONE 4675 PC

PANTONE 502 PC

PANTONE 500 PC PANTONE 203 PC

PANTONE 487 PC

PANTONE 489 PC PANTONE 7430 PC

PANTONE 693 PC

PANTONE 473 PC PANTONE 7403 PC

PANTONE 719 PC

PANTONE 7430 PC PANTONE 468 PC

PANTONE 256 PC

PANTONE 5035 PC PANTONE 494 PC

PANTONE 523 PC

PANTONE 7506 PC PANTONE 467 PC

PANTONE 4685 PC

PANTONE 508 PC PANTONE 7507 PC

PANTONE 7520 PC

PANTONE 7521 PC PANTONE 4755 PC

PANTONE 603 PC

PANTONE 270 PC PANTONE 155 PC

PANTONE 4705 PC

PANTONE 720 PC PANTONE 495 PC

PANTONE 475 PC

PANTONE 522 PC PANTONE 510 PC

PANTONE 270 PC

PANTONE 7506 PC PANTONE 4735 PC

PANTONE 480 PC

PANTONE 196 PC PANTONE 7415 PC

PANTONE 5025 PC

PANTONE 680 PC PANTONE 665 PC

PANTONE 481 PC

PANTONE 5215 PC PANTONE 524 PC

PANTONE 726 PC

PANTONE 488 PC PANTONE 480 PC

PANTONE 503 PC

PANTONE 481 PC PANTONE 7501 PC

PANTONE 496 PC

PANTONE 480 PC PANTONE 474 PC

PANTONE 7513 PC

PANTONE 727 PC PANTONE 7402 PC

PANTONE 686 PC

PANTONE 4745 PC PANTONE 475 PC

provocative

Titillating, flavorful and a little bit flirty, these come-hither colors cajole the viewer into what psychologists refer to as a "high arousal mode". Advancing forward in the line of vision, they prove to stimulate appetites of all kinds in energetic red-based shades of cherry, tangerine, cranberry, raspberry, sparkling grape and snow-cone purple.

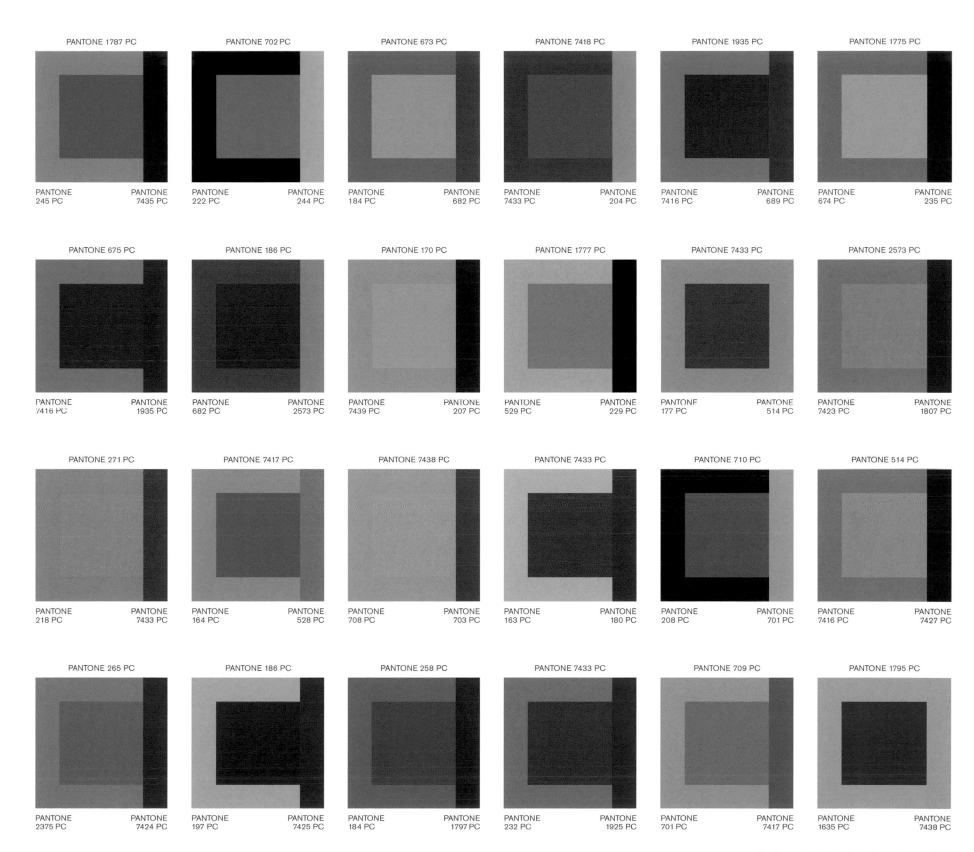

PANTONE 1787 PC
PANTONE 245 PC PANTONE 7435 PC

PANTONE 702 PC
PANTONE 222 PC PANTONE 244 PC

PANTONE 673 PC
PANTONE 184 PC PANTONE 682 PC

PANTONE 7418 PC
PANTONE 7433 PC PANTONE 204 PC

PANTONE 1935 PC
PANTONE 7416 PC PANTONE 689 PC

PANTONE 1775 PC
PANTONE 674 PC PANTONE 235 PC

PANTONE 675 PC
PANTONE 7416 PC PANTONE 1935 PC

PANTONE 186 PC
PANTONE 682 PC PANTONE 2573 PC

PANTONE 170 PC
PANTONE 7439 PC PANTONE 207 PC

PANTONE 1777 PC
PANTONE 529 PC PANTONE 229 PC

PANTONE 7433 PC
PANTONE 177 PC PANTONE 514 PC

PANTONE 2573 PC
PANTONE 7423 PC PANTONE 1807 PC

PANTONE 271 PC
PANTONE 218 PC PANTONE 7433 PC

PANTONE 7417 PC
PANTONE 164 PC PANTONE 528 PC

PANTONE 7438 PC
PANTONE 708 PC PANTONE 703 PC

PANTONE 7433 PC
PANTONE 163 PC PANTONE 180 PC

PANTONE 710 PC
PANTONE 208 PC PANTONE 701 PC

PANTONE 514 PC
PANTONE 7416 PC PANTONE 7427 PC

PANTONE 265 PC
PANTONE 2375 PC PANTONE 7424 PC

PANTONE 186 PC
PANTONE 197 PC PANTONE 7425 PC

PANTONE 258 PC
PANTONE 184 PC PANTONE 1797 PC

PANTONE 7433 PC
PANTONE 232 PC PANTONE 1925 PC

PANTONE 709 PC
PANTONE 701 PC PANTONE 7417 PC

PANTONE 1795 PC
PANTONE 1635 PC PANTONE 7438 PC

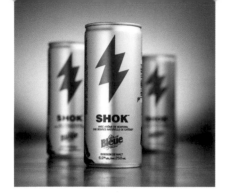

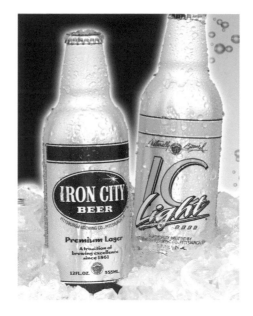

nightlife

Night must obviously be visited by after-dark shades of ubiquitous black, charcoal, deep taupes and twilight blues, topped by the radiating points of multicolored lights. These are the glamorous hours, the time for celebrating the life, energy and drama of the city. Twinkling pure white would also add an incandescent glow to this sophisticated collection of colors.

PANTONE Reflex Blue PC

PANTONE
2768 PC

PANTONE
2725 PC

PANTONE 430 PC

PANTONE
2745 PC

PANTONE
1787 PC

PANTONE 5275 PC

PANTONE
430 PC

PANTONE
2665 PC

PANTONE Cool Gray 9 PC

PANTONE
Cool Gray 11 PC

PANTONE
7406 PC

PANTONE Black 5 PC

PANTONE
7532 PC

PANTONE
2725 PC

PANTONE 5275 PC

PANTONE
5295 PC

PANTONE
2597 PC

PANTONE 669 PC

PANTONE
667 PC

PANTONE
1785 PC

PANTONE 7540 PC

PANTONE
7539 PC

PANTONE
2726 PC

PANTONE 431 PC

PANTONE
7546 PC

PANTONE
199 PC

PANTONE 433 PC

PANTONE
371 PC

PANTONE
2736 PC

PANTONE 403 PC

PANTONE
405 PC

PANTONE
383 PC

PANTONE 409 PC

PANTONE
411 PC

PANTONE
2736 PC

PANTONE 418 PC

PANTONE
416 PC

PANTONE
115 PC

PANTONE 431 PC

PANTONE
432 PC

PANTONE
2665 PC

PANTONE 2695 PC

PANTONE
2613 PC

PANTONE
2725 PC

PANTONE 647 PC

PANTONE
262 PC

PANTONE
7405 PC

PANTONE 7448 PC

PANTONE
7446 PC

PANTONE
2582 PC

PANTONE 7463 PC

PANTONE
7462 PC

PANTONE
380 PC

PANTONE 7477 PC

PANTONE
7475 PC

PANTONE
7442 PC

PANTONE 7475 PC

PANTONE
7498 PC

PANTONE
1797 PC

PANTONE 7532 PC

PANTONE
7530 PC

PANTONE
7455 PC

PANTONE 7533 PC

PANTONE
7531 PC

PANTONE
185 PC

PANTONE 7545 PC

PANTONE
7544 PC

PANTONE
2725 PC

PANTONE 648 PC

PANTONE
653 PC

PANTONE
265 PC

invigorating

To invigorate is to refresh, rejuvenate and restore—the kind of restorative that comes from a brisk, waterborne source like a clear cool blue green lake, the chilling blue of ocean depths, the jolt of a dive into an aqua lagoon or perhaps the taste of an ice filled citrusy drink. There is yet another meaning to the word invigorate—that it is health-enhancing and health-producing, best reflected by the rosy tones that are "in the pink".

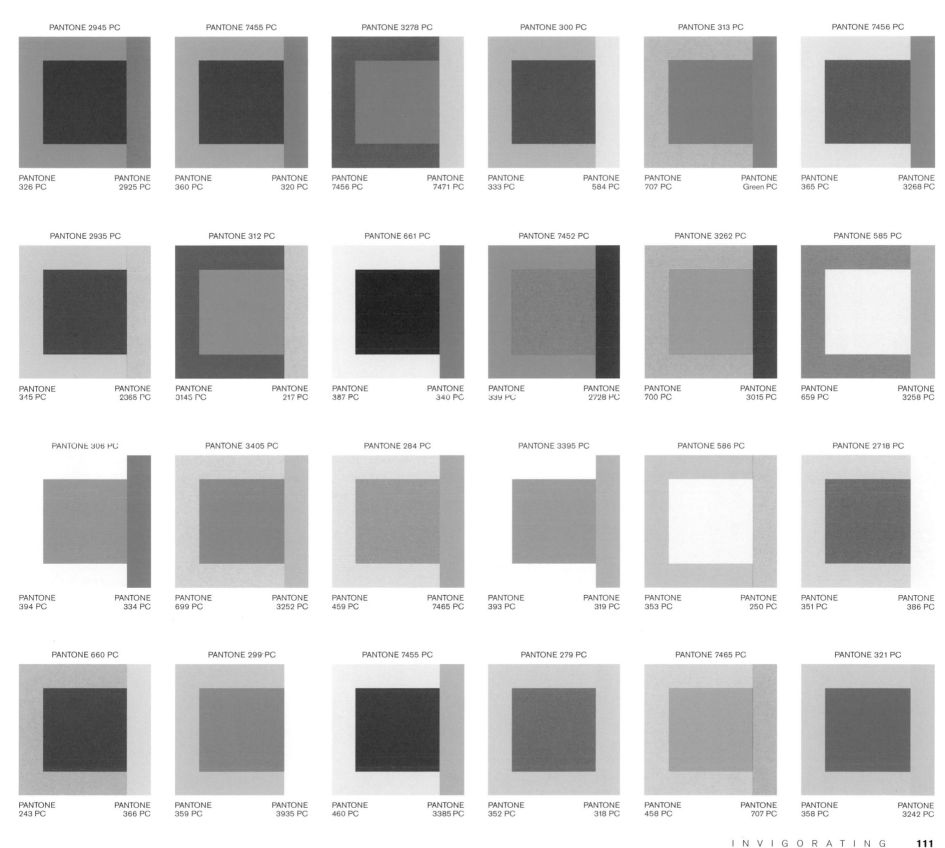

PANTONE 2945 PC

PANTONE 326 PC — PANTONE 2925 PC

PANTONE 7455 PC

PANTONE 360 PC — PANTONE 320 PC

PANTONE 3278 PC

PANTONE 7456 PC — PANTONE 7471 PC

PANTONE 300 PC

PANTONE 333 PC — PANTONE 584 PC

PANTONE 313 PC

PANTONE 707 PC — PANTONE Green PC

PANTONE 7456 PC

PANTONE 365 PC — PANTONE 3268 PC

PANTONE 2935 PC

PANTONE 345 PC — PANTONE 2365 PC

PANTONE 312 PC

PANTONE 3145 PC — PANTONE 217 PC

PANTONE 661 PC

PANTONE 387 PC — PANTONE 340 PC

PANTONE 7452 PC

PANTONE 339 PC — PANTONE 2728 PC

PANTONE 3262 PC

PANTONE 700 PC — PANTONE 3015 PC

PANTONE 585 PC

PANTONE 659 PC — PANTONE 3258 PC

PANTONE 306 PC

PANTONE 394 PC — PANTONE 334 PC

PANTONE 3405 PC

PANTONE 699 PC — PANTONE 3252 PC

PANTONE 284 PC

PANTONE 459 PC — PANTONE 7465 PC

PANTONE 3395 PC

PANTONE 393 PC — PANTONE 319 PC

PANTONE 586 PC

PANTONE 353 PC — PANTONE 250 PC

PANTONE 2718 PC

PANTONE 351 PC — PANTONE 386 PC

PANTONE 660 PC

PANTONE 243 PC — PANTONE 366 PC

PANTONE 299 PC

PANTONE 359 PC — PANTONE 3935 PC

PANTONE 7455 PC

PANTONE 460 PC — PANTONE 3385 PC

PANTONE 279 PC

PANTONE 352 PC — PANTONE 318 PC

PANTONE 7465 PC

PANTONE 458 PC — PANTONE 707 PC

PANTONE 321 PC

PANTONE 358 PC — PANTONE 3242 PC

CHIANTI IL RISTORANTE

pungent

Pungent tastes are best described as acrid, sharp, hot, peppery, snappy and very tart, often spicy. But these are tastes that are beyond spicy—with an undertone of the exotic. The colors in this palette are also descriptive of the tastes mentioned above—unusual mixes of chili pepper reds, curried yellows, olive greens, paprika and magentas, to name a few.

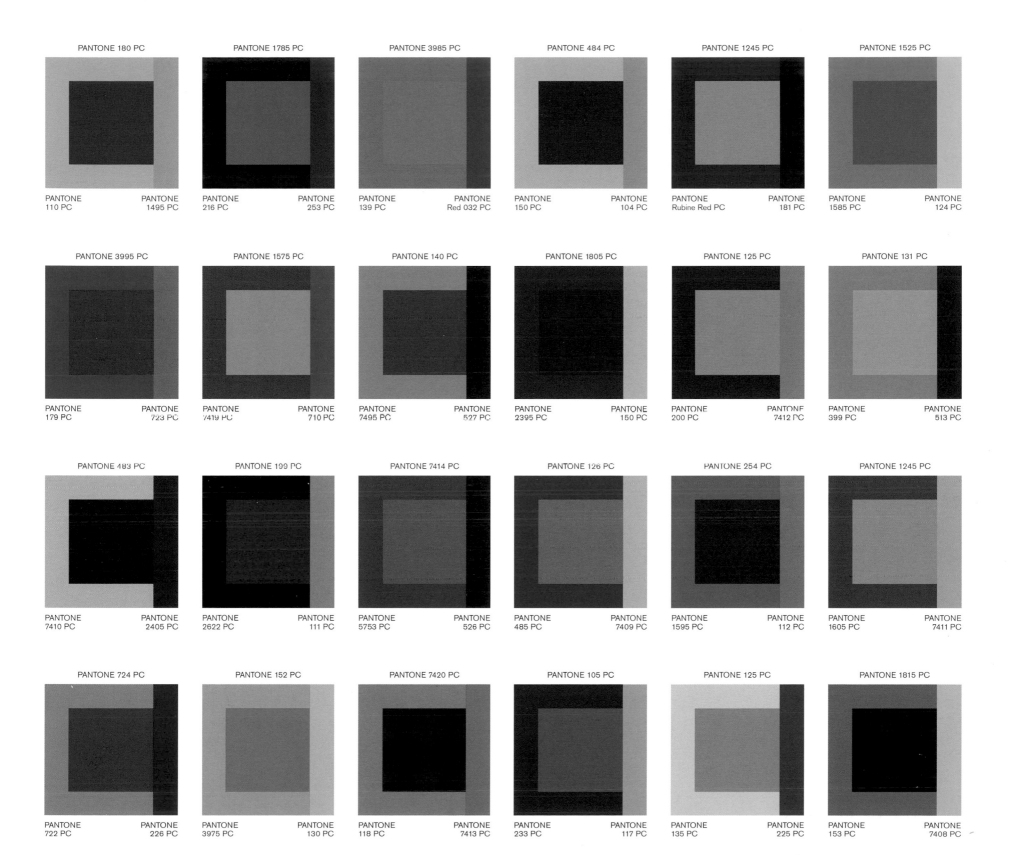

PANTONE 180 PC

PANTONE 110 PC — PANTONE 1495 PC

PANTONE 1785 PC

PANTONE 216 PC — PANTONE 253 PC

PANTONE 3985 PC

PANTONE 139 PC — PANTONE Red 032 PC

PANTONE 484 PC

PANTONE 150 PC — PANTONE 104 PC

PANTONE 1245 PC

PANTONE Rubine Red PC — PANTONE 181 PC

PANTONE 1525 PC

PANTONE 1585 PC — PANTONE 124 PC

PANTONE 3995 PC

PANTONE 179 PC — PANTONE 723 PC

PANTONE 1575 PC

PANTONE 7419 PC — PANTONE 710 PC

PANTONE 140 PC

PANTONE 7495 PC — PANTONE 527 PC

PANTONE 1805 PC

PANTONE 2395 PC — PANTONE 150 PC

PANTONE 125 PC

PANTONE 200 PC — PANTONE 7412 PC

PANTONE 131 PC

PANTONE 399 PC — PANTONE 513 PC

PANTONE 483 PC

PANTONE 7410 PC — PANTONE 2405 PC

PANTONE 199 PC

PANTONE 2622 PC — PANTONE 111 PC

PANTONE 7414 PC

PANTONE 5753 PC — PANTONE 526 PC

PANTONE 126 PC

PANTONE 485 PC — PANTONE 7409 PC

PANTONE 254 PC

PANTONE 1595 PC — PANTONE 112 PC

PANTONE 1245 PC

PANTONE 1605 PC — PANTONE 7411 PC

PANTONE 724 PC

PANTONE 722 PC — PANTONE 226 PC

PANTONE 152 PC

PANTONE 3975 PC — PANTONE 130 PC

PANTONE 7420 PC

PANTONE 118 PC — PANTONE 7413 PC

PANTONE 105 PC

PANTONE 233 PC — PANTONE 117 PC

PANTONE 125 PC

PANTONE 135 PC — PANTONE 225 PC

PANTONE 1815 PC

PANTONE 153 PC — PANTONE 7408 PC

contemplation

This is a thought-provoking, somewhat "intellectual" palette, related to the Restful palette but more robust and complicated. They are a compilation of mid to deep ethereal tones, most closely related mixes of grays, blues, purples, taupe, complex greens and shadowy mauves.

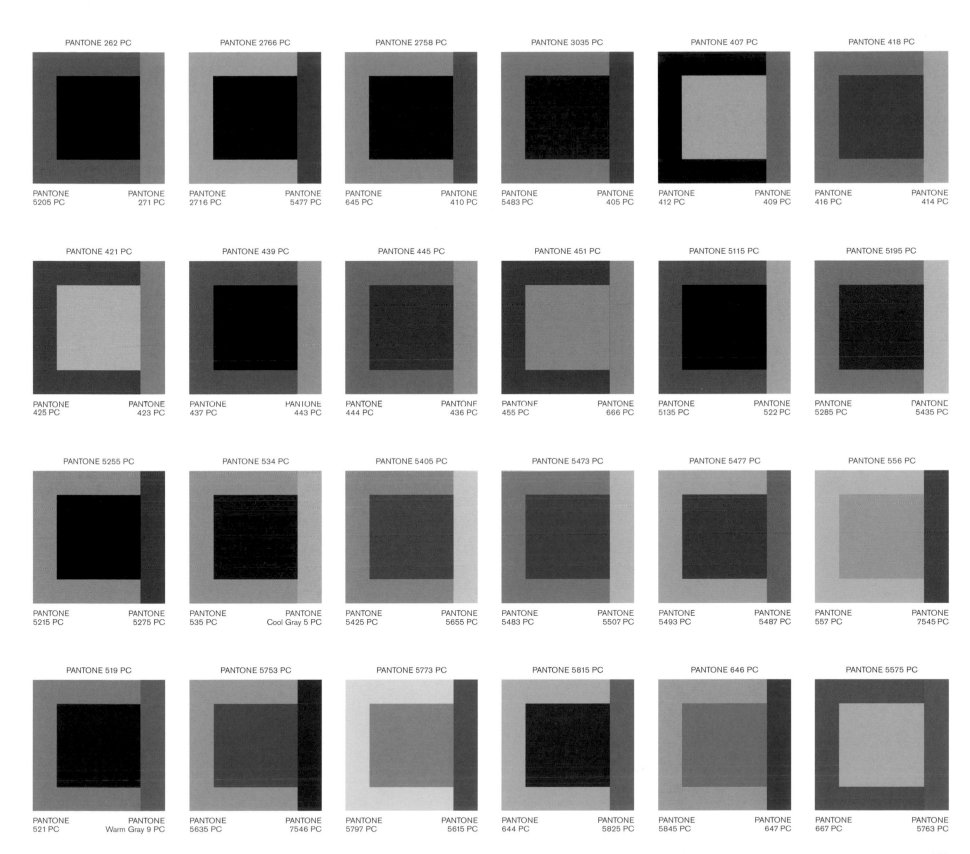

PANTONE 262 PC

PANTONE 2766 PC

PANTONE 2758 PC

PANTONE 3035 PC

PANTONE 407 PC

PANTONE 418 PC

PANTONE
5205 PC

PANTONE
271 PC

PANTONE
2716 PC

PANTONE
5477 PC

PANTONE
645 PC

PANTONE
410 PC

PANTONE
5483 PC

PANTONE
405 PC

PANTONE
412 PC

PANTONE
409 PC

PANTONE
416 PC

PANTONE
414 PC

PANTONE 421 PC

PANTONE 439 PC

PANTONE 445 PC

PANTONE 451 PC

PANTONE 5115 PC

PANTONE 5195 PC

PANTONE
425 PC

PANTONE
423 PC

PANTONE
437 PC

PANTONE
443 PC

PANTONE
444 PC

PANTONE
436 PC

PANTONE
455 PC

PANTONE
666 PC

PANTONE
5135 PC

PANTONE
522 PC

PANTONE
5285 PC

PANTONE
5435 PC

PANTONE 5255 PC

PANTONE 534 PC

PANTONE 5405 PC

PANTONE 5473 PC

PANTONE 5477 PC

PANTONE 556 PC

PANTONE
5215 PC

PANTONE
5275 PC

PANTONE
535 PC

PANTONE
Cool Gray 5 PC

PANTONE
5425 PC

PANTONE
5655 PC

PANTONE
5483 PC

PANTONE
5507 PC

PANTONE
5493 PC

PANTONE
5487 PC

PANTONE
557 PC

PANTONE
7545 PC

PANTONE 519 PC

PANTONE 5753 PC

PANTONE 5773 PC

PANTONE 5815 PC

PANTONE 646 PC

PANTONE 5575 PC

PANTONE
521 PC

PANTONE
Warm Gray 9 PC

PANTONE
5635 PC

PANTONE
7546 PC

PANTONE
5797 PC

PANTONE
5615 PC

PANTONE
644 PC

PANTONE
5825 PC

PANTONE
5845 PC

PANTONE
647 PC

PANTONE
667 PC

PANTONE
5763 PC

integrity

Just as the name implies, Integrity is a palette heavily weighted with deeper, historically significant colors. But this is tradition with a twist, in that the combinations are more contemporized, for example, mixes of cadet blue, deep taupe and olive green, claret red and chocolate browns or aubergine, sage and bluish grays.

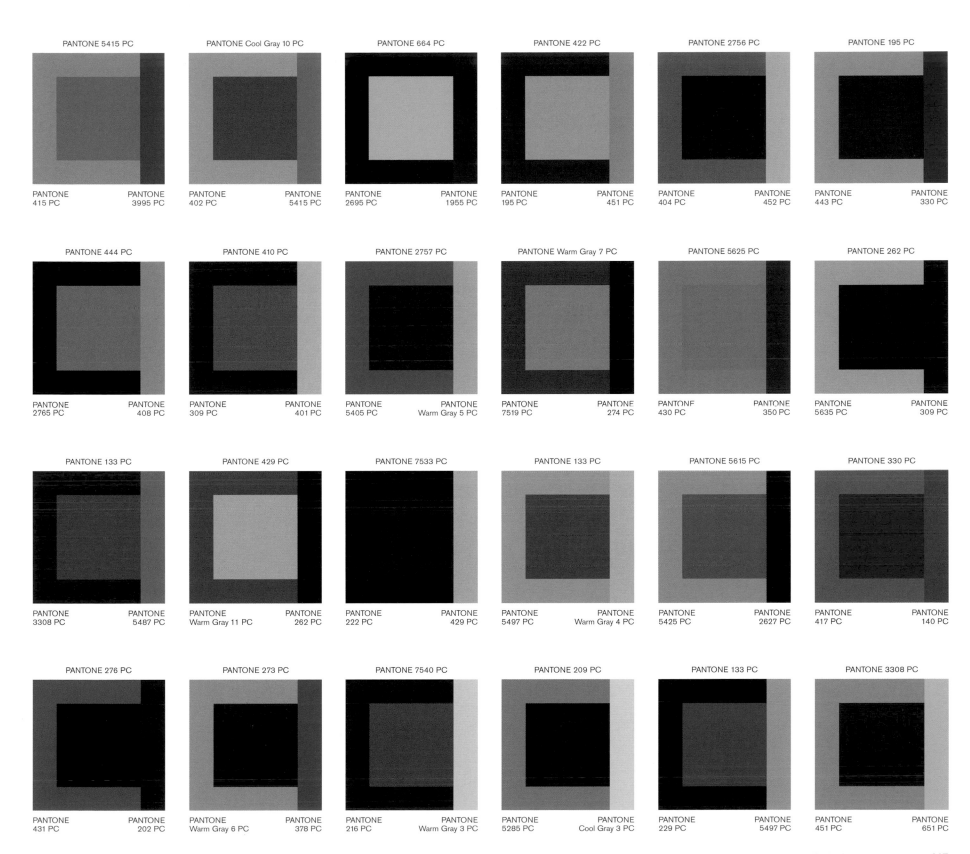

PANTONE 5415 PC
PANTONE 415 PC
PANTONE 3995 PC

PANTONE Cool Gray 10 PC
PANTONE 402 PC
PANTONE 5415 PC

PANTONE 664 PC
PANTONE 2695 PC
PANTONE 1955 PC

PANTONE 422 PC
PANTONE 195 PC
PANTONE 451 PC

PANTONE 2756 PC
PANTONE 404 PC
PANTONE 452 PC

PANTONE 195 PC
PANTONE 443 PC
PANTONE 330 PC

PANTONE 444 PC
PANTONE 2765 PC
PANTONE 408 PC

PANTONE 410 PC
PANTONE 309 PC
PANTONE 401 PC

PANTONE 2757 PC
PANTONE 5405 PC
PANTONE Warm Gray 5 PC

PANTONE Warm Gray 7 PC
PANTONE 7519 PC
PANTONE 274 PC

PANTONE 5625 PC
PANTONE 430 PC
PANTONE 350 PC

PANTONE 262 PC
PANTONE 5635 PC
PANTONE 309 PC

PANTONE 133 PC
PANTONE 3308 PC
PANTONE 5487 PC

PANTONE 429 PC
PANTONE Warm Gray 11 PC
PANTONE 262 PC

PANTONE 7533 PC
PANTONE 222 PC
PANTONE 429 PC

PANTONE 133 PC
PANTONE 5497 PC
PANTONE Warm Gray 4 PC

PANTONE 5615 PC
PANTONE 5425 PC
PANTONE 2627 PC

PANTONE 330 PC
PANTONE 417 PC
PANTONE 140 PC

PANTONE 276 PC
PANTONE 431 PC
PANTONE 202 PC

PANTONE 273 PC
PANTONE Warm Gray 6 PC
PANTONE 378 PC

PANTONE 7540 PC
PANTONE 216 PC
PANTONE Warm Gray 3 PC

PANTONE 209 PC
PANTONE 5285 PC
PANTONE Cool Gray 3 PC

PANTONE 133 PC
PANTONE 229 PC
PANTONE 5497 PC

PANTONE 3308 PC
PANTONE 451 PC
PANTONE 651 PC

unearthed

This is a different "take" on earth tones in a palette that connects to the earth, one that could even be described as organic and natural, yet at the same time, artful. The colors evoke the eroded copper browns, rustic tans, red ochres, burnt siennas, baked clays, canyon rosewoods and dusted lavenders of the earth's layers, as well as fossilized grayed mineral shades combined with vegetal greens. Just as an occasional gold veining might glimmer through the striations of minerals, metallic gold would add an unexpected touch.

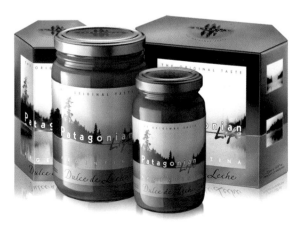

scent

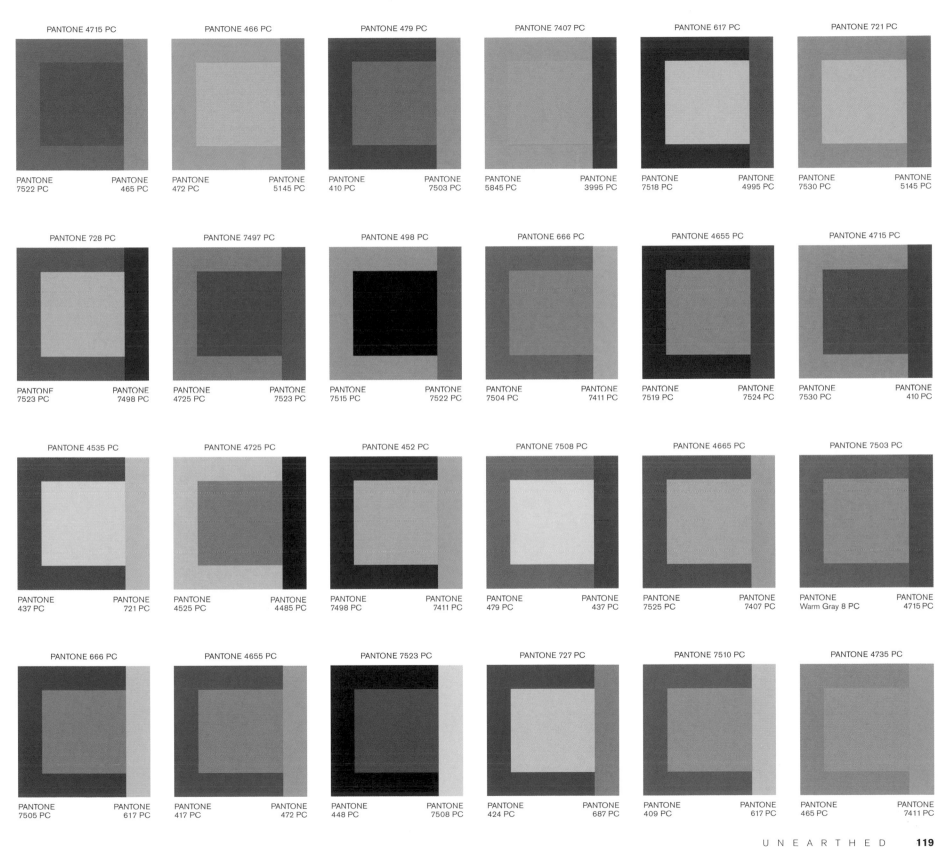

PANTONE 4715 PC
PANTONE 7522 PC
PANTONE 465 PC

PANTONE 466 PC
PANTONE 472 PC
PANTONE 5145 PC

PANTONE 479 PC
PANTONE 410 PC
PANTONE 7503 PC

PANTONE 7407 PC
PANTONE 5845 PC
PANTONE 3995 PC

PANTONE 617 PC
PANTONE 7518 PC
PANTONE 4995 PC

PANTONE 721 PC
PANTONE 7530 PC
PANTONE 5145 PC

PANTONE 728 PC
PANTONE 7523 PC
PANTONE 7498 PC

PANTONE 7497 PC
PANTONE 4725 PC
PANTONE 7523 PC

PANTONE 498 PC
PANTONE 7515 PC
PANTONE 7522 PC

PANTONE 666 PC
PANTONE 7504 PC
PANTONE 7411 PC

PANTONE 4655 PC
PANTONE 7519 PC
PANTONE 7524 PC

PANTONE 4715 PC
PANTONE 7530 PC
PANTONE 410 PC

PANTONE 4535 PC
PANTONE 437 PC
PANTONE 721 PC

PANTONE 4725 PC
PANTONE 4525 PC
PANTONE 4485 PC

PANTONE 452 PC
PANTONE 7498 PC
PANTONE 7411 PC

PANTONE 7508 PC
PANTONE 479 PC
PANTONE 437 PC

PANTONE 4665 PC
PANTONE 7525 PC
PANTONE 7407 PC

PANTONE 7503 PC
PANTONE Warm Gray 8 PC
PANTONE 4715 PC

PANTONE 666 PC
PANTONE 7505 PC
PANTONE 617 PC

PANTONE 4655 PC
PANTONE 417 PC
PANTONE 472 PC

PANTONE 7523 PC
PANTONE 448 PC
PANTONE 7508 PC

PANTONE 727 PC
PANTONE 424 PC
PANTONE 687 PC

PANTONE 7510 PC
PANTONE 409 PC
PANTONE 617 PC

PANTONE 4735 PC
PANTONE 465 PC
PANTONE 7411 PC

water

seagrass

A tropical influence is found in the vibrant turquoises, aquas, ultramarines and radiant blues reminiscent of ocean, sea, lagoon and sky. Akin to the Invigorating palette, this group is also exhilarating and refreshing, but the addition of the warmer kelp greens adds a more exotic feel while offering an intriguing contrast to the cooler blues and greens.

PANTONE 3302 PC

PANTONE 7465 PC PANTONE 298 PC

PANTONE 4505 PC

PANTONE 383 PC PANTONE 7472 PC

PANTONE 625 PC

PANTONE 301 PC PANTONE 637 PC

PANTONE 7462 PC

PANTONE 7474 PC PANTONE 616 PC

PANTONE 364 PC

PANTONE 613 PC PANTONE 637 PC

PANTONE 7490 PC

PANTONE 653 PC PANTONE 4505 PC

PANTONE 399 PC

PANTONE 554 PC PANTONE 624 PC

PANTONE 385 PC

PANTONE 2738 PC PANTONE 633 PC

PANTONE 617 PC

PANTONE 624 PC PANTONE 5815 PC

PANTONE 111 PC

PANTONE 626 PC PANTONE 660 PC

PANTONE 7491 PC

PANTONE 284 PC PANTONE 302 PC

PANTONE 5835 PC

PANTONE 653 PC PANTONE 625 PC

PANTONE 335 PC

PANTONE 659 PC PANTONE 620 PC

PANTONE 384 PC

PANTONE 3995 PC PANTONE 631 PC

PANTONE 112 PC

PANTONE 3015 PC PANTONE 555 PC

PANTONE 280 PC

PANTONE 7465 PC PANTONE 576 PC

PANTONE 341 PC

PANTONE 619 PC PANTONE 632 PC

PANTONE 618 PC

PANTONE 322 PC PANTONE 301 PC

PANTONE 3255 PC

PANTONE 7496 PC PANTONE 336 PC

PANTONE 5777 PC

PANTONE 659 PC PANTONE 653 PC

PANTONE 577 PC

PANTONE 5763 PC PANTONE 2915 PC

PANTONE 3025 PC

PANTONE 577 PC PANTONE 3288 PC

PANTONE 383 PC

PANTONE 323 PC PANTONE 2985 PC

PANTONE 616 PC

PANTONE 2748 PC PANTONE 619 PC

exotic

Just as exotic destinations should arouse the promise of the unexpected—the intrigue, adventure and mystique of far away places—exotic colors must speak to uniquely different combinations that seem to reflect a mix of multi-cultural meanings and messages. Exotic embraces vibrancy and complexity in the mix of spicy warm tones such as curried gold, Tandori reds, ginger and tawny olive greens with sensual fuchsias, red purples and ebony black. Metallic glimmers of copper, bronze and gold can add a distinct glow.

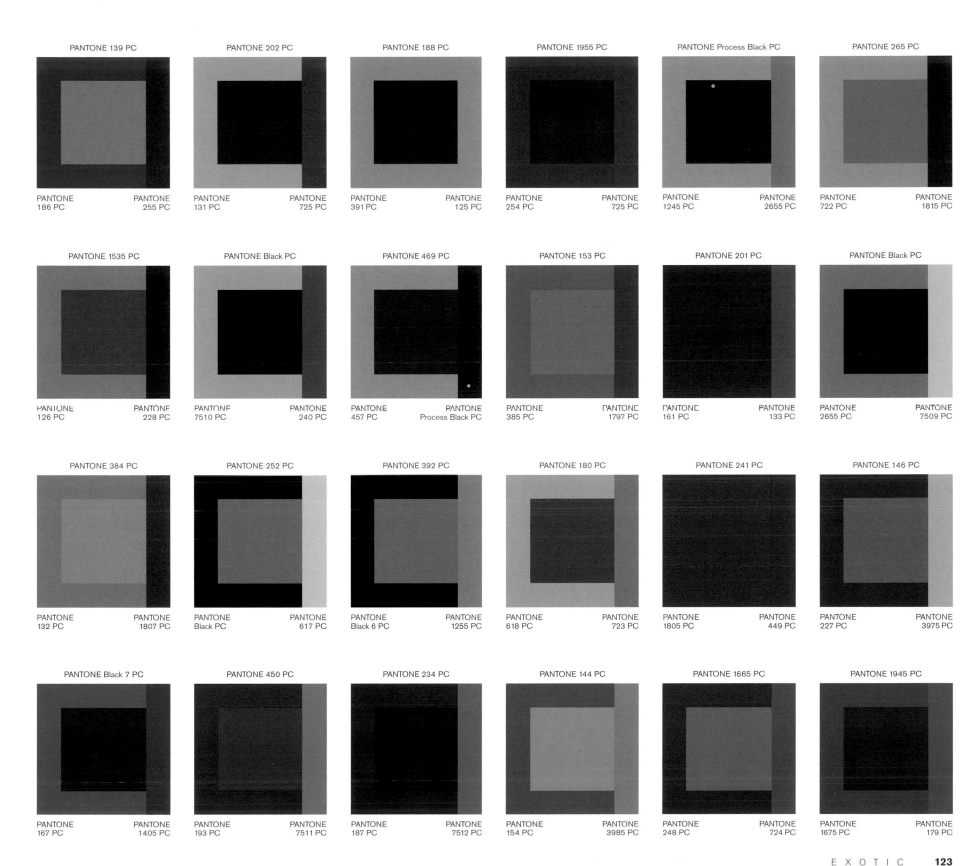

PANTONE 139 PC

PANTONE
186 PC

PANTONE
255 PC

PANTONE 202 PC

PANTONE
131 PC

PANTONE
725 PC

PANTONE 188 PC

PANTONE
391 PC

PANTONE
125 PC

PANTONE 1955 PC

PANTONE
254 PC

PANTONE
725 PC

PANTONE Process Black PC

PANTONE
1245 PC

PANTONE
2655 PC

PANTONE 265 PC

PANTONE
722 PC

PANTONE
1815 PC

PANTONE 1535 PC

PANTONE
126 PC

PANTONE
228 PC

PANTONE Black PC

PANTONE
7510 PC

PANTONE
240 PC

PANTONE 469 PC

PANTONE
457 PC

PANTONE
Process Black PC

PANTONE 153 PC

PANTONE
385 PC

PANTONE
1797 PC

PANTONE 201 PC

PANTONE
161 PC

PANTONE
133 PC

PANTONE Black PC

PANTONE
2655 PC

PANTONE
7509 PC

PANTONE 384 PC

PANTONE
132 PC

PANTONE
1807 PC

PANTONE 252 PC

PANTONE
Black PC

PANTONE
617 PC

PANTONE 392 PC

PANTONE
Black 6 PC

PANTONE
1255 PC

PANTONE 180 PC

PANTONE
618 PC

PANTONE
723 PC

PANTONE 241 PC

PANTONE
1805 PC

PANTONE
449 PC

PANTONE 146 PC

PANTONE
227 PC

PANTONE
3975 PC

PANTONE Black 7 PC

PANTONE
167 PC

PANTONE
1405 PC

PANTONE 450 PC

PANTONE
193 PC

PANTONE
7511 PC

PANTONE 234 PC

PANTONE
187 PC

PANTONE
7512 PC

PANTONE 144 PC

PANTONE
154 PC

PANTONE
3985 PC

PANTONE 1665 PC

PANTONE
248 PC

PANTONE
724 PC

PANTONE 1945 PC

PANTONE
1675 PC

PANTONE
179 PC

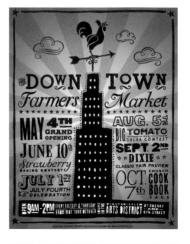

unique 1

Nothing says "unique" better than intriguingly unusual color combinations. As seen in the amazing combinations of anime and manga illustrations, here there are no absolutes as far as rules are concerned. Some mixes are fun while others are outrageous or simply surprising. The juxtaposition of the colors are unexpected and bound to attract attention…that's the whole idea!

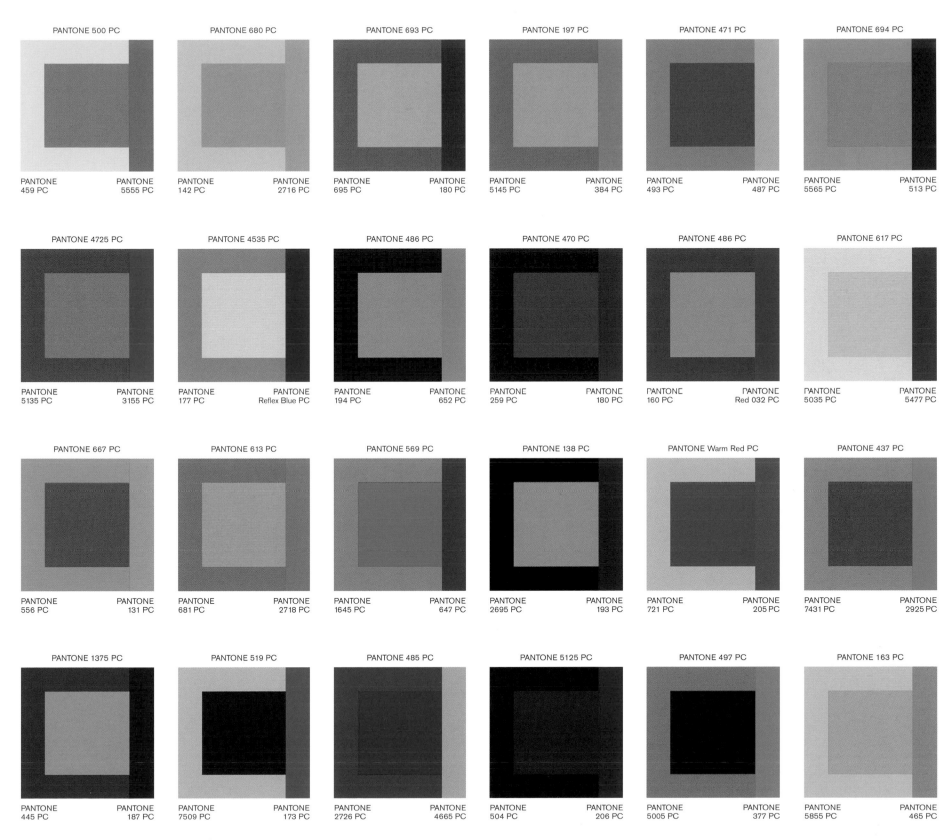

PANTONE 500 PC

PANTONE 459 PC PANTONE 5555 PC

PANTONE 680 PC

PANTONE 142 PC PANTONE 2716 PC

PANTONE 693 PC

PANTONE 695 PC PANTONE 180 PC

PANTONE 197 PC

PANTONE 5145 PC PANTONE 384 PC

PANTONE 471 PC

PANTONE 493 PC PANTONE 487 PC

PANTONE 694 PC

PANTONE 5565 PC PANTONE 513 PC

PANTONE 4725 PC

PANTONE 5135 PC PANTONE 3155 PC

PANTONE 4535 PC

PANTONE 177 PC PANTONE Reflex Blue PC

PANTONE 486 PC

PANTONE 194 PC PANTONE 652 PC

PANTONE 470 PC

PANTONE 259 PC PANTONE 180 PC

PANTONE 486 PC

PANTONE 160 PC PANTONE Red 032 PC

PANTONE 617 PC

PANTONE 5035 PC PANTONE 5477 PC

PANTONE 667 PC

PANTONE 556 PC PANTONE 131 PC

PANTONE 613 PC

PANTONE 681 PC PANTONE 2718 PC

PANTONE 569 PC

PANTONE 1645 PC PANTONE 647 PC

PANTONE 138 PC

PANTONE 2695 PC PANTONE 193 PC

PANTONE Warm Red PC

PANTONE 721 PC PANTONE 205 PC

PANTONE 437 PC

PANTONE 7431 PC PANTONE 2925 PC

PANTONE 1375 PC

PANTONE 445 PC PANTONE 187 PC

PANTONE 519 PC

PANTONE 7509 PC PANTONE 173 PC

PANTONE 485 PC

PANTONE 2726 PC PANTONE 4665 PC

PANTONE 5125 PC

PANTONE 504 PC PANTONE 206 PC

PANTONE 497 PC

PANTONE 5005 PC PANTONE 377 PC

PANTONE 163 PC

PANTONE 5855 PC PANTONE 465 PC

unique 2

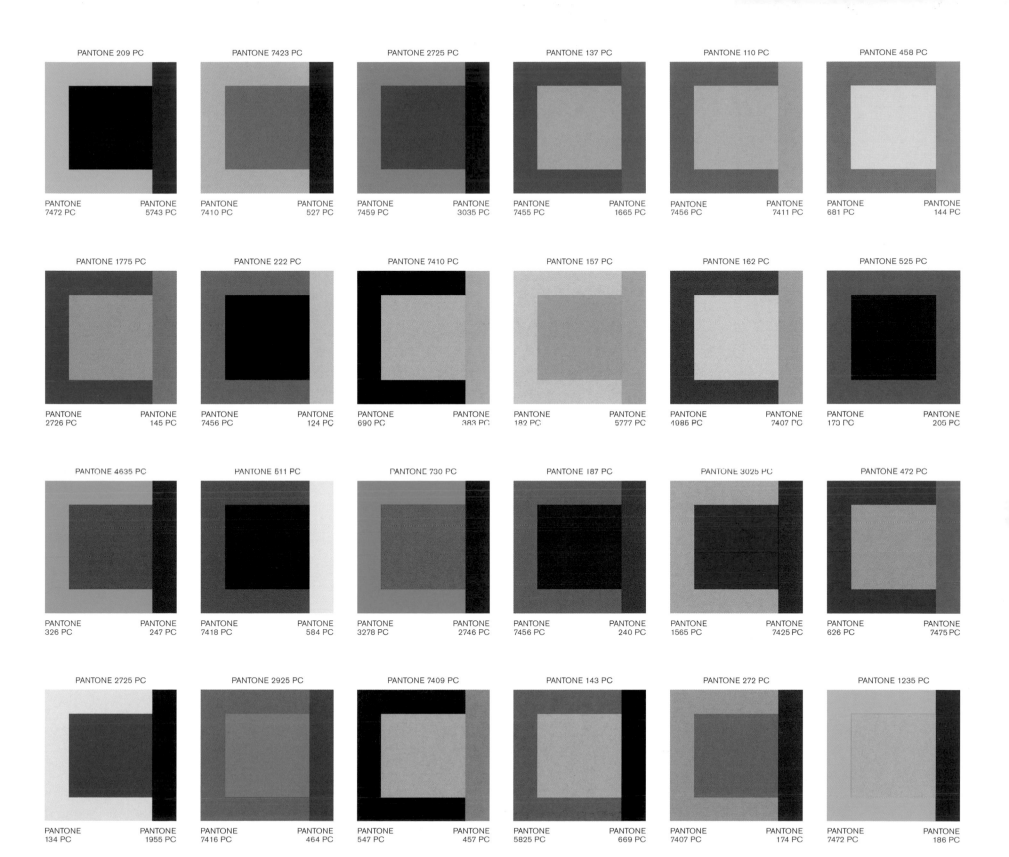

PANTONE 209 PC

PANTONE 7472 PC PANTONE 5743 PC

PANTONE 7423 PC

PANTONE 7410 PC PANTONE 527 PC

PANTONE 2725 PC

PANTONE 7459 PC PANTONE 3035 PC

PANTONE 137 PC

PANTONE 7455 PC PANTONE 1665 PC

PANTONE 110 PC

PANTONE 7456 PC PANTONE 7411 PC

PANTONE 458 PC

PANTONE 681 PC PANTONE 144 PC

PANTONE 1775 PC

PANTONE 2726 PC PANTONE 145 PC

PANTONE 222 PC

PANTONE 7456 PC PANTONE 124 PC

PANTONE 7410 PC

PANTONE 690 PC PANTONE 383 PC

PANTONE 157 PC

PANTONE 182 PC PANTONE 5777 PC

PANTONE 162 PC

PANTONE 4085 PC PANTONE 7407 PC

PANTONE 525 PC

PANTONE 173 PC PANTONE 205 PC

PANTONE 4635 PC

PANTONE 326 PC PANTONE 247 PC

PANTONE 511 PC

PANTONE 7418 PC PANTONE 584 PC

PANTONE 730 PC

PANTONE 3278 PC PANTONE 2746 PC

PANTONE 187 PC

PANTONE 7456 PC PANTONE 240 PC

PANTONE 3025 PC

PANTONE 1565 PC PANTONE 7425 PC

PANTONE 472 PC

PANTONE 626 PC PANTONE 7475 PC

PANTONE 2725 PC

PANTONE 134 PC PANTONE 1955 PC

PANTONE 2925 PC

PANTONE 7416 PC PANTONE 464 PC

PANTONE 7409 PC

PANTONE 547 PC PANTONE 457 PC

PANTONE 143 PC

PANTONE 5825 PC PANTONE 669 PC

PANTONE 272 PC

PANTONE 7407 PC PANTONE 174 PC

PANTONE 1235 PC

PANTONE 7472 PC PANTONE 186 PC

unique 3

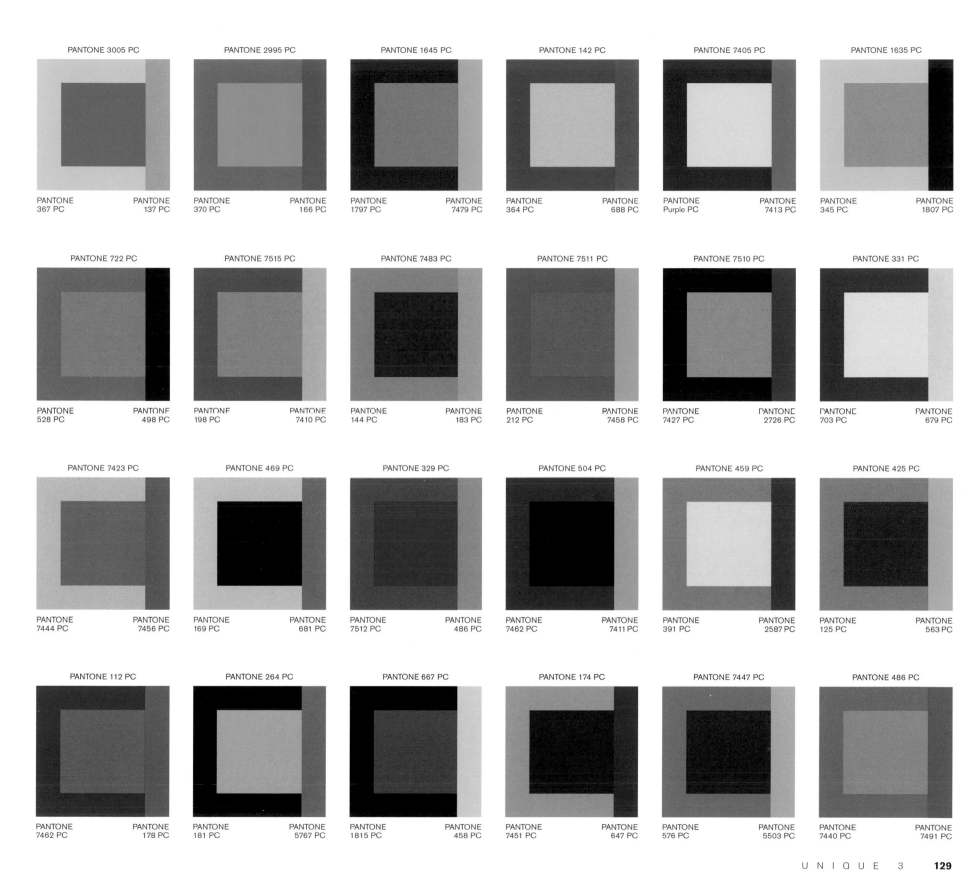

PANTONE 3005 PC
PANTONE 367 PC
PANTONE 137 PC

PANTONE 2995 PC
PANTONE 370 PC
PANTONE 166 PC

PANTONE 1645 PC
PANTONE 1797 PC
PANTONE 7479 PC

PANTONE 142 PC
PANTONE 364 PC
PANTONE 688 PC

PANTONE 7405 PC
PANTONE Purple PC
PANTONE 7413 PC

PANTONE 1635 PC
PANTONE 345 PC
PANTONE 1807 PC

PANTONE 722 PC
PANTONE 528 PC
PANTONE 498 PC

PANTONE 7515 PC
PANTONE 198 PC
PANTONE 7410 PC

PANTONE 7483 PC
PANTONE 144 PC
PANTONE 183 PC

PANTONE 7511 PC
PANTONE 212 PC
PANTONE 7458 PC

PANTONE 7510 PC
PANTONE 7427 PC
PANTONE 2726 PC

PANTONE 331 PC
PANTONE 703 PC
PANTONE 679 PC

PANTONE 7423 PC
PANTONE 7444 PC
PANTONE 7456 PC

PANTONE 469 PC
PANTONE 169 PC
PANTONE 681 PC

PANTONE 329 PC
PANTONE 7512 PC
PANTONE 486 PC

PANTONE 504 PC
PANTONE 7462 PC
PANTONE 7411 PC

PANTONE 459 PC
PANTONE 391 PC
PANTONE 2587 PC

PANTONE 425 PC
PANTONE 125 PC
PANTONE 563 PC

PANTONE 112 PC
PANTONE 7462 PC
PANTONE 178 PC

PANTONE 264 PC
PANTONE 181 PC
PANTONE 5767 PC

PANTONE 667 PC
PANTONE 1815 PC
PANTONE 458 PC

PANTONE 174 PC
PANTONE 7451 PC
PANTONE 647 PC

PANTONE 7447 PC
PANTONE 576 PC
PANTONE 5503 PC

PANTONE 486 PC
PANTONE 7440 PC
PANTONE 7491 PC

trends The Future is Not What it Used to Be

Guidelines for Spotting Trends

Spotting future trends is much like detective work. It's not the one big "AHA" that hits you but rather a string of clues that leads to the ultimate realization. It's very important to view the big picture first—the macro level that precedes the micro.

Look for the symbolic colors that represent a trend. For example, the 90s led to a growing emergence of environmentalism as a social issue. Environmentalism and the preservation of nature always are tied to the color green (think Greenpeace). In the early 2000s, there was a surge of interest in healthy eating, fresh food and all things organic. Nothing depicts freshness better than green with its inevitable connection to healthy vegetables or the first tender shoots of spring, or the revitalizing influence of a walk in the woods surrounded by nature's prolific greens.

The Park

In addition, sustainability has become one of the most meaningful buzzwords that continue to gain momentum. There are "green communities" sprouting up where people are utilizing sustainable, replenishable resources. In the world of industry, it is really good to be green.

Obviously, this has prolonged the life of green as a very important, socially correct color family for years to come. A cause or concern may move well beyond a trend, becoming a social issue, but it might have started its life as a trend.

At the end of the 90s, as the millennium grew near, there was almost a mystic reverence for the coming of the 2000s—a new century with great technological advances and promises. At the same time, some prognosticators direly predicted "Millennium Bugs", ranging from giant meltdowns of computer programs to the destruction of civilization. So there were for many people, great expectations, while for others, a huge fear factor.

Technological advances are both thrilling and scary. As a result, many people sought a "safe haven"—a reassurance that all would be peaceful and well. So it was very much a search for serenity, constancy, a literal "keeping your cool" in the face of the unknown.

The symbolic hue that embodies all of these needs (if you haven't already guessed!) is blue. Long associated with the soothing effects of sky and sea, blue was the perfect antidote to stress and was dubbed "the color of the new millennium". Consequently, every design area, including graphics, fashion, home furnishings, industrial design and consumer products all embraced the blue hues.

Obviously, not all color trends come from such lofty levels. Brown was raised from its humble beginnings to a very fashionable color largely because of the "Starbuck's phenomena" brought about by a company that created a social milieu in designing very attractive shops (largely in sophisticated earthtones) where people could gather, meet their friends, bring their computers and enjoy, not a simple cup of coffee, but an elegant espresso or a luscious latte.

The fashion industry can certainly bring new color influences as much of that business is based on color and styling trends. The challenge in observing fashion trends is tracking the longevity of a fad before it becomes a trend. If a color shows a strong presence in any given season, then a red flag is raised that says "pay attention". If that color continues to present itself in the following season, then we know that the trip down the runway will march into other design areas.

Fashion magazines are full of current color trends, but that doesn't always indicate what will be hot for future. It is the fashion collections, such as the European or New York Designer Shows that take place twice a year that are most

revealing as they include many different collections. For the short term, fashion magazines are a help, as are websites that show photos hot off the runway. A consensus can then be formed as to the outstanding colors for the following season. And if you really need to have a "leg up" on fashion colors, there are color forecasts and major trade shows that predict eighteen months to two years ahead.

Again, fashion is most often the forerunner to color trends, but one season of a "hot" color doesn't do it. One or two seasons of a hot color is still a fad. But tracking a "new" color for several seasons will tell you if it translates from fad to trend. Read the magazines or visit the websites that talk about trends. If a trend is growing, you will see it in more than one resource.

Don't make the assumption that all new color trends come from fashion. The best examples of a trend that was spawned from the industrial/graphic design arena were the ads and commercials for the Apple iPod. Those dancing silhouettes were originally black against very colorful backgrounds. They popped up everywhere—faceless people with no distinguishing features as the entire design world re-discovered silhouettes, adapting them to their specific needs. There were several alterations to the theme and many of the black figures morphed into other colors, but the basic concept started in an area that only recently has been recognized as a source of the hot trends—industrial and graphic design.

No one can or should work in a vacuum. Discuss what you are seeing and reading about that you feel might be a harbinger of the future. Discuss it with other people who you feel are good prognosticators, especially those who are well read and observant. They are the "first adapters". Network with them. Belonging to groups such as professional organizations gives you ready resources to "tap into".

Being too myopic can cause you to miss trends, thinking short-term rather than long-term. In addition, it's important to look outside your own industry. Look especially to pop culture and the entertainment world, as it is so highly visible and accessible that it causes the trends to spread quickly. But don't look to the films that are in the theatres now or to the videos and DVD's that are coming out shortly after. It's the trade magazines such as *Variety* that tell you what is in production—its location, story line, time period, leading players and director that suggest the color and design story might be influential.

New films and videos are especially important in children's markets, as kids identify strongly with film heroes or favorite characters. If a new character comes on the scene and it's orange (remember Nemo?) or chartreuse (think Shrek), the kids will want to buy anything related to the character in the character's colors. The film becomes a video and then possibly a sequel and/or a Saturday morning cartoon character and the "shelf life" of the character and its prime color is prolonged.

Once a trend happens, it can sustain a lifespan of three to five years, sometimes even longer if it really becomes very popular. The character will appear on bedspreads, towels and curtains, in toys and many other consumer products such as candy, lunchboxes and backpacks.

Look to sports events, especially those of vast international significance such as the Olympics (as you will know years in advance where the next Olympic games will be held), and that specific geographic location can render

much significance as to what the trendy colors will be. Research the hot travel destinations (through the internet or large travel agencies) as they can also help to determine trends.

Shifting or growing ethnic patterns can bring an awareness of different color mixes and preferences. Think of the feng shui movement in interior design and how this helped to spread the word about traditional Asian design and color. Typical Latina and Latino colors have enriched our world through music, food and art and will continue to do so as the population enters the "mainstream".

Certainly, the world of art has always influenced color trends, especially art that is traveling to various locations, as it helps to spread the word more quickly. At one time, art as an influence was seen as rather elitist as only the wealthy could afford works of art and only the intelligentsia (or so it was believed) frequented museums. Today we see people lining up in Las Vegas to view Monet, Manet or Jackson Pollack; or milling through the Bellagio lobby to ogle Chihuly's undulating colors and amorphous shapes. Fine art has become more affordable through convincing reproductions and the burgeoning field of arts and crafts renders very original and unique pieces in a multitude of fabrications and colors.

Look to architecture, industrial design and one of the most important areas, technology. The auto industry, high-end fashion jewelry and the cosmetic industry will give you great insight to anticipated finishes or surfaces. Even if you are not a technology geek, magazines such as *Wired* can give you insight into how new technologies could impact trends.

HOLLYWOOD
AMERICAN LIFE
WARNER BROS.
Stylist ARIANNE PHILLIPS
▶ See Video

StyleBiters

MADONNA

Cyclical patterns are important in predicting color trends. What has been around before will come around again. If it is true "retro" it will come back in the same sort of combinations shown before, as in the 60s combo of shocking pink and orange, the 70s avocado and harvest gold, the 80s mauve and gray, and the vibrant citrus tones that hit the mid 90s (although it's too soon to label that decade "retro"). Color cycles will repeat, but the way to keep it looking fresh and "au courant" is by combining colors in new ways or adding colors to a classic mix that will make it seem new or unique.

Of course, there are those totally unexpected, sometimes cataclysmic events that are entirely unpredictable. The national trauma caused by the loss of lives in the World Trade Center collapse brought a return to the use of typical traditional colors, especially the red, white and blue

of the American flag. This was beyond a trend—an almost instinctive need to embrace revered symbols and colors in a time of national tragedy.

Photos become the actual proof of what you are seeing and it does help you to remember what you spot that might be a trend. Become an inveterate observer and photographer. A digital camera should be your constant companion. Keep notes in an easily available notebook or PDA for those times when observations should be noted or inspiration hits you.

Collect data from reliable sources, such as the marketing people within your own organization (or those that you know if you work alone). Trade publications often quote statistics on consumer behavior—become a collector of that kind of information. And it doesn't have to be complicated. Publications such as the *Kiplinger Report* give meaningful, easily understood trend info from a broader perspective.

And, in the end, it might be all of the above, a bit of the above or possibly none of the above, but just a "hunch", an instinctive "I-just-feel-this-is-going to-happen" kind of feeling. Maybe you are one of those people who seem to get it just by "osmosis". I am more inclined to believe that creative people are predisposed to being inveterate observers. It probably started when you were a child and will continue all of your life. It's a blessing and a curse as you are super sensitive to your surroundings (both real and imagined). But it will, I promise you, keep your "creative juices" flowing!

color conversion

PANTONE Color	CMYK, US				PANTONE Color	CMYK, US				PANTONE Color	CMYK, US				PANTONE Color	CMYK, US			
	Run Sequence					*Run Sequence*					*Run Sequence*					*Run Sequence*			
PANTONE 101 PC	C-0	M-0	Y-70	K-0	PANTONE 150 PC	C-0	M-35	Y-70	K-0	PANTONE 181 PC	C-14	M-94	Y-88	K-51	PANTONE 211 PC	C-0	M-61	Y-6	K-0
PANTONE 102 PC	C-0	M-0	Y-95	K-0	PANTONE 151 PC	C-0	M-55	Y-100	K-0	PANTONE 1775 PC	C-0	M-50	Y-21	K-0	PANTONE 212 PC	C-0	M-78	Y-8	K-0
PANTONE 103 PC	C-5	M-10	Y-100	K-15	PANTONE 152 PC	C-0	M-62	Y-100	K-0	PANTONE 1785 PC	C-0	M-79	Y-50	K-0	PANTONE 213 PC	C-0	M-92	Y-18	K-0
PANTONE 104 PC	C-7	M-13	Y-100	K-28	PANTONE 153 PC	C-3	M-61	Y-100	K-16	PANTONE 1788 PC	C-0	M-88	Y-80	K-0	PANTONE 214 PC	C-0	M-100	Y-24	K-4
PANTONE 105 PC	C-14	M-20	Y-88	K-50	PANTONE 154 PC	C-7	M-64	Y-100	K-36	PANTONE 1795 PC	C-0	M-96	Y-90	K-2	PANTONE 215 PC	C-5	M-100	Y-26	K-24
PANTONE 109 PC	C-0	M-10	Y-100	K-0	PANTONE 1495 PC	C-0	M-45	Y-69	K-0	PANTONE 1805 PC	C-5	M-96	Y-76	K-21	PANTONE 216 PC	C-12	M-96	Y-26	K-50
PANTONE 110 PC	C-2	M-24	Y-100	K-7	PANTONE 1505 PC	C-0	M-52	Y-80	K-0	PANTONE 1815 PC	C-13	M-96	Y-81	K-54	PANTONE 217 PC	C-1	M-31	Y-0	K-0
PANTONE 111 PC	C-7	M-18	Y-100	K-29	PANTONE Orange 021 PC	C-0	M-68	Y-100	K-0	PANTONE 1777 PC	C-0	M-68	Y-28	K-0	PANTONE 218 PC	C-2	M-62	Y-0	K-0
PANTONE 112 PC	C-10	M-20	Y-100	K-38	PANTONE 1525 PC	C-1	M-75	Y-100	K-8	PANTONE 1787 PC	C-0	M-82	Y-53	K-0	PANTONE 219 PC	C-1	M-92	Y-1	K-0
PANTONE 114 PC	C-0	M-5	Y-77	K-0	PANTONE 1535 PC	C-8	M-75	Y-100	K-40	PANTONE Red 032 PC	C-0	M-90	Y-60	K-0	PANTONE Rubine Red PC	C-0	M-100	Y-18	K-3
PANTONE 115 PC	C-0	M-7	Y-80	K-0	PANTONE 155 PC	C-0	M-12	Y-32	K-0	PANTONE 1797 PC	C-2	M-98	Y-85	K-7	PANTONE 220 PC	C-5	M-100	Y-22	K-23
PANTONE 116 PC	C-0	M-12	Y-100	K-0	PANTONE 157 PC	C-0	M-44	Y-71	K-0	PANTONE 1807 PC	C-7	M-94	Y-65	K-31	PANTONE 221 PC	C-8	M-100	Y-24	K-35
PANTONE 117 PC	C-2	M-22	Y-100	K-15	PANTONE 158 PC	C-0	M-64	Y-95	K-0	PANTONE 1817 PC	C-23	M-84	Y-54	K-68	PANTONE 222 PC	C-17	M-100	Y-21	K-60
PANTONE 118 PC	C-5	M-26	Y-100	K-27	PANTONE 160 PC	C-6	M-71	Y-100	K-32	PANTONE 182 PC	C-0	M-30	Y-8	K-0	PANTONE 223 PC	C-1	M-50	Y-0	K-0
PANTONE 119 PC	C-15	M-21	Y-100	K-46	PANTONE 161 PC	C-16	M-67	Y-100	K-70	PANTONE 183 PC	C-0	M-47	Y-15	K-0	PANTONE 224 PC	C-4	M-71	Y-0	K-0
PANTONE 124 PC	C-0	M-27	Y-100	K-0	PANTONE 1565 PC	C-0	M-39	Y-50	K-0	PANTONE 184 PC	C-0	M-76	Y-32	K-0	PANTONE 225 PC	C-5	M-90	Y-0	K-0
PANTONE 125 PC	C-8	M-31	Y-100	K-19	PANTONE 1575 PC	C-0	M-50	Y-77	K-0	PANTONE 185 PC	C-0	M-92	Y-76	K-0	PANTONE 226 PC	C-0	M-100	Y-2	K-0
PANTONE 126 PC	C-10	M-30	Y-100	K-34	PANTONE 1585 PC	C-0	M-62	Y-97	K-0	PANTONE 186 PC	C-0	M-100	Y-75	K-4	PANTONE 227 PC	C-6	M-100	Y-7	K-20
PANTONE 1215 PC	C-0	M-8	Y-48	K-0	PANTONE 1595 PC	C-0	M-72	Y-100	K-3	PANTONE 187 PC	C-5	M-100	Y-71	K-22	PANTONE 228 PC	C-15	M-100	Y-11	K-41
PANTONE 1235 PC	C-0	M-30	Y-95	K-0	PANTONE 1605 PC	C-7	M-72	Y-100	K-32	PANTONE 188 PC	C-12	M-95	Y-59	K-54	PANTONE 229 PC	C-24	M-100	Y-17	K-60
PANTONE 1245 PC	C-7	M-35	Y-100	K-13	PANTONE 1615 PC	C-11	M-74	Y-100	K-50	PANTONE 190 PC	C-0	M-58	Y-16	K-0	PANTONE 230 PC	C-1	M-40	Y-0	K-0
PANTONE 1255 PC	C-8	M-30	Y-95	K-30	PANTONE 162 PC	C-0	M-24	Y-31	K-0	PANTONE 191 PC	C-0	M-80	Y-35	K-0	PANTONE 231 PC	C-3	M-58	Y-0	K-0
PANTONE 1265 PC	C-15	M-34	Y-98	K-45	PANTONE 163 PC	C-0	M-40	Y-44	K-0	PANTONE 192 PC	C-0	M-97	Y-60	K-0	PANTONE 232 PC	C-6	M-69	Y-0	K-0
PANTONE 127 PC	C-0	M-5	Y-57	K-0	PANTONE 164 PC	C-0	M-55	Y-75	K-0	PANTONE 193 PC	C-2	M-100	Y-60	K-11	PANTONE Rhodamine Red PC	C-9	M-87	Y-0	K-0
PANTONE 129 PC	C-0	M-11	Y-70	K-0	PANTONE 165 PC	C-0	M-68	Y-98	K-0	PANTONE 194 PC	C-7	M-100	Y-54	K-35	PANTONE 233 PC	C-12	M-100	Y-0	K-0
PANTONE 130 PC	C-0	M-30	Y-100	K-0	PANTONE 166 PC	C-0	M-74	Y-100	K-0	PANTONE 195 PC	C-14	M-88	Y-42	K-56	PANTONE 234 PC	C-18	M-100	Y-4	K-17
PANTONE 131 PC	C-3	M-36	Y-100	K-6	PANTONE 167 PC	C-3	M-78	Y-100	K-15	PANTONE 1895 PC	C-0	M-28	Y-2	K-0	PANTONE 235 PC	C-19	M-100	Y-9	K-40
PANTONE 132 PC	C-8	M-36	Y-100	K-31	PANTONE 168 PC	C-13	M-80	Y-100	K-60	PANTONE 1905 PC	C-0	M-46	Y-6	K-0	PANTONE 237 PC	C-6	M-51	Y-0	K-0
PANTONE 133 PC	C-16	M-32	Y-100	K-61	PANTONE 1625 PC	C-0	M-40	Y-39	K-0	PANTONE 1915 PC	C-0	M-77	Y-21	K-0	PANTONE 238 PC	C-14	M-74	Y-0	K-0
PANTONE 134 PC	C-0	M-11	Y-56	K-0	PANTONE 1635 PC	C-0	M-47	Y-50	K-0	PANTONE 1925 PC	C-0	M-98	Y-46	K-0	PANTONE 239 PC	C-18	M-80	Y-0	K-0
PANTONE 135 PC	C-0	M-21	Y-74	K-0	PANTONE 1645 PC	C-0	M-56	Y-62	K-0	PANTONE 1935 PC	C-1	M-100	Y-51	K-6	PANTONE 240 PC	C-21	M-90	Y-0	K-0
PANTONE 137 PC	C-0	M-38	Y-95	K-0	PANTONE 1655 PC	C-0	M-68	Y-90	K-0	PANTONE 1945 PC	C-5	M-100	Y-50	K-24	PANTONE 241 PC	C-33	M-100	Y-1	K-2
PANTONE 138 PC	C-0	M-50	Y-100	K-0	PANTONE 1665 PC	C-0	M-76	Y-100	K-0	PANTONE 1955 PC	C-8	M-100	Y-47	K-39	PANTONE 242 PC	C-31	M-100	Y-9	K-44
PANTONE 139 PC	C-5	M-46	Y-100	K-21	PANTONE 1675 PC	C-5	M-82	Y-100	K-26	PANTONE 196 PC	C-0	M-23	Y-5	K-0	PANTONE 2365 PC	C-3	M-29	Y-0	K-0
PANTONE 140 PC	C-13	M-42	Y-100	K-56	PANTONE 1685 PC	C-11	M-82	Y-100	K-48	PANTONE 197 PC	C-0	M-45	Y-12	K-0	PANTONE 2375 PC	C-16	M-61	Y-0	K-0
PANTONE 1355 PC	C-0	M-22	Y-58	K-0	PANTONE 169 PC	C-0	M-30	Y-22	K-0	PANTONE 198 PC	C-0	M-82	Y-37	K-0	PANTONE 2385 PC	C-26	M-84	Y-0	K-0
PANTONE 1375 PC	C-0	M-45	Y-95	K-0	PANTONE 170 PC	C-0	M-50	Y-45	K-0	PANTONE 199 PC	C-0	M-100	Y-65	K-0	PANTONE 2395 PC	C-29	M-95	Y-0	K-0
PANTONE 1385 PC	C-0	M-56	Y-100	K-7	PANTONE 171 PC	C-0	M-61	Y-70	K-0	PANTONE 200 PC	C-3	M-100	Y-66	K-12	PANTONE 2405 PC	C-38	M-100	Y-0	K-0
PANTONE 1395 PC	C-10	M-51	Y-100	K-36	PANTONE 172 PC	C-0	M-72	Y-90	K-0	PANTONE 201 PC	C-7	M-100	Y-65	K-32	PANTONE 2415 PC	C-39	M-100	Y-0	K-7
PANTONE 1405 PC	C-14	M-49	Y-100	K-66	PANTONE 173 PC	C-0	M-80	Y-94	K-1	PANTONE 202 PC	C-10	M-97	Y-61	K-48	PANTONE 2425 PC	C-40	M-100	Y-6	K-27
PANTONE 141 PC	C-0	M-17	Y-62	K-0	PANTONE 174 PC	C-8	M-85	Y-100	K-34	PANTONE 203 PC	C-0	M-36	Y-2	K-0	PANTONE 243 PC	C-5	M-30	Y-0	K-0
PANTONE 142 PC	C-0	M-25	Y-76	K-0	PANTONE 175 PC	C-18	M-79	Y-71	K-56	PANTONE 204 PC	C-0	M-59	Y-5	K-0	PANTONE 244 PC	C-11	M-43	Y-0	K-0
PANTONE 143 PC	C-0	M-32	Y-86	K-0	PANTONE 176 PC	C-0	M-34	Y-18	K-0	PANTONE 205 PC	C-0	M-83	Y-17	K-0	PANTONE 245 PC	C-19	M-56	Y-0	K-0
PANTONE 144 PC	C-0	M-52	Y-100	K-0	PANTONE 177 PC	C-0	M-58	Y-38	K-0	PANTONE 206 PC	C-0	M-100	Y-48	K-0	PANTONE 246 PC	C-34	M-90	Y-0	K-0
PANTONE 145 PC	C-0	M-58	Y-100	K-8	PANTONE 178 PC	C-0	M-74	Y-57	K-0	PANTONE 207 PC	C-5	M-100	Y-45	K-22	PANTONE 247 PC	C-37	M-100	Y-0	K-0
PANTONE 146 PC	C-7	M-55	Y-100	K-34	PANTONE Warm Red PC	C-0	M-86	Y-80	K-0	PANTONE 208 PC	C-10	M-97	Y-37	K-43	PANTONE 248 PC	C-45	M-100	Y-0	K-0
PANTONE 148 PC	C-0	M-17	Y-42	K-0	PANTONE 179 PC	C-0	M-88	Y-84	K-0	PANTONE 209 PC	C-14	M-94	Y-36	K-60	PANTONE 249 PC	C-43	M-95	Y-7	K-32
PANTONE 149 PC	C-0	M-22	Y-47	K-0	PANTONE 180 PC	C-3	M-92	Y-84	K-12	PANTONE 210 PC	C-0	M-44	Y-4	K-0	PANTONE 250 PC	C-7	M-26	Y-0	K-0

PANTONE Color	C	M	Y	K
PANTONE 251 PC	C-16	M-41	Y-0	K-0
PANTONE 252 PC	C-31	M-66	Y-0	K-0
PANTONE Purple PC	C-43	M-90	Y-0	K-0
PANTONE 253 PC	C-46	M-91	Y-0	K-0
PANTONE 254 PC	C-52	M-96	Y-0	K-0
PANTONE 255 PC	C-55	M-96	Y-6	K-25
PANTONE 256 PC	C-9	M-20	Y-0	K-0
PANTONE 258 PC	C-50	M-77	Y-0	K-0
PANTONE 259 PC	C-69	M-100	Y-1	K-5
PANTONE 260 PC	C-66	M-100	Y-6	K-28
PANTONE 261 PC	C-62	M-98	Y-9	K-45
PANTONE 262 PC	C-57	M-92	Y-12	K-56
PANTONE 2582 PC	C-50	M-75	Y-0	K-0
PANTONE 2592 PC	C-61	M-88	Y-0	K-0
PANTONE 2602 PC	C-68	M-100	Y-0	K-0
PANTONE 2612 PC	C-70	M-100	Y-0	K-5
PANTONE 2622 PC	C-65	M-91	Y-9	K-45
PANTONE 2563 PC	C-23	M-37	Y-0	K-0
PANTONE 2573 PC	C-36	M-50	Y-0	K-0
PANTONE 2583 PC	C-48	M-70	Y-0	K-0
PANTONE 2613 PC	C-74	M-98	Y-2	K-12
PANTONE 2587 PC	C-66	M-76	Y-0	K-0
PANTONE 2597 PC	C-78	M-94	Y-0	K-0
PANTONE 2627 PC	C-84	M-100	Y-7	K-33
PANTONE 263 PC	C-12	M-15	Y-0	K-0
PANTONE 264 PC	C-27	M-28	Y-0	K-0
PANTONE 265 PC	C-56	M-59	Y-0	K-0
PANTONE 267 PC	C-86	M-96	Y-0	K-0
PANTONE 2635 PC	C-25	M-26	Y-0	K-0
PANTONE 2655 PC	C-53	M-55	Y-0	K-0
PANTONE 2665 PC	C-67	M-68	Y-0	K-0
PANTONE 2695 PC	C-90	M-100	Y-10	K-47
PANTONE 270 PC	C-31	M-25	Y-0	K-0
PANTONE 271 PC	C-48	M-40	Y-0	K-0
PANTONE 272 PC	C-60	M-50	Y-0	K-0
PANTONE 273 PC	C-100	M-100	Y-0	K-15
PANTONE 274 PC	C-100	M-100	Y-0	K-32
PANTONE 275 PC	C-100	M-100	Y-8	K-43
PANTONE 276 PC	C-100	M-100	Y-13	K-68
PANTONE 2725 PC	C-76	M-70	Y-0	K-0
PANTONE 2765 PC	C-100	M-98	Y-0	K-45
PANTONE 2706 PC	C-21	M-9	Y-0	K-0
PANTONE 2716 PC	C-42	M-27	Y-0	K-0
PANTONE 2726 PC	C-84	M-70	Y-0	K-0
PANTONE 2736 PC	C-100	M-92	Y-0	K-0
PANTONE 2746 PC	C-100	M-88	Y-0	K-10
PANTONE 2756 PC	C-100	M-90	Y-0	K-30
PANTONE 2766 PC	C-100	M-92	Y-10	K-47
PANTONE 2707 PC	C-21	M-4	Y-0	K-0
PANTONE 2747 PC	C-100	M-85	Y-4	K-16
PANTONE 2757 PC	C-100	M-82	Y-8	K-32
PANTONE 2767 PC	C-100	M-75	Y-12	K-67
PANTONE 2708 PC	C-28	M-9	Y-0	K-0
PANTONE 2718 PC	C-68	M-39	Y-0	K-0
PANTONE 2728 PC	C-96	M-66	Y-0	K-0
PANTONE 2738 PC	C-100	M-84	Y-0	K-2
PANTONE 2748 PC	C-100	M-90	Y-4	K-12
PANTONE 2758 PC	C-100	M-91	Y-7	K-32
PANTONE 2768 PC	C-100	M-90	Y-13	K-61
PANTONE 277 PC	C-32	M-6	Y-0	K-0
PANTONE 278 PC	C-44	M-13	Y-0	K-0
PANTONE 279 PC	C-70	M-33	Y-0	K-0
PANTONE Reflex Blue PC	C-100	M-82	Y-0	K-2
PANTONE 280 PC	C-100	M-78	Y-5	K-18
PANTONE 281 PC	C-100	M-85	Y-5	K-20
PANTONE 282 PC	C-100	M-82	Y-10	K-64
PANTONE 283 PC	C-40	M-8	Y-0	K-0
PANTONE 284 PC	C-58	M-17	Y-0	K-0
PANTONE 285 PC	C-90	M-48	Y-0	K-0
PANTONE 290 PC	C-24	M-1	Y-1	K-0
PANTONE 2915 PC	C-61	M-7	Y-0	K-0
PANTONE 2925 PC	C-84	M-21	Y-0	K-0
PANTONE 2935 PC	C-100	M-52	Y-0	K-0
PANTONE 2945 PC	C-100	M-52	Y-2	K-12
PANTONE 298 PC	C-68	M-3	Y-0	K-0
PANTONE 299 PC	C-86	M-8	Y-0	K-0
PANTONE 300 PC	C-100	M-42	Y-0	K-0
PANTONE 301 PC	C-100	M-46	Y-5	K-18
PANTONE 302 PC	C-100	M-43	Y-12	K-56
PANTONE 2985 PC	C-60	M-0	Y-4	K-0
PANTONE 2995 PC	C-87	M-1	Y-0	K-0
PANTONE 3005 PC	C-100	M-28	Y-0	K-0
PANTONE 3015 PC	C-100	M-31	Y-5	K-20
PANTONE 3025 PC	C-100	M-24	Y-11	K-52
PANTONE 3035 PC	C-100	M-25	Y-18	K-72
PANTONE 306 PC	C-79	M-0	Y-6	K-5
PANTONE 309 PC	C-100	M-24	Y-20	K-77
PANTONE 312 PC	C-94	M-0	Y-11	K-0
PANTONE 313 PC	C-100	M-0	Y-10	K-4
PANTONE 315 PC	C-100	M-8	Y-18	K-38
PANTONE 3145 PC	C-100	M-5	Y-20	K-22
PANTONE 3155 PC	C-100	M-8	Y-26	K-38
PANTONE 3165 PC	C-100	M-12	Y-28	K-59
PANTONE 317 PC	C-24	M-0	Y-7	K-0
PANTONE 318 PC	C-41	M-0	Y-12	K-0
PANTONE 319 PC	C-62	M-0	Y-20	K-0
PANTONE 320 PC	C-100	M-0	Y-30	K-2
PANTONE 321 PC	C-100	M-2	Y-32	K-12
PANTONE 322 PC	C-100	M-6	Y-35	K-32
PANTONE 323 PC	C-100	M-10	Y-36	K-48
PANTONE 326 PC	C-85	M-0	Y-38	K-0
PANTONE 329 PC	C-100	M-8	Y-50	K-40
PANTONE 330 PC	C-95	M-15	Y-47	K-62
PANTONE 3242 PC	C-46	M-0	Y-18	K-0
PANTONE 3252 PC	C-54	M-0	Y-24	K-0
PANTONE 3262 PC	C-78	M-0	Y-32	K-0
PANTONE 3292 PC	C-100	M-11	Y-48	K-50
PANTONE 3302 PC	C-94	M-16	Y-48	K-65
PANTONE 3255 PC	C-55	M-0	Y-26	K-0
PANTONE 3258 PC	C-63	M-0	Y-32	K-0
PANTONE 3268 PC	C-89	M-0	Y-50	K-0
PANTONE 3278 PC	C-100	M-0	Y-59	K-0
PANTONE 3288 PC	C-100	M-3	Y-58	K-16
PANTONE 3298 PC	C-100	M-8	Y-59	K-38
PANTONE 3308 PC	C-100	M-20	Y-59	K-74
PANTONE 331 PC	C-27	M-0	Y-14	K-0
PANTONE 333 PC	C-56	M-0	Y-30	K-0
PANTONE Green PC	C-95	M-0	Y-58	K-0
PANTONE 334 PC	C-100	M-0	Y-60	K-3
PANTONE 335 PC	C-100	M-0	Y-58	K-22
PANTONE 336 PC	C-100	M-9	Y-58	K-45
PANTONE 339 PC	C-84	M-0	Y-54	K-0
PANTONE 340 PC	C-100	M-0	Y-74	K-0
PANTONE 341 PC	C-100	M-0	Y-67	K-30
PANTONE 3385 PC	C-54	M-0	Y-37	K-0
PANTONE 3395 PC	C-74	M-0	Y-52	K-0
PANTONE 3405 PC	C-90	M-0	Y-70	K-0
PANTONE 3435 PC	C-95	M-19	Y-70	K-72
PANTONE 345 PC	C-43	M-0	Y-33	K-0
PANTONE 347 PC	C-96	M-0	Y-88	K-1
PANTONE 349 PC	C-94	M-11	Y-84	K-43
PANTONE 350 PC	C-80	M-24	Y-69	K-70
PANTONE 351 PC	C-34	M-0	Y-26	K-0
PANTONE 352 PC	C-37	M-0	Y-29	K-0
PANTONE 353 PC	C-46	M-0	Y-36	K-0
PANTONE 357 PC	C-83	M-19	Y-73	K-58
PANTONE 358 PC	C-38	M-0	Y-45	K-0
PANTONE 359 PC	C-42	M-0	Y-48	K-0
PANTONE 360 PC	C-62	M-0	Y-78	K-0
PANTONE 361 PC	C-75	M-0	Y-100	K-0
PANTONE 362 PC	C-78	M-2	Y-98	K-9
PANTONE 364 PC	C-73	M-9	Y-94	K-39
PANTONE 365 PC	C-22	M-0	Y-36	K-0
PANTONE 366 PC	C-29	M-0	Y-45	K-0
PANTONE 367 PC	C-37	M-0	Y-58	K-0
PANTONE 368 PC	C-63	M-0	Y-97	K-0
PANTONE 370 PC	C-64	M-5	Y-100	K-24
PANTONE 371 PC	C-53	M-14	Y-89	K-56
PANTONE 374 PC	C-27	M-0	Y-55	K-0
PANTONE 375 PC	C-47	M-0	Y-94	K-0
PANTONE 376 PC	C-53	M-0	Y-96	K-0
PANTONE 377 PC	C-51	M-5	Y-98	K-23
PANTONE 378 PC	C-43	M-13	Y-98	K-62
PANTONE 379 PC	C-10	M-0	Y-54	K-0
PANTONE 380 PC	C-15	M-0	Y-72	K-0
PANTONE 381 PC	C-23	M-0	Y-89	K-0
PANTONE 382 PC	C-28	M-0	Y-92	K-0
PANTONE 383 PC	C-26	M-3	Y-93	K-17
PANTONE 384 PC	C-24	M-5	Y-98	K-35
PANTONE 385 PC	C-22	M-14	Y-92	K-56
PANTONE 386 PC	C-6	M-0	Y-54	K-0
PANTONE 387 PC	C-10	M-0	Y-72	K-0
PANTONE 388 PC	C-14	M-0	Y-76	K-0
PANTONE 389 PC	C-23	M-0	Y-83	K-0
PANTONE 390 PC	C-24	M-0	Y-98	K-8
PANTONE 391 PC	C-20	M-4	Y-100	K-32
PANTONE 392 PC	C-20	M-12	Y-100	K-48
PANTONE 393 PC	C-3	M-0	Y-48	K-0
PANTONE 394 PC	C-3	M-0	Y-66	K-0
PANTONE 395 PC	C-7	M-0	Y-79	K-0
PANTONE 396 PC	C-11	M-0	Y-90	K-0
PANTONE 397 PC	C-10	M-1	Y-98	K-15
PANTONE 398 PC	C-11	M-4	Y-100	K-25
PANTONE 399 PC	C-14	M-10	Y-100	K-35
PANTONE 3935 PC	C-1	M-0	Y-58	K-0
PANTONE 3945 PC	C-1	M-0	Y-73	K-0
PANTONE 3955 PC	C-4	M-0	Y-100	K-0
PANTONE 3965 PC	C-6	M-0	Y-100	K-0
PANTONE 3975 PC	C-6	M-9	Y-100	K-22
PANTONE 3985 PC	C-11	M-16	Y-100	K-38
PANTONE 3995 PC	C-17	M-26	Y-100	K-66
PANTONE 400 PC	C-5	M-6	Y-10	K-14
PANTONE 401 PC	C-8	M-9	Y-14	K-24
PANTONE 402 PC	C-10	M-13	Y-16	K-29
PANTONE 403 PC	C-14	M-18	Y-22	K-42
PANTONE 404 PC	C-18	M-23	Y-27	K-55
PANTONE 405 PC	C-23	M-29	Y-32	K-67
PANTONE Black PC	C-56	M-56	Y-53	K-92
PANTONE 406 PC	C-5	M-9	Y-10	K-13
PANTONE 407 PC	C-8	M-15	Y-13	K-24
PANTONE 408 PC	C-11	M-19	Y-18	K-35
PANTONE 409 PC	C-16	M-25	Y-21	K-45
PANTONE 410 PC	C-19	M-31	Y-26	K-56
PANTONE 411 PC	C-27	M-39	Y-30	K-70
PANTONE 412 PC	C-53	M-56	Y-45	K-87
PANTONE 413 PC	C-8	M-5	Y-12	K-15
PANTONE 414 PC	C-13	M-8	Y-16	K-26
PANTONE 415 PC	C-17	M-12	Y-20	K-34
PANTONE 416 PC	C-22	M-14	Y-24	K-45
PANTONE 417 PC	C-28	M-18	Y-28	K-54
PANTONE 418 PC	C-33	M-23	Y-34	K-68
PANTONE 419 PC	C-87	M-74	Y-63	K-95
PANTONE 420 PC	C-6	M-4	Y-7	K-11
PANTONE 421 PC	C-12	M-8	Y-9	K-21
PANTONE 422 PC	C-16	M-11	Y-11	K-29
PANTONE 423 PC	C-21	M-14	Y-14	K-38
PANTONE 424 PC	C-30	M-22	Y-19	K-53
PANTONE 425 PC	C-38	M-28	Y-21	K-63
PANTONE 426 PC	C-91	M-74	Y-51	K-93
PANTONE 427 PC	C-7	M-3	Y-4	K-8
PANTONE 429 PC	C-21	M-11	Y-9	K-22
PANTONE 430 PC	C-33	M-17	Y-13	K-37
PANTONE 431 PC	C-45	M-27	Y-17	K-51
PANTONE 432 PC	C-67	M-45	Y-27	K-70
PANTONE 433 PC	C-90	M-69	Y-40	K-89
PANTONE 434 PC	C-5	M-11	Y-8	K-12
PANTONE 435 PC	C-9	M-17	Y-8	K-18
PANTONE 436 PC	C-14	M-23	Y-10	K-26
PANTONE 437 PC	C-21	M-37	Y-18	K-50
PANTONE 438 PC	C-37	M-51	Y-33	K-78

Run Sequence

PANTONE Color	CMYK, US			
PANTONE 439 PC	C-41	M-54	Y-37	K-84
PANTONE 440 PC	C-52	M-61	Y-47	K-92
PANTONE 441 PC	C-18	M-4	Y-10	K-13
PANTONE 442 PC	C-23	M-7	Y-12	K-18
PANTONE 443 PC	C-29	M-10	Y-14	K-28
PANTONE 444 PC	C-38	M-15	Y-18	K-43
PANTONE 445 PC	C-50	M-28	Y-24	K-65
PANTONE 446 PC	C-52	M-32	Y-30	K-76
PANTONE 447 PC	C-55	M-39	Y-38	K-83
PANTONE Warm Gray 1 PC	C-2	M-3	Y-4	K-5
PANTONE Warm Gray 3 PC	C-6	M-7	Y-9	K-15
PANTONE Warm Gray 4 PC	C-9	M-11	Y-13	K-23
PANTONE Warm Gray 5 PC	C-11	M-13	Y-14	K-26
PANTONE Warm Gray 6 PC	C-11	M-16	Y-18	K-32
PANTONE Warm Gray 7 PC	C-14	M-19	Y-21	K-38
PANTONE Warm Gray 8 PC	C-16	M-23	Y-23	K-44
PANTONE Warm Gray 9 PC	C-17	M-25	Y-25	K-49
PANTONE Warm Gray 10 PC	C-20	M-29	Y-28	K-56
PANTONE Warm Gray 11 PC	C-23	M-32	Y-31	K-64
PANTONE Cool Gray 1 PC	C-3	M-2	Y-4	K-5
PANTONE Cool Gray 2 PC	C-5	M-3	Y-4	K-8
PANTONE Cool Gray 3 PC	C-8	M-5	Y-6	K-13
PANTONE Cool Gray 4 PC	C-12	M-7	Y-6	K-17
PANTONE Cool Gray 5 PC	C-15	M-9	Y-8	K-22
PANTONE Cool Gray 6 PC	C-18	M-11	Y-8	K-23
PANTONE Cool Gray 7 PC	C-22	M-15	Y-11	K-32
PANTONE Cool Gray 8 PC	C-23	M-17	Y-13	K-41
PANTONE Cool Gray 9 PC	C-29	M-23	Y-16	K-51
PANTONE Cool Gray 10 PC	C-38	M-29	Y-20	K-58
PANTONE Cool Gray 11 PC	C-48	M-36	Y-24	K-66
PANTONE Black 2 PC	C-39	M-42	Y-68	K-88
PANTONE Black 3 PC	C-72	M-46	Y-56	K-95
PANTONE Black 4 PC	C-40	M-53	Y-59	K-89
PANTONE Black 5 PC	C-37	M-60	Y-35	K-80
PANTONE Black 6 PC	C-100	M-70	Y-44	K-91
PANTONE Black 7 PC	C-51	M-44	Y-36	K-84
PANTONE 448 PC	C-30	M-35	Y-62	K-79
PANTONE 449 PC	C-32	M-36	Y-73	K-77
PANTONE 450 PC	C-31	M-31	Y-77	K-74
PANTONE 451 PC	C-17	M-13	Y-45	K-34
PANTONE 452 PC	C-12	M-8	Y-35	K-22
PANTONE 453 PC	C-10	M-6	Y-28	K-14
PANTONE 454 PC	C-7	M-4	Y-22	K-8
PANTONE 4485 PC	C-24	M-42	Y-89	K-72
PANTONE 4495 PC	C-16	M-31	Y-80	K-51
PANTONE 4505 PC	C-13	M-23	Y-67	K-38
PANTONE 4515 PC	C-8	M-14	Y-50	K-24
PANTONE 4525 PC	C-6	M-9	Y-39	K-16
PANTONE 4535 PC	C-5	M-7	Y-32	K-10
PANTONE 455 PC	C-21	M-34	Y-93	K-66
PANTONE 456 PC	C-9	M-25	Y-98	K-41
PANTONE 457 PC	C-6	M-23	Y-97	K-26
PANTONE 458 PC	C-2	M-7	Y-58	K-7
PANTONE 459 PC	C-2	M-5	Y-53	K-5
PANTONE 460 PC	C-2	M-2	Y-43	K-3

PANTONE Color	CMYK, US			
PANTONE 463 PC	C-17	M-52	Y-87	K-63
PANTONE 464 PC	C-13	M-51	Y-87	K-48
PANTONE 465 PC	C-7	M-27	Y-55	K-22
PANTONE 466 PC	C-5	M-17	Y-42	K-14
PANTONE 467 PC	C-3	M-12	Y-34	K-10
PANTONE 468 PC	C-2	M-7	Y-26	K-5
PANTONE 4625 PC	C-29	M-78	Y-91	K-78
PANTONE 4635 PC	C-13	M-53	Y-68	K-40
PANTONE 4645 PC	C-8	M-43	Y-50	K-26
PANTONE 4655 PC	C-6	M-38	Y-42	K-18
PANTONE 4665 PC	C-4	M-27	Y-33	K-11
PANTONE 4675 PC	C-2	M-18	Y-24	K-6
PANTONE 4685 PC	C-1	M-14	Y-20	K-4
PANTONE 469 PC	C-21	M-70	Y-92	K-70
PANTONE 470 PC	C-8	M-68	Y-94	K-34
PANTONE 471 PC	C-5	M-70	Y-97	K-20
PANTONE 472 PC	C-0	M-44	Y-53	K-1
PANTONE 473 PC	C-0	M-26	Y-31	K-0
PANTONE 474 PC	C-0	M-23	Y-30	K-0
PANTONE 475 PC	C-0	M-18	Y-25	K-0
PANTONE 4695 PC	C-29	M-79	Y-71	K-73
PANTONE 4705 PC	C-17	M-64	Y-60	K-51
PANTONE 4715 PC	C-13	M-47	Y-43	K-38
PANTONE 4725 PC	C-9	M-36	Y-33	K-26
PANTONE 4735 PC	C-6	M-27	Y-25	K-17
PANTONE 4745 PC	C-4	M-20	Y-22	K-12
PANTONE 4755 PC	C-3	M-14	Y-16	K-7
PANTONE 476 PC	C-32	M-67	Y-63	K-78
PANTONE 477 PC	C-25	M-75	Y-73	K-68
PANTONE 478 PC	C-19	M-75	Y-74	K-58
PANTONE 479 PC	C-9	M-43	Y-45	K-27
PANTONE 480 PC	C-4	M-25	Y-27	K-14
PANTONE 481 PC	C-3	M-17	Y-21	K-8
PANTONE 482 PC	C-2	M-13	Y-18	K-6
PANTONE 483 PC	C-20	M-81	Y-76	K-61
PANTONE 484 PC	C-8	M-91	Y-92	K-33
PANTONE 485 PC	C-0	M-93	Y-95	K-0
PANTONE 486 PC	C-0	M-52	Y-43	K-0
PANTONE 487 PC	C-0	M-40	Y-33	K-0
PANTONE 488 PC	C-0	M-28	Y-24	K-0
PANTONE 489 PC	C-0	M-21	Y-19	K-0
PANTONE 490 PC	C-29	M-85	Y-54	K-72
PANTONE 491 PC	C-15	M-85	Y-53	K-54
PANTONE 492 PC	C-12	M-84	Y-53	K-44
PANTONE 493 PC	C-1	M-54	Y-17	K-4
PANTONE 494 PC	C-0	M-43	Y-10	K-0
PANTONE 495 PC	C-0	M-31	Y-6	K-0
PANTONE 496 PC	C-0	M-25	Y-5	K-0
PANTONE 497 PC	C-32	M-73	Y-52	K-80
PANTONE 498 PC	C-23	M-74	Y-54	K-63
PANTONE 500 PC	C-5	M-47	Y-20	K-14
PANTONE 501 PC	C-0	M-36	Y-12	K-4
PANTONE 502 PC	C-0	M-26	Y-9	K-1
PANTONE 503 PC	C-0	M-18	Y-6	K-1
PANTONE 4985 PC	C-16	M-63	Y-32	K-47

PANTONE Color	CMYK, US			
PANTONE 4995 PC	C-11	M-53	Y-25	K-33
PANTONE 5005 PC	C-8	M-44	Y-18	K-21
PANTONE 5015 PC	C-3	M-31	Y-13	K-10
PANTONE 5025 PC	C-2	M-24	Y-10	K-5
PANTONE 5035 PC	C-1	M-17	Y-7	K-3
PANTONE 504 PC	C-30	M-82	Y-44	K-73
PANTONE 505 PC	C-20	M-86	Y-38	K-62
PANTONE 506 PC	C-14	M-83	Y-32	K-49
PANTONE 507 PC	C-2	M-45	Y-6	K-6
PANTONE 508 PC	C-2	M-36	Y-4	K-1
PANTONE 509 PC	C-0	M-30	Y-4	K-1
PANTONE 510 PC	C-0	M-25	Y-4	K-0
PANTONE 511 PC	C-46	M-90	Y-12	K-50
PANTONE 512 PC	C-55	M-99	Y-3	K-16
PANTONE 513 PC	C-56	M-98	Y-0	K-0
PANTONE 514 PC	C-17	M-53	Y-0	K-0
PANTONE 5115 PC	C-52	M-85	Y-21	K-64
PANTONE 5125 PC	C-45	M-77	Y-13	K-42
PANTONE 5135 PC	C-37	M-61	Y-0	K-26
PANTONE 5145 PC	C-27	M-46	Y-6	K-18
PANTONE 5155 PC	C-13	M-29	Y-3	K-8
PANTONE 5165 PC	C-6	M-17	Y-2	K-4
PANTONE 5175 PC	C-4	M-14	Y-2	K-4
PANTONE 519 PC	C-64	M-88	Y-10	K-39
PANTONE 520 PC	C-66	M-86	Y-5	K-17
PANTONE 521 PC	C-35	M-49	Y-0	K-0
PANTONE 522 PC	C-23	M-36	Y-0	K-0
PANTONE 523 PC	C-16	M-27	Y-0	K-0
PANTONE 524 PC	C-11	M-19	Y-0	K-0
PANTONE 5195 PC	C-42	M-67	Y-18	K-52
PANTONE 5205 PC	C-27	M-48	Y-11	K-34
PANTONE 5215 PC	C-15	M-33	Y-7	K-20
PANTONE 5225 PC	C-9	M-23	Y-4	K-11
PANTONE 5235 PC	C-5	M-16	Y-3	K-8
PANTONE 5245 PC	C-2	M-9	Y-3	K-5
PANTONE 525 PC	C-71	M-90	Y-9	K-37
PANTONE 526 PC	C-76	M-99	Y-0	K-0
PANTONE 527 PC	C-75	M-100	Y-0	K-0
PANTONE 528 PC	C-40	M-56	Y-0	K-0
PANTONE 529 PC	C-25	M-37	Y-0	K-0
PANTONE 5255 PC	C-97	M-95	Y-15	K-65
PANTONE 5265 PC	C-84	M-79	Y-10	K-38
PANTONE 5275 PC	C-73	M-62	Y-8	K-26
PANTONE 5285 PC	C-48	M-39	Y-5	K-14
PANTONE 5295 PC	C-27	M-20	Y-2	K-7
PANTONE 534 PC	C-95	M-72	Y-9	K-38
PANTONE 535 PC	C-43	M-26	Y-3	K-8
PANTONE 536 PC	C-34	M-18	Y-2	K-7
PANTONE 537 PC	C-21	M-9	Y-1	K-4
PANTONE 5405 PC	C-71	M-30	Y-13	K-41
PANTONE 5415 PC	C-57	M-23	Y-10	K-31
PANTONE 5425 PC	C-44	M-15	Y-7	K-22
PANTONE 5435 PC	C-28	M-7	Y-4	K-12
PANTONE 5445 PC	C-21	M-4	Y-3	K-8
PANTONE 547 PC	C-100	M-29	Y-27	K-79

PANTONE Color	CMYK, US			
PANTONE 551 PC	C-35	M-3	Y-5	K-7
PANTONE 552 PC	C-22	M-2	Y-3	K-3
PANTONE 5473 PC	C-83	M-14	Y-23	K-50
PANTONE 5483 PC	C-62	M-9	Y-20	K-27
PANTONE 5493 PC	C-46	M-5	Y-14	K-14
PANTONE 5503 PC	C-39	M-3	Y-11	K-8
PANTONE 5513 PC	C-28	M-2	Y-8	K-5
PANTONE 5477 PC	C-64	M-21	Y-36	K-59
PANTONE 5487 PC	C-46	M-14	Y-26	K-43
PANTONE 5497 PC	C-35	M-8	Y-19	K-25
PANTONE 5507 PC	C-26	M-5	Y-13	K-15
PANTONE 554 PC	C-83	M-17	Y-62	K-56
PANTONE 555 PC	C-82	M-13	Y-64	K-45
PANTONE 556 PC	C-51	M-5	Y-37	K-15
PANTONE 557 PC	C-41	M-3	Y-28	K-8
PANTONE 558 PC	C-32	M-2	Y-22	K-4
PANTONE 559 PC	C-23	M-1	Y-18	K-3
PANTONE 5555 PC	C-47	M-11	Y-30	K-33
PANTONE 5565 PC	C-39	M-7	Y-23	K-21
PANTONE 5575 PC	C-31	M-5	Y-19	K-14
PANTONE 5585 PC	C-22	M-3	Y-14	K-8
PANTONE 563 PC	C-52	M-1	Y-26	K-3
PANTONE 565 PC	C-32	M-0	Y-14	K-0
PANTONE 5615 PC	C-48	M-17	Y-41	K-51
PANTONE 5625 PC	C-41	M-13	Y-34	K-39
PANTONE 5635 PC	C-29	M-8	Y-25	K-24
PANTONE 5645 PC	C-22	M-5	Y-19	K-16
PANTONE 5655 PC	C-17	M-4	Y-16	K-12
PANTONE 569 PC	C-80	M-6	Y-45	K-20
PANTONE 576 PC	C-52	M-6	Y-79	K-25
PANTONE 577 PC	C-33	M-1	Y-49	K-4
PANTONE 5743 PC	C-52	M-28	Y-74	K-74
PANTONE 5753 PC	C-40	M-19	Y-66	K-58
PANTONE 5763 PC	C-36	M-16	Y-62	K-48
PANTONE 5773 PC	C-28	M-10	Y-48	K-31
PANTONE 5783 PC	C-20	M-7	Y-35	K-20
PANTONE 5793 PC	C-16	M-5	Y-28	K-15
PANTONE 5803 PC	C-10	M-3	Y-22	K-9
PANTONE 5767 PC	C-30	M-12	Y-66	K-36
PANTONE 5777 PC	C-22	M-7	Y-51	K-22
PANTONE 5787 PC	C-14	M-4	Y-36	K-12
PANTONE 5797 PC	C-10	M-3	Y-29	K-8
PANTONE 583 PC	C-25	M-3	Y-100	K-14
PANTONE 584 PC	C-15	M-0	Y-73	K-1
PANTONE 585 PC	C-10	M-0	Y-56	K-0
PANTONE 586 PC	C-8	M-0	Y-50	K-0
PANTONE 5815 PC	C-32	M-31	Y-96	K-79
PANTONE 5825 PC	C-21	M-17	Y-76	K-48
PANTONE 5835 PC	C-15	M-12	Y-57	K-30
PANTONE 5845 PC	C-14	M-9	Y-51	K-25
PANTONE 5855 PC	C-10	M-5	Y-37	K-14
PANTONE 5865 PC	C-7	M-4	Y-31	K-9
PANTONE 5875 PC	C-5	M-3	Y-26	K-6
PANTONE 604 PC	C-2	M-2	Y-80	K-2
PANTONE 605 PC	C-0	M-2	Y-100	K-8

Run Sequence (indicated beneath the colored swatches in each column header)

PANTONE Color	CMYK, US				PANTONE Color	CMYK, US				PANTONE Color	CMYK, US				PANTONE Color	CMYK, US			
PANTONE 606 PC	C-0	M-6	Y-100	K-14	PANTONE 689 PC	C-27	M-81	Y-8	K-28	PANTONE 7424 PC	C-0	M-87	Y-12	K-0	PANTONE 7505 PC	C-17	M-44	Y-59	K-49
PANTONE 610 PC	C-3	M-2	Y-62	K-5	PANTONE 690 PC	C-25	M-96	Y-15	K-60	PANTONE 7425 PC	C-4	M-93	Y-28	K-14	PANTONE 7506 PC	C-0	M-7	Y-23	K-1
PANTONE 611 PC	C-5	M-3	Y-76	K-11	PANTONE 692 PC	C-1	M-22	Y-8	K-2	PANTONE 7426 PC	C-5	M-98	Y-40	K-20	PANTONE 7507 PC	C-0	M-13	Y-33	K-0
PANTONE 612 PC	C-0	M-2	Y-100	K-22	PANTONE 693 PC	C-2	M-33	Y-9	K-6	PANTONE 7427 PC	C-7	M-100	Y-67	K-31	PANTONE 7508 PC	C-0	M-15	Y-40	K-4
PANTONE 613 PC	C-0	M-4	Y-100	K-30	PANTONE 694 PC	C-4	M-43	Y-14	K-12	PANTONE 7428 PC	C-18	M-85	Y-31	K-59	PANTONE 7509 PC	C-2	M-25	Y-50	K-5
PANTONE 615 PC	C-4	M-3	Y-35	K-6	PANTONE 695 PC	C-7	M-56	Y-20	K-23	PANTONE 7430 PC	C-2	M-32	Y-2	K-1	PANTONE 7510 PC	C-4	M-35	Y-65	K-10
PANTONE 616 PC	C-5	M-4	Y-42	K-9	PANTONE 696 PC	C-12	M-75	Y-33	K-43	PANTONE 7431 PC	C-3	M-48	Y-5	K-7	PANTONE 7511 PC	C-5	M-48	Y-93	K-23
PANTONE 617 PC	C-7	M-6	Y-52	K-15	PANTONE 697 PC	C-14	M-80	Y-39	K-45	PANTONE 7432 PC	C-7	M-68	Y-8	K-16	PANTONE 7512 PC	C-6	M-53	Y-100	K-31
PANTONE 618 PC	C-11	M-10	Y-68	K-25	PANTONE 699 PC	C-0	M-24	Y-5	K-0	PANTONE 7433 PC	C-7	M-83	Y-16	K-23	PANTONE 7513 PC	C-0	M-26	Y-26	K-1
PANTONE 619 PC	C-13	M-17	Y-78	K-35	PANTONE 700 PC	C-0	M-38	Y-8	K-0	PANTONE 7434 PC	C-9	M-89	Y-23	K-34	PANTONE 7514 PC	C-2	M-33	Y-33	K-6
PANTONE 620 PC	C-15	M-20	Y-96	K-48	PANTONE 701 PC	C-0	M-53	Y-14	K-0	PANTONE 7435 PC	C-13	M-94	Y-19	K-45	PANTONE 7515 PC	C-4	M-38	Y-47	K-12
PANTONE 622 PC	C-25	M-2	Y-14	K-5	PANTONE 702 PC	C-1	M-72	Y-24	K-2	PANTONE 7437 PC	C-15	M-29	Y-0	K-0	PANTONE 7518 PC	C-22	M-51	Y-47	K-61
PANTONE 623 PC	C-36	M-3	Y-21	K-10	PANTONE 703 PC	C-4	M-86	Y-43	K-13	PANTONE 7438 PC	C-19	M-43	Y-0	K-0	PANTONE 7519 PC	C-24	M-42	Y-43	K-69
PANTONE 624 PC	C-47	M-6	Y-28	K-18	PANTONE 704 PC	C-6	M-93	Y-58	K-28	PANTONE 7439 PC	C-30	M-44	Y-0	K-0	PANTONE 7520 PC	C-0	M-24	Y-22	K-0
PANTONE 625 PC	C-61	M-10	Y-38	K-32	PANTONE 707 PC	C-0	M-34	Y-8	K-0	PANTONE 7440 PC	C-39	M-54	Y-1	K-2	PANTONE 7521 PC	C-4	M-29	Y-30	K-12
PANTONE 626 PC	C-79	M-17	Y-49	K-56	PANTONE 708 PC	C-0	M-52	Y-17	K-0	PANTONE 7441 PC	C-51	M-71	Y-0	K-0	PANTONE 7522 PC	C-6	M-58	Y-53	K-18
PANTONE 627 PC	C-94	M-34	Y-60	K-82	PANTONE 709 PC	C-0	M-70	Y-27	K-0	PANTONE 7442 PC	C-70	M-93	Y-0	K-0	PANTONE 7523 PC	C-8	M-62	Y-48	K-25
PANTONE 631 PC	C-73	M-0	Y-11	K-0	PANTONE 710 PC	C-0	M-84	Y-41	K-0	PANTONE 7444 PC	C-28	M-20	Y-0	K-0	PANTONE 7524 PC	C-9	M-70	Y-59	K-28
PANTONE 632 PC	C-93	M-2	Y-13	K-6	PANTONE 711 PC	C-0	M-92	Y-56	K-1	PANTONE 7445 PC	C-40	M-30	Y-0	K-2	PANTONE 7525 PC	C-11	M-51	Y-59	K-34
PANTONE 633 PC	C-100	M-6	Y-10	K-28	PANTONE 715 PC	C-0	M-46	Y-85	K-0	PANTONE 7446 PC	C-51	M-43	Y-0	K-0	PANTONE 7526 PC	C-10	M-78	Y-100	K-46
PANTONE 637 PC	C-65	M-0	Y-7	K-0	PANTONE 719 PC	C-0	M-14	Y-24	K-0	PANTONE 7447 PC	C-76	M-77	Y-6	K-18	PANTONE 7529 PC	C-7	M-14	Y-20	K-21
PANTONE 644 PC	C-41	M-11	Y-2	K-6	PANTONE 720 PC	C-0	M-20	Y-32	K-2	PANTONE 7448 PC	C-70	M-74	Y-19	K-55	PANTONE 7530 PC	C-10	M-18	Y-25	K-29
PANTONE 645 PC	C-55	M-24	Y-2	K-8	PANTONE 721 PC	C-0	M-31	Y-43	K-2	PANTONE 7449 PC	C-68	M-85	Y-29	K-74	PANTONE 7531 PC	C-16	M-28	Y-36	K-49
PANTONE 646 PC	C-73	M-30	Y-3	K-10	PANTONE 722 PC	C-3	M-45	Y-64	K-9	PANTONE 7451 PC	C-46	M-26	Y-0	K-0	PANTONE 7532 PC	C-23	M-36	Y-43	K-64
PANTONE 647 PC	C-96	M-53	Y-5	K-24	PANTONE 723 PC	C-5	M-53	Y-79	K-20	PANTONE 7452 PC	C-55	M-33	Y-0	K-0	PANTONE 7533 PC	C-36	M-52	Y-65	K-85
PANTONE 648 PC	C-100	M-71	Y-9	K-54	PANTONE 724 PC	C-7	M-65	Y-100	K-37	PANTONE 7453 PC	C-55	M-25	Y-0	K-0	PANTONE 7535 PC	C-7	M-10	Y-22	K-20
PANTONE 651 PC	C-40	M-16	Y-1	K-2	PANTONE 725 PC	C-11	M-69	Y-100	K-50	PANTONE 7454 PC	C-62	M-22	Y-4	K-11	PANTONE 7536 PC	C-11	M-13	Y-30	K-32
PANTONE 652 PC	C-62	M-28	Y-2	K-3	PANTONE 726 PC	C-1	M-15	Y-24	K-2	PANTONE 7455 PC	C-90	M-60	Y-0	K-0	PANTONE 7537 PC	C-18	M-8	Y-20	K-24
PANTONE 653 PC	C-96	M-59	Y-4	K-17	PANTONE 727 PC	C-2	M-21	Y-30	K-4	PANTONE 7456 PC	C-72	M-50	Y-0	K-0	PANTONE 7538 PC	C-24	M-11	Y-24	K-33
PANTONE 659 PC	C-60	M-29	Y-0	K-0	PANTONE 728 PC	C-3	M-27	Y-38	K-8	PANTONE 7458 PC	C-52	M-3	Y-6	K-7	PANTONE 7539 PC	C-24	M-13	Y-18	K-38
PANTONE 660 PC	C-91	M-53	Y-0	K-0	PANTONE 729 PC	C-7	M-39	Y-53	K-17	PANTONE 7459 PC	C-76	M-6	Y-8	K-15	PANTONE 7540 PC	C-40	M-30	Y-22	K-60
PANTONE 661 PC	C-100	M-75	Y-0	K-5	PANTONE 730 PC	C-10	M-47	Y-67	K-27	PANTONE 7462 PC	C-100	M-45	Y-6	K-27	PANTONE 7542 PC	C-24	M-4	Y-8	K-13
PANTONE 662 PC	C-100	M-88	Y-0	K-20	PANTONE 731 PC	C-12	M-63	Y-100	K-61	PANTONE 7463 PC	C-100	M-62	Y-12	K-62	PANTONE 7543 PC	C-23	M-11	Y-8	K-21
PANTONE 664 PC	C-5	M-7	Y-1	K-4	PANTONE 732 PC	C-16	M-68	Y-100	K-70	PANTONE 7465 PC	C-67	M-0	Y-33	K-0	PANTONE 7544 PC	C-33	M-14	Y-11	K-31
PANTONE 665 PC	C-20	M-20	Y-0	K-1	PANTONE 7401 PC	C-0	M-5	Y-25	K-0	PANTONE 7471 PC	C-40	M-0	Y-17	K-0	PANTONE 7545 PC	C-55	M-30	Y-17	K-51
PANTONE 666 PC	C-40	M-39	Y-2	K-5	PANTONE 7402 PC	C-0	M-6	Y-38	K-0	PANTONE 7472 PC	C-62	M-0	Y-26	K-0	PANTONE 7546 PC	C-70	M-43	Y-23	K-63
PANTONE 667 PC	C-59	M-58	Y-4	K-12	PANTONE 7403 PC	C-0	M-11	Y-51	K-0	PANTONE 7473 PC	C-74	M-0	Y-36	K-8	PANTONE 7547 PC	C-99	M-73	Y-30	K-80
PANTONE 668 PC	C-74	M-73	Y-7	K-20	PANTONE 7404 PC	C-0	M-9	Y-86	K-0	PANTONE 7474 PC	C-98	M-7	Y-30	K-30					
PANTONE 669 PC	C-90	M-95	Y-10	K-41	PANTONE 7405 PC	C-0	M-11	Y-97	K-0	PANTONE 7475 PC	C-68	M-12	Y-28	K-35					
PANTONE 671 PC	C-2	M-25	Y-0	K-0	PANTONE 7406 PC	C-0	M-17	Y-100	K-0	PANTONE 7476 PC	C-92	M-18	Y-32	K-65					
PANTONE 672 PC	C-4	M-41	Y-0	K-0	PANTONE 7407 PC	C-3	M-34	Y-68	K-8	PANTONE 7477 PC	C-85	M-29	Y-21	K-63					
PANTONE 673 PC	C-8	M-51	Y-0	K-0	PANTONE 7408 PC	C-0	M-30	Y-99	K-0	PANTONE 7479 PC	C-60	M-0	Y-55	K-0					
PANTONE 674 PC	C-14	M-71	Y-0	K-0	PANTONE 7409 PC	C-0	M-33	Y-98	K-0	PANTONE 7483 PC	C-83	M-16	Y-83	K-54					
PANTONE 675 PC	C-15	M-94	Y-3	K-12	PANTONE 7410 PC	C-0	M-36	Y-50	K-0	PANTONE 7490 PC	C-54	M-7	Y-79	K-21					
PANTONE 676 PC	C-9	M-100	Y-12	K-32	PANTONE 7411 PC	C-0	M-42	Y-69	K-0	PANTONE 7491 PC	C-43	M-10	Y-83	K-39					
PANTONE 679 PC	C-4	M-23	Y-0	K-0	PANTONE 7412 PC	C-3	M-53	Y-79	K-7	PANTONE 7493 PC	C-20	M-3	Y-38	K-8					
PANTONE 680 PC	C-10	M-43	Y-1	K-2	PANTONE 7413 PC	C-1	M-62	Y-95	K-2	PANTONE 7494 PC	C-31	M-5	Y-36	K-16					
PANTONE 681 PC	C-18	M-57	Y-3	K-8	PANTONE 7414 PC	C-4	M-62	Y-99	K-18	PANTONE 7495 PC	C-30	M-4	Y-85	K-30					
PANTONE 682 PC	C-27	M-76	Y-7	K-21	PANTONE 7415 PC	C-0	M-28	Y-26	K-1	PANTONE 7496 PC	C-44	M-4	Y-98	K-40					
PANTONE 683 PC	C-23	M-88	Y-11	K-47	PANTONE 7416 PC	C-0	M-69	Y-65	K-0	PANTONE 7497 PC	C-20	M-22	Y-45	K-58					
PANTONE 684 PC	C-2	M-20	Y-2	K-1	PANTONE 7417 PC	C-0	M-80	Y-80	K-0	PANTONE 7498 PC	C-45	M-24	Y-80	K-68					
PANTONE 685 PC	C-3	M-27	Y-1	K-0	PANTONE 7418 PC	C-3	M-80	Y-48	K-9	PANTONE 7501 PC	C-0	M-4	Y-20	K-7					
PANTONE 686 PC	C-5	M-36	Y-1	K-2	PANTONE 7419 PC	C-8	M-77	Y-37	K-27	PANTONE 7502 PC	C-0	M-8	Y-33	K-10					
PANTONE 687 PC	C-10	M-48	Y-2	K-7	PANTONE 7420 PC	C-7	M-98	Y-44	K-33	PANTONE 7503 PC	C-10	M-15	Y-45	K-28					
PANTONE 688 PC	C-18	M-63	Y-4	K-11	PANTONE 7423 PC	C-0	M-71	Y-16	K-0	PANTONE 7504 PC	C-17	M-30	Y-45	K-38					

Run Sequence

PANTONE Color values displayed represent the colors referenced within this book. To obtain color values for all PANTONE MATCHING SYSTEM Colors, please refer to a current PANTONE COLOR BRIDGE publication. To obtain one, visit www.pantone.com or call 888-PANTONE.

credits

PANCRACIO packaging
ODM oficina de diseño y marketing
Art Director: Pedro Álvarez
Designer: Raúl Reguera

iStar Financial Annual Report
Addison
Creative Director: Richard Colbourne
Designer: Christina Antonopoulos
Photographers: Vincent Dixon,
Lorne Bridgman

Page 56
Evian "Vines" ad
Euro RSCG
Photographer: Marcel Christ

Psarotaverna Du Symposium ad
AMEN.
Creative Director/Copywriter/Stylist:
Nicolas Massey
Art Director/Designer: Carl Robichaud
Photographer: Alain Desjean

"Water is Our Muse" ad
Waterworks

Page 57
Garnet Hill catalog cover
Garnet Hill, Inc.
Art Director: Jennifer Hanna
Photographer: Francine Zaslow

Bella Cucina Pasta packaging
Louise Fili Ltd
Art Director/Designer: Louise Fili

Page 58
Cotton, Inc. Annual Report
Suka Design
Art Director/Designer: Brian Wong

Irving Farm Coffee logo & packaging
Louise Fili Ltd
Art Director: Louise Fili
Designers: Louise Fili, Chad Roberts
Illustrator: Lars Leetaru

Page 60
Finch Paper "Smoothie" swatchbooks
Finch Design Group
Creative Director: Rob Deluke
Designer: Jim Best
Photographer: Mark McCarty

"Pedro the Lion" poster
Foundation
Lure Design
Designer: Sarah Blacksmer

Page 61
ROJO packaging
ODM oficina de diseño y marketing
Art Director: Pedro Álvarez
Designer: Raúl Reguera

iStar Financial Annual Report
Addison
Creative Director: Richard Colbourne
Designer: Christina Antonopoulos
Photographers: Vincent Dixon,
Lorne Bridgman

Kleenex "Leather" packaging
Kimberly-Clark

Page 62
Silverado SOLO packaging
Silverado Vineyards
Michael Osborne Design
Art Director: Michael Osborne
Designer: Beth Leonardo

"Tiger Jam" image & identity
Tiger Woods Foundation
Top Design
Art Director/Designer: Peleg Top

Peterbilt Motors ad
Marc USA Dallas
Art Director/Designer: Gary Strange
Photographer: Tom Burkhart
Account Director: Warren Lett

Jimmy John's Gourmet Sandwiches ad
Planet Propaganda
Art Director: Kevin Wade
Designer: Dan Ibarra
Copywriter: Seth Gordon

Pages 63
GATX Annual Report
GATX Corporation
Addison
Creative Director: David Kohler
Designer: Eunice Woo
Photographers: Todd Boebel,
Charlie Westerman

Kailis Olive Oil packaging
Kailis Organic Olive Groves United
Chemistry
Art Director/Designer: Roland Butcher

Page 64
BMW ad
Cundari
Art Director/Designer: Richard Mortella
Photographer: David Sloan
Retoucher: George Kanellakis

Elektra identity & collateral
AMEN.
Creative Directors: Daniel Fortin,
Jean-Christophe Yacono
Art Director: Stéphane Legault
Designers: Stéphane Legault,
Maryse Verreault
Illustrators: Yvan Pinard, Jonathan Legris,
Stéphane Legault

Beauty & Nuance paper promotion
Mohawk Fine Papers
VSA Partners, Michael Vanderbyl Design
Art Directors: Jamie Koval,
Michael Vanderbyl

Page 66
Ruben Toledo Nordstrom Designer website
Nordstrom, Ruben Toledo

Page 67
Hummer ad
General Motors
© General Motors Corporation.
Image used with permission of HUMMER
and General Motors.
Modernista
Art Director: Will Uromis
Photographer: Tim Simmons Photography

Gary Fisher Bicycles ad
Planet Propaganda
Art Director: Dana Lytle
Designer: David I. Taylor
Illustrator: David Huyck
Copywriter: John Besmer
Photographer: Sterling Lorence

At Home in the City ad
Young & Laramore
Creative Director: Charlie Hopper
Art Director: Trevor Williams
Copywriter: Jeff Nieberding

Page 68
Balducci's Brand identity
Pearlfisher
Art Director/Designer: Karen Welman

Page 69
America Online, Inc. logo
Desgrippes Gobe

Kodak Brand logo
Eastman Kodak Company

New York Life retirement plan brochure
Suka Design
Art Director/Designer: Brian Wong

Page 70
Chapter 8 Steakhouse & Dancelounge
brand launch & I.D. collateral
Talbot Design Group, Inc.
Art Director: Gaylyn Talbot
Designer: Chris Kosman

Asti packaging
Truax & Company
Art Director/Designer: Tiphaine Guillemet

Page 71
Jimmy Chips packaging
Jimmy John's Gourmet Sandwiches
Planet Propaganda
Art Director: Kevin Wade
Designer: Kelly English

YOLO Colorhouse packaging
YaM Studio
Art Directors: Michael Young, Angela Mack
Designer: Angela Mack
Photographer: Michael Young

Page 72
Microsoft XBOX 360, structural package
design
Swerve, Inc.

Page 73
Paddywax Candle packaging
Principle
Art Director: Pamela Zuccker
Designers: Pamela Zuccker, Jennifer Sukis
Photographer: David Lefler
Printer: WS Packaging

Page 74
Hayman Safes promotional poster/POP
Hayman Safes/Right Creative
Art Directors: Jeff Matz, Jane Harrison
Designer: Jeff Matz
Retoucher: Studio FX

Page 75
HBF Textiles "stitch" promotion
Creativille, Inc.
Art Director/Designer: Steve Hartman
Photographer: Mike Speckhard
Gregg Goldman Photography

Page 80
Santina Design identity
Laura Herrmann Design
Art Director/Designer: Laura H. Couallier

Page 82
ch-chocolates packaging
YaM Studio
Art Directors: Michael Young/Angela Mack
Designer: Angela Mack
Photographer: Michael Young

"Love" stamp
United States Postal Service
Michael Osborne Design
Art Director: Ethel Kessler
Designer: Michael Osborne

PANTONE® ad
Courtesy of Pantone, Inc.

Bella Cucina packaging
Louise Fili Ltd
Art Director/Designer: Louise Fili

"Easy as Pie" postcard
Cornell Storefront Systems
Amazing Spaces, Inc.
Art Director/Designer: Michelle L. Evans
Photographer: Burke/Triolo Productions
(brand x pictures, c/o Getty Images)
Printing: Llewellyn & McKane

Edible Art event materials
Art Institute of Boston at Lesley University
Pangaro Beer
Art Directors: Natalie Pangaro, Shannon Beer
Designers: Trish Leavitt, David Salafia

Page 84
Wend-Tyler Winery label
Dave Tyler
Marcia Herrmann Design
Art Director/Designer: Marcia Herrmann
Illustrator: Jim Long

Graylyn International Conference Center
brochures
Mitre Design
Art Director: Troy Tyner
Designers: Troy Tyner, Elliot Strunk,
John Foust
Photographer: Black Horse

Candinas Chocolatier packaging
Planet Propaganda
Art Director: Kevin Wade
Production Designer: Angie Mcdonwaldt

"Pietra Dura" stationery packaging
The Roudnice Lobkowicz Collection
Anderson Creative Group
Designer: William Anderson

Bernhardt ad
The Richards Group
Creative Director: Stan Richards
Art Director: Jeff Hopfer
Print Producer: Peter Stettner
Illustrator/Calligrapher: John Stevens
Photographer: Jeff Campbell

DADA directory
Downtown Arts District Association
Mitre Design
Art Director/Designer: Troy Tyner
Photographer: Black Horse Studio

Page 86
Peninsula Community Foundation brochure
Michael Osborne Design
Art Director: Michael Osborne
Designer: Alice Koswara
Illustrations: Craig Frazier

Redwood Creek Wines of California ad
BBDO West
Art Director: Heward Jue
Illustrator: Jeff Foster

Fiesta® ad
The Homer Laughlin China Company
Benghiat Marketing and Communications
Art Director/Designer: Jodie McLeod
Photographer: Ken Mengay

Nancy Koltes at Home ad
Nancy Koltes & Associates, In-house

Niccolò Showroom website
Mucca Design Corporation
Art Director: Matteo Bologna
Designer: Christine Celic Strohl
Web Programmer: Alex Smoller Design

Page 88
Creative Nail Design Enamel Line-up ad
In-house Creative Services
Creative Director: Patricia Ybarra
Designer: Suzy Everson
Photographers: Al Quiala, Pacific PreMedia

Scentsations Black Cherry & Nutmeg ad
Creative Nail Design
In-house Creative Services
Creative Director: Patricia Ybarra
Designer: Suzy Everson
Photographer: Alberto Tolot

Edward Carriere Salon identity & window ads
Velocity Design Works
Art Director/Designer: Lasha Orzechowski
Photographer: Deborah Seguin

Engelhard Corporation Annual Report
Addison
Art Director: David Kohler
Designer: Rick Slusher
Photographer: Kai Weichmann
Printer: L.P. Thebault Co.

Keelie Jones wedding invitation
Emspace Group
Designer: Amy Schonlau

Page 90
Juliska ad
Art Directors: Elaine McCleary,
David Gooding
Photographer: Joel Cipes

Barbara Barry on Options paper promotion
Mohawk Fine Papers
VSA Partners; Michael Vanderbyl Design
Art Directors: Jamie Koval, Michael Vanderbyl

40th Grammy Awards logo
The Recording Academy
Top Design
Art Director/Designer: Peleg Top

18K Catalog
Eighteen Karat International
David Cook Design
Photographer: Philippe Martin-Morice

Page 116
Raftman ad
Sleeman-Unibroue
AMEN.
Creative Director: Nicolas Massey
Art Director/Designer: Simon Touzin,
Photographer: Alain Desjean (Rhino Studio)
Copywriter: Simon Touzin

Mooney Airplane Company posters
Greteman Group
Art Director: Sonia Greteman

Wake Forest University Inaugural Materials
Mitre Design
Art Director: Troy Tyner
Designers: Troy Tyner, ShauThony Exum
Photographer: Black Horse Studio

Morgan Stanley environmental graphics
Poulin + Morris, Inc.
Designers: L. Richard Poulin, Douglas Morris

La Piazzetta identity
AMEN.
Creative Directors: Daniel Fortin, George Fok
Art Director/Designer: Maryse Verreault

Page 110
Su-Zen identity
Mucca Design Corporation
Art Director: Matteo Bologna
Designers: Matteo Bologna, Ayako Hosono
Photographer: Stephen Gross

Domani brochure
Kolter Communities
Gouthier Design: a brand collective
Art Director: Jonathan Gouthier
Designer: Kiley Del Valle
Photographer: Fiddler Productions
Printer: Southeastern Printing

Opie's Southbound Grille identity
Mitre Design
Art Director/Designer: Troy Tyner

The Phillips Collection™ ad
Designers: Anna Lazarus, Yuri Zatarain
Photographer: Atlantic Photographics, Inc.

Dulce de Leche packaging
Patagonian Life Family of Products
Estudio Visso
Art Director: Damián Visso
Designers: Damián Visso, Martín Epcldc
Photographer: Guillermo Balboa

18K Catalog
Eighteen Karat International
David Cook Design
Photographer: Philippe Martin-Morice

Page 120
RCFCU Annual Report
Mitre Design
Art Director/Designer: Troy Tyner

Kiss My Face packaging
Kiss My Face Corp.

18K Catalog
Eighteen Karat International
David Cook Design
Photographer: Philippe Martin-Morice

Zenprise packaging
Connie Hwang Design
Art Director/Designer: Connie Hwang

Praia-Bar-Lounge identity & collateral
Truax & Company
Art Director/Designer: Tiphaine Guillemet

Page 122
Exotic Cars at Caesar's Palace ads
Canyon Creative
Art Director: Dale Sprague
Designers: Dale Sprague, Joslynn Anderson,
David Adler
Photographer: Peter Harasty
Copywriter: Ann Sprague

Woof Stock poster
Kansas Humane Society
Greteman Group
Art Director: Sonia Greteman

Tantra Lounge packaging
Water Music Records
Top Design
Art Director/Designer: Peleg Top

"Talking to The Dead" bookcover
Doubleday
Art Director/Designer: Steven Rydberg
Typography Designer: Julie Duquet

Nordstrom/Ruben Toledo "Tea Party"
Nordstrom, Ruben Toledo

Madikwe packaging
Sayles Graphic Design
Art Director/Designer: John Sayles

Page 124
**Downtown Winston-Salem
Farmers' Market posters**
Mitre Design
Art Director: Troy Tyner
Designer/Illustrator: Kevin Pojman

**The Children's Museum of Winston-Salem
groundbreaking invitation**
Mitre Design
Art Director: Troy Tyner
Designer: John Foust

Dancing Diablo marketing postcards
Art Director: Beatriz Helena Ramos
Designers: Miguel Villalobos,
Veronica Ettedgui

Sears "Ty Pennington Style" media event
Edelman Design Communication
Art Directors: John Avila, Angela Payne
Designer: Rudy Rios
Print Production Coordinator/Producer:
Todd Novak

Immaculate Baking cookie packaging
Immaculate Baking Co.

Haworth OnSite brochure
Square One Design
Art Director: Mike Gorman
Designer: Martin Schoenborn
Photographer: Hedrich Blessing
Printer: Etheridge and Integra

CTI Paper USA swatchbook series
Greenleaf Media
Art Director: Mary Walsh
Designers: Erica Hess, Mary Walsh
Photographer: Erica Hess
Paper: CTI Paper USA
Printer: Fey Publishing

Page 126
"Book of Lure" cover
American Players Theatre
Planet Propaganda
Art Director: Dana Lytle
Designer: Geoff Halber

School of the Museum of Fine Arts, Boston
Creative Communication Assoc., Albany, NY
Art Director/Designer: Mark Geer
Photo courtesy of Mitchell-Innes & Nash
© Jessica Stockholder
Featured artwork: Jessica Stockholder,
"Your Skin in this Weather Bourne
Eye-Threads & Swollen Perfume" (detail),
1995. Concrete, structolite, miscellaneous
building materials, paint, carpet, lamps,
electrical cord, purple plastic stacking
crates, swimming pool liner, steel, stuffed
shirts, pillows, paper mache, and balls.
Installation, Dia Center for the Arts,
New York.

"DECOR" magazine cover
Pfingston Publishing
Art Director/Designer:
Margaux Medewitz-Zesch
Photographer: The Phillips Collection
Product Designer: Mimi Robinson at
Traditions Made Modern®

Ultimate Lounge CD packaging
Water Music Records
Top Design
Art Director/Designer: Peleg Top

Still from "Get Up & Grow"
Sesame Workshop
Dancing Diablo
Art Director/Designer: Breatriz Helena Ramos

"C.R.A.Z.Y." Limited Edition poster
AMEN.
Creative Director: Daniel Fortin, George Fok
Art Director/Designer/Illustrator:
Marie-Héléne Trottier

**Children's Museum of Winston-Salem
brochure**
Mitre Design
Art Director: Troy Tyner
Designers: ShanThony Exum, Elliot Strunk
Photographer: Black Horse Studio

Omaha Children's Museum brochure
Emspace
Designer: Gail Snodgrass

Page 128
At Edge packaging
Serbin Communications
Howry Design Associates
Art Director: Jill Howry
Designer: Ty Whittington

PANTONE® ad
Courtesy of Pantone, Inc.

**Educational Alliance, event brand, invitations
& accessories**
Creative Intelligence, Inc.

P6 Restaurant Lounge identity & collateral
Talbot Design Group, Inc.
Art Director: Gaylyn Talbot
Designer: Chris Kosman

Kansas State Fair posters
Greteman Group
Art Director: Sonia Greteman

Big Fold Z product launch
Georgia-Pacific
Function:
Art Director: Michele DeHaven
Designer: Gia Graham
Photographer: John Groven

Durham Western Heritage Museum invitation
Emspace
Designer: Gail Snodgrass
Illustrator: Karen Wolcott

Page 130
The Park brochure
Allegacy Federal Credit Union
Mitre Design
Art Director/Designer: Troy Tyner
Photographer: Black Horse Studio

Page 131
Thomas Paul catalog
Goodesign
Art Director/Designer: Kathryn Hammill
Photographers: Alexa M. Delatush,
Jay Bierach

Page 132
Wasabi Restaurant menus
Velocity Design Works
Art Director: Lasha Orzechowski
Designers: Lasha Orzechowski, Rick Sellar,
Krista Kline

Page 133
**"Outstanding Latina of the Year" poster
& collateral**
Target Stores
UNO "Branding for the New Majority"
Art Director: Luis Fitch
Designer: Jennife Zimeren
Illustration: Anthony Russo

Dale Chihuly exhibition brochure
Joslyn Art Museum
Emspace
Designer: Gail Snodgrass

Page 134
Stylebiters website (Madonna)
reduced fat
Art Director/Designer: John Bolster

index